"Having spent years trying to get companies whc ,
work with others, in bliss, where the mission of Corporate Cultural Responsibility
(CCR) is integrated into the fabric of the company, I can appreciate the nature of
this thoughtful review of what it means to apply CCR to the work a company does.
Corporate Cultural Responsibility: How Business Can Support Art, Design, and Culture
is a fine exploration of this topic written by Michael Bzdak, who is a consummate
believer in the principles he outlines and has lived his life applying them to his work.
The only way to get meaningful change going is for everyone who works in business
to understand these concepts and put them to use inside their companies."

—Chris Hacker, *Former CDO Johnson & Johnson, Chair of
Product Design at ArtCenter College of Design*

"Given the awesome influence of corporations in our lives, Michael Bzdak's exam-
ination of the association between commerce and art is particularly timely. Bzdak
provides us with an honest and clear-eyed assessment of the history, current con-
dition and suggestions for shaping the future of the relationship. In *Corporate
Cultural Responsibility: How Business Can Support Art, Design, and Culture*, Bzdak
brings decades of experience from inside a corporation with a long historical con-
nection to the arts and the humanities (cultural responsibility) as well as a broadly
established presence in the area of social responsibility. The insights and observa-
tions in this book are vital for corporate leaders as well as engaged members of
the arts and culture communities. Recent events have provided a stark reminder,
in case we had forgotten, that all members (stakeholders in corporate parlance) of
the community are interconnected and obligated to one another. Michael Bzdak
advances the conversation in this remarkable overview of the link between culture
and commerce."

—Wendel A. White, *Distinguished Professor of Art, Stockton
University, New Jersey, USA*

"Any effort trying to overcome the traditional boundaries of Corporate Social
Responsibility (CSR) is fresh air for business – as CSR clearly failed. Culture pro-
vides a much wider narrative to elevate the debate, paving the way to talk in a differ-
ent manner about the full potential of that part of business intentionally and deeply
engaged in the social impact race. Culture speaks a universal language based on not
only values, histories and traditions, but also creativity, empowerment, propensity
and capacity to imagine: all things which build the future thinking mindset of peo-
ple across different generations. A book for managers and leaders who want to aspire

to a re-imagined, beautiful value creation strategy as a way to steer organizational efforts towards meaningful transformation."

—Elisa Ricciuti, *Executive Director, Cottino Social Impact Campus, Turin, Italy*

"Michael Bzdak's thoughtful, well-researched and provocative *Corporate Cultural Responsibility: How Business Can Support Art, Design, and Culture* delivers on an ambitious agenda to articulate the concept of Corporate Cultural Responsibility and explore the cultural dimensions of a corporation's relationship with society. It is especially welcome, timely and necessary in the wake of the global upheaval created by the novel coronavirus along with the need to address climate change, social justice and economic inequities."

—Charles A. Birnbaum, *FASLA, FAAR, President and CEO, The Cultural Landscape Foundation, Washington, DC, USA*

"Michael Bzdak's book *Corporate Cultural Responsibility: How Business Can Support Art, Design, and Culture* comes at a significant moment when people are questioning corporate culture, the 1%, and the need for more philanthropy in this time of global crisis. As he shows, Corporate Social Responsibility has a long legacy dating back to Carnegie and his libraries and often takes shape as Corporate Cultural Responsibility. Corporations, whether through sponsorship of artful architectural programs or public programming, need to re-evaluate their efforts through the lenses of contemporary social and economic concerns. Today arts benefactors have an even more urgent task to focus on equity, sustainability, diversity, and social justice as audiences and communities demand a broad change in exhibition and performance content. Bzdak's timely investigation of numerous case studies through published literature and first-hand research codifies, questions, and synthesizes the companies' own views towards social responsibility as they fully realize that the public is their prime vocal critic."

—Nina Rappaport, *author of* Vertical Urban Factory *and publications director, Yale School of Architecture, New York, USA*

"The time of the pandemic has shown how important art and culture is for humanity and what is missing without it. Although business and managers have always been involved in supporting the arts, a systematic and structured approach to corporate cultural responsibility is missing. In *Corporate Cultural Responsibility: How Business Can Support Art, Design, and Culture*, Michael Bzdak offers a compelling and comprehensive framework that is informed by both, practice and theory. For readers, starting from students to global managers, the book will initiate an inspiring journey to redefine the relationship between business and the arts."

—Georg von Schnurbein, *Professor for Philanthropy Studies, Center for Philanthropy Studies (CEPS), University of Basel, Switzerland*

"Written during a time when art and industry found themselves taking on new forms to adapt to the insecurity and uncertainty that a global crisis delivered, this book revives the relationship between the arts and commerce and sets out a blueprint that contributes directly to the business of the sustainability agenda. Going forward from the 2020 pandemic we need a profound change in the way that societal systems behave, and one of the most significant barometers of systems is the corporation. Michael Bzdak throws a revolutionary idea onto the table at the start of this book, when he asks the question, 'What if there were an index that measured how much humanity a CEO embraced during his/her tenure as a leader?' Culture could be this indicator and Corporate Cultural Responsibility could deliver to the purpose of companies to more effectively and fully engage all their stakeholders in value creation. Corporate Cultural Responsibility could enable the ambitions of the United Nations Year of Creative Economy for Sustainable Development to become embedded into the practice of doing and being business, bringing forward the profound change that is needed to cross disciplines, and bring humanity into the centre of business. Michael Bzdak brings his in-depth appreciation of and knowledge about the arts and his expert business leadership and strategy management to draw together a work that is a form of art. It is crafted together, spanning geographies, modalities and time, it draws together materials that have been separated. It is prescient, we need this new relationship between art and commerce to allow us to chart out our way forward in this time of change."

—Professor Liz Grant, *FRSE, FRCPE, MFPH, Assistant Principal and Director Global Health Academy, Co-Director Global Compassion Initiative, University of Edinburgh, Scotland*

"As our world becomes more globalized and complex, businesses should take on more diverse roles, especially ones that promote social justice through the arts. The Nobel Prize winner in economics, Daniel Kahneman, makes the distinction between Econs and Humans. Econs are derived from the University of Chicago's model of human nature, that man and markets are wholly rational. This is reflected collectively by corporations devoted to their shareholders as the sole stakeholders of value with a vision of maximizing profit. Not only does Kahneman's research disabuse us of this model, but he calls for a more nuanced alternative. The arts and humanities have been devalued in the academy by the ascendence of STEM (science, technology, engineering and math) disciplines; in the corporate world this is reflected in the tendency to embrace the Chicago school's narrow focus on stockholders as the sole stakeholders. Michael Bzdak in this book demonstrates the need for a more expansive model of corporate responsibilities to multiple stakeholders. He argues for a robust relationship (intercourse) between corporations and the arts. This expanded vision of corporate responsibility has a holistic appeal that addresses the ills of society, the need for cultural transformation, and the call for social justice."

—Vicki Gold Levi, *collector, curator, and co-author of* Cuba Style *with Steve Heller and* Promising Paradise *with Rosa Lowinger and Frank Luca, New York, USA*

Corporate Cultural Responsibility

Is corporate investing in the arts and culture within communities good business? Written by an expert on the topic who ran the Corporate Art Program at Johnson & Johnson, the book sets out the case for business patronage of the arts and culture and demonstrates how to build an effective program for businesses to follow.

As companies seek new ways to add value to society, this book places business support of the arts in a corporate social responsibility context and offers a new concept: Corporate Cultural Responsibility. It discusses the issues underlying business support of the arts and explores new avenues of collaboration and value creation. The framework presented in the book serves as a guide for identifying the key attributes and projected impact of successful and sustainable models. Unlike other books centered on the relationship of art and commerce, this book looks at the broader and global implications of Corporate Cultural Responsibility. It also usefully sets the discussion about the role of philanthropy and corporate social responsibility and the arts within an historical timeframe.

As the first book to link culture to community responsibility, the book will be of particular relevance to corporate art advisors and auction houses, as well as students of arts management and corporate social responsibility at advanced undergraduate and postgraduate levels.

Michael Bzdak is the Global Director of Employee Engagement in the office of Global Community Impact at Johnson & Johnson. His first role at Johnson & Johnson was to manage the Corporate Art Program. He received a BFA from Virginia Commonwealth University and an MA and a PhD in Art History from Rutgers University.

Corporate Cultural Responsibility

How Business Can Support Art, Design, and Culture

Michael Bzdak

LONDON AND NEW YORK

Cover image: Harry Schwalb (1925–2019), *Corporate Image*, 1961, Corporate Image (ALCOA Headquarters Building), Ink on Natsume rice paper, Collection of Brittany Reilly, Image Courtesy of The Estate of Harry M. Schwalb, All rights reserved. Used with permission.

First published 2022
by Routledge
4 Park Square, Milton Park, Abingdon, Oxon OX14 4RN

and by Routledge
605 Third Avenue, New York, NY 10158

Routledge is an imprint of the Taylor & Francis Group, an informa business

British Library Cataloguing-in-Publication Data
A catalogue record for this book is available from the British Library

Library of Congress Cataloging-in-Publication Data
Names: Bzdak, Michael, 1958– author.
Title: Corporate cultural responsibility : how business can support art, design and culture / Michael Bzdak.
Description: Abingdon, Oxon ; New York, NY : Routledge, 2022. | Includes bibliographical references and index.
Subjects: LCSH: Social responsibility of business. | Culture—Economic aspects. | Art—Economic aspects.
Classification: LCC HD60 .B97 2022 (print) | LCC HD60 (ebook) | DDC 658.4/08—dc23/eng/20211213
LC record available at https://lccn.loc.gov/2021058660
LC ebook record available at https://lccn.loc.gov/2021058661

ISBN: 978-0-367-56741-5 (hbk)
ISBN: 978-0-367-56743-9 (pbk)
ISBN: 978-1-003-09922-2 (ebk)

DOI: 10.4324/9781003099222

Typeset in Adobe Garamond Pro
by codeMantra

Contents

Figures

Figures

Acknowledgements

This book would not have been possible without the help and support of many organizations and individuals. First, I thank the leadership of my company, Johnson & Johnson, for providing the inspiration to not only see the intersection between corporate responsibility and cultural responsibility but also support and champion the company's cultural responsibility. Many of the questions and issues explored in this book were the result of my direct experience at Johnson & Johnson. Throughout my career, I have been mentored and inspired by many purpose-driven leaders including the late James E. Burke, Conrad Person, Michael Sneed, Kathy Wengel, and Lauren Moore, to name a few. My current colleagues at Johnson & Johnson have also been supportive and inspiring. Thanks to Margaret Gurowitz, Julian A. Jimarez Howard, Maria Cia, and Shaun Mickus who understand the value of the arts in the workplace as well as the role of business in the community.

At Rutgers University, my other home, Mark Aakhus and Jonathan Potter provided important feedback and connected me to other scholars in the field. My early ideas were nurtured by time spent in Aspen, thanks to the Aspen Institute. Many thanks to Judy Samuelson and Nancy McGaw from the Aspen Business and Society Program for their supportive guidance and insights. Thanks also to Dawn Marie Castellana from the Corning Glass Foundation, Rob Cassetti from the Corning Museum of Glass, and Mikki Smith at the Raskow Library for helping me to discover the cultural responsibility of a great company. Also in Corning, many thanks to Brian Whisenhut from the Rockwell Museum.

I would also like to acknowledge Sandy Lang from NYU. In my early days as a corporate curator, I was fortunate to work with Sandy when she led the Art Advisory Service at the Museum of Modern Art. I would also like to thank Suzanne Lemakis for her friendship and guidance. Suzanne led the CitiBank Art Program and generously shared her experience managing a major collection. I am also grateful to Keith Davis, former curator of the Hallmark Collection. Keith is one of the rare examples of an individual who managed to bridge the three worlds of corporate, art, and academia. Under Keith's leadership, Hallmark developed a world-class photography collection which has become a public asset as part of a major museum. I am also grateful to Richard McCoy for sharing his insights on Columbus, Indiana.

His work with the Landmark Columbus Fund continues to prove the power of multi-stakeholder engagement and cultural responsibility. I learned a great deal about Cummins and Irwin Miller from his son, Will Miller.

Judi Jedlicka, former director of the Business Committee for the Arts, provided me access to some key pieces of literature from the organization's history and also some great insights from her experience on the frontlines of art and commerce. I am grateful to Laura Callanan for sharing her vision around the potential for impact investing in creativity and culture. Her efforts to build coalitions and to introduce new funding models inspire great optimism. Many thanks also to Paolo Costa who provided valuable information on Novartis and the company's commitment to cultural responsibility.

Thanks also to Brittany Reilly who shared great resources on Pittsburgh. Many thanks to Benjamin Farr for his help in securing images rights. Special thanks to Marina Spinazzi for translation support and Aislinn Weidele for graphic design help. I am also grateful for Cathryn Drake's masterful editing and expertise. Many thanks to David Bzdak for his expert creation of the index. This project would not have been possible without the amazing guidance from the Routledge team. Rebecca Marsh and Sophie Peoples have been great partners in bringing this work to life.

My wife Meredith Arms Bzdak served on numerous occasions as architecture expert, sounding board, and editor. I am truly grateful for her inspiration, support, optimism, and wisdom.

Introduction

What if there were an index that measured how much cultural benefit a CEO brought to society during his or her tenure at a company and also measured how much their company enhanced or preserved culture? In other words, how did the leader and the company demonstrate cultural responsibility? This book will make the argument that "cultural responsibility" is a critical element of the broader commitment that business has to society. The practice of Corporate Social Responsibility (CSR) has become a norm for business, yet there is little discussion of cultural practice as part of a broader CSR program. It is almost as though "culture" lost a seat at the table as the CSR movement matured. Corporate patrons and collectors of art such as Andrew Carnegie and John D. Rockefeller are well known, but there are many others that serve as examples for business and culture to engage in a mutually beneficial relationship.

In the nascent study of the partnership between art and commerce, it is important to examine the social and cultural practices of early industrialists, which were often both innovative and replicable. This book begins with a historical overview of pioneering efforts by the private sector to support culture and the arts. First, it is clear that the arts have benefited greatly from the patronage of visionary business leaders throughout history. Certainly, the wealth created by industry allowed Carnegie and the Rockefeller family to become benefactors of art, culture, and the humanities. These early leaders viewed art and culture as humanizing forces within the workplace and society. Although mostly paternalistic, their practices reflected attempts to promote humanism and underscored the importance of art and culture to a healthy society. Second, the arts have provided corporations and their leaders opportunities to improve their own business performance, brands, reputations, and communities. Third, well-designed company campuses and products as well as art collections have boosted the corporate image, the art market, and appreciation of living artists while enriching the lives of employees, consumers, and communities.

Why is it that the mid-twentieth century witnessed a steady growth in business engagement with the arts? There were certainly a few business leaders who had the vision and interest. In addition, sociologists and historians began to examine all aspects of humanity in the context of industrial culture and critics looked at the

DOI: 10.4324/9781003099222-1

burgeoning union of art and commerce. The concept of creativity became a topic for management as companies championed innovation and looked for ways to partner with artists, designers, and architects. Additionally, the bridges between art and technology were beginning to be explored. This was all happening while the practice of CSR was just beginning to gain momentum among business leaders.

The business and cultural communities have had fruitful relationships throughout history. The Medici family is often celebrated as an early exemplar of merchants as cultural patrons. These relationships through the ages have been classified into four categories—patronage, sponsorship, partnership, and investment—offering a useful framework through which to study the emergence of Corporate Cultural Responsibility (CCR) (Herranz-de-la-Casa, Manfredi-Sánchez and Cabezuelo-Lorenzo, 2015). While patronage reflects a philanthropic approach, sponsorship and partnership imply social and business motivations. Investment is the more common incentive for a company to develop a public cultural space or museum, often associated with its brand.

Most often, these approaches involve a beneficiary or partner. Museums have been the most consistent recipients of patronage as well as willing collaborators, playing a critical role in the relationship between art and commerce. The roles of the Museum of Modern Art, Metropolitan Museum of Art, and Guggenheim Museum, for example, are explored in the following chapters. This book also discusses new models of company-sponsored museums as potential keys to a sustainable future for CCR. The role of museums is key to the discussion of CCR as they have played critical, complex, and controversial roles in the validation of companies as both catalysts for promoting good design and recipients of business patronage and sponsorship.

Beyond patronage, the book explores business involvement in fostering design excellence from the perspectives of both producer and user. The role of department stores in advancing good design and bridging the divide between art and commerce is also part of the narrative. In the following chapters, case studies from the United States as well as Germany, India, Italy, and Switzerland provide valuable lessons. Each example reveals the common elements of individual vision and leadership in response to the demands of multiple stakeholders. All of the examples balance the demands of multiple stakeholders, ranging from customers and employees to community members and shareholders. In each of the examples presented, company leaders have acted as a patron, partner, or producer in the belief that business can be a force for the common good. These cases provide the basis for a new framework titled "Principles of Corporate Cultural Responsibility," outlined in Figure 0.1. It serves as a guide for identifying the key attributes and potential impacts of successful and sustainable models of CCR as well as how value can be created through collaborations between art and commerce.

Key elements of the proposed new framework are impact areas including human and community development, cultural diversity, and increased access to new markets. When implemented properly, CCR can promote both social inclusion and

employee engagement. Authentic CCR celebrates the humanity at the core of our society. While certainly not a playbook for potential corporate partnerships or promotion of the arts, this framework is useful for businesses, NGOs, and governments seeking to create new collaborations and coalitions. Its precepts acknowledge the business and social value of a well-designed program, sponsorship, or partnership. At the core of CCR is a successful bridging of business and art worlds to create value for society. Underpinning the framework is how the company balances the value its practice creates for various stakeholder groups.

While CCR is an emerging framework focusing on the cultural dimensions of a corporation's relationship with society, CSR is a broadly established practice. At its heart is the assumption that a company has an obligation beyond merely generating profit. As early as 1975, S. Prakash Sethi defined the practice of CSR as focusing on three domains: social obligation, social responsibility, and social responsiveness (Sethi, 1975). All three of these areas emphasize the need for a company to fulfill both implicit and explicit expectations of multiple stakeholders to be seen as a legitimate, respected, and relevant actor in society. In the decades since, the meanings of obligation, responsibility, and responsiveness have evolved. This book chronicles the changing role of business in society and the role culture has played in shaping expectations and aspirations.

In the past decade, the term *Corporate Cultural Responsibility* has appeared in a limited number of publications, and it is safe to say there is no standard definition. In 2015, Wolfgang Lamprecht stated that CCR "is an important contribution to social responsibility that a company should, if not must, provide to maintain a balanced and civilized society, as well to the long-term sustainability of its own success" (Lamprecht, 2015). In 2014, Francois Maon and Adam Lindgreen approached the concept of CCR in a more sociological way by looking at cultural beliefs and globalization beyond the arts and humanities (Maon and Lindgreen, 2014). In the context of this study, CCR is defined as a subset of CSR where a business engages with the arts to achieve sustainable value for relevant stakeholders. In addition, CCR can deliver business and social value through traditional philanthropy and patronage as well as through advocacy, policy, partnership, and practice. The formal framework provided in Table 1 is critical to understanding this definition of CCR. Based on the analysis of arts and business partnerships over the past 100 years, it identifies the critical elements of successful approaches. The framework also recognizes that there are motivations for a company to practice CCR well beyond traditional public relations.

At a time when Western capitalism is under siege, the role of business in supporting, creating, and sustaining cultural value for society is often acknowledged but not yet defined. Capitalism has been under more intense scrutiny in the wake of repeated missteps by various companies and entire sectors. A call for a new stakeholder capitalism is based on a return to morality with a focus on human dignity (Friedman and Adler, 2011). The collaboration between the Council for Inclusive Capitalism and the Vatican is among the many new efforts to redirect market forces and reimagine capitalism as a more inclusive and sustainable system. The World

CORPORATE CULTURAL RESPONSIBILITY

Aligning Principles	Means of Impact	Impact areas	Areas of indirect impact
Direct Engagement w/ artists/designers	Funding	Human Development	Replication of successful models
Economic, Cultural & Social value evident and balanced	Advocacy	Cultural Diversity	Thriving and engaged workforce
Initiated with long-term vision	Policy	Community Development	Thriving and sustainable communities
Sustainability not tied solely to donor/sponsor	Practice	Increased access to new markets	Enhanced reputation of donor

Figure 0.1 Corporate Cultural Responsibility © Michael Bzdak

Economic Forum's definition of stakeholder capitalism is most relevant here: "The capacity of the private sector to harness the innovative, creative power of individuals and teams to generate long-term value for shareholders, for all members of society, and for the planet we share" (World Economic Fourm, 2020). This reassessment of capitalism, which emphasizes long-term value for multiple stakeholders, comes more than 50 years after Milton Friedman's seminal essay arguing that profit should be the sole focus of business and underscoring the virtues of free-market capitalism and shareholder primacy (Friedman, 1970). It has taken half a century for the majority of business leaders to reconsider this dictum and turn the focus on the needs and expectations of multiple stakeholders.

Companies are increasingly being expected to return value to all of their stakeholders. For example, emerging evidence suggests that stakeholders are rewarding those companies that develop emotional connections to employees and customers (Bhattacharya, Sen and Korschun, 2011). Business has the potential to affect society on a massive scale, through product design, environmental practice, employee engagement, community involvement, and philanthropy. Clearly, corporations have a great deal of value to contribute to the well-being of society by supporting and sustaining the arts as well. This book will argue that business can also benefit from its engagement with art on many levels. In short, companies that engage with their stakeholders around the arts, design, and culture will be rewarded in both tangible and intangible ways.

Given that the United Nations General Assembly declared 2021 the International Year of Creative Economy for Sustainable Development, it is an ideal time to elevate art, culture, and design in global conversations around the economy, the

environment, and the future of society (United Nations, 2019). It can be argued that there is a strategic opportunity for all companies, large and small, to embrace cultural responsibility as an element of their identity as a corporate citizen. The COVID-19 pandemic has forced society to reevaluate and reflect upon core human values and the role that art and culture plays on local, national, and global levels. The pandemic has also revealed the vulnerability of arts institutions and the creative industries, showing in turn how, in some cases, national governments have renewed their commitments to the importance of the arts to the economy (Artforum, 2020).

Scholarly research at the intersection of art and commerce is surprisingly rare, although there are pockets of rich material. James Sloan Allen's book *The Romance of Commerce and Culture: Capitalism, Modernism, and the Chicago-Aspen Crusade for Cultural Reform* broke new ground in interdisciplinary research when it was published in 1983. In a sweeping look at the relationship between midcentury Modernism and philanthropy, Allen explored Walter Paepcke's role as an industrial patron and his company's embrace of Modern design and humanism (Allen, 2002). Allen provided a valuable portrayal of the context around the establishment of the Aspen Institute and carefully chronicled its evolution. The exhibition catalog *Art, Design, and the Modern Corporation*, documenting the Container Corporation of America's donation of its art collection to the National Museum of American Art, is an invaluable resource (Smithsonian Institution, 1985). The essay by Neil Harris is perhaps one of the most comprehensive narratives on the history of art and commerce (Harris, 1985).

In *Art for Work: The New Renaissance in Corporate Collecting*, a sweeping roundup of 40 corporate art programs, Marjory Jacobson declared the rebirth of corporate collecting (Jacobson, 1993). Published in 1995, Michele Bogart's *Artists, Advertising, and the Borders of Art* made a major contribution to the understanding of fine versus commercial art. Her rigorous study of the work of fine artists in the advertising world set the standard for scholarship on artists serving business and business supporting artists (Bogart, 1995). Interest in the topic of arts sponsorship was heightened by the efforts of the Reagan and Thatcher administrations to privatize many areas of society, including the arts. Chin-Tao Wu's *Privatising Culture: Corporate Art Intervention since the 1980s* highlighted important points of tension in the area of arts sponsorship and philanthropy (Wu, 2002). The issue of corporate sponsorship was addressed by Mark Rectanus in his important work on how corporations shape culture, *Culture Incorporated: Museums, Artists, and Corporate Sponsorships* (Rectanus, 2002). Georgina Walker's recent work, *The Private Collector's Museum: Public Good Versus Private Gain* on private collectors and their museums raises crucial questions around culture, privatization, and the common good (Walker, 2019). The author documents the growth of private museums in the recent past and grapples with the complexities of private versus public and the motivations behind these seemingly philanthropic efforts.

The recent series "Contextualizing Art Markets," published by Bloomsbury Visual Arts, promises to reverse the limited and siloed nature of previous scholarship

on art markets and hopefully dispel many of the negative connotations of "corporate art," "art for advertising," and "corporate art patronage." The latest volume, *Corporate Patronage of Art and Architecture in the United States, Late 19th Century to the Present*, is a welcome addition to the broader reexamination of the intersection of art markets, patronage, and the private sector. Published in 2019, the book is a diverse interdisciplinary effort that brings together the work of 12 scholars exploring critical aspects of corporate patronage. It also points to the fact that the history of business intervention in the arts is both poorly understood and not completely known.

Research on the creative industries outside of the United States has become increasingly important to economists and politicians. In their 2019 publication *A Research Agenda for Creative Industries*, Stuart Cunningham and Terry Flew have demonstrated that there is a great deal of work to do in understanding the impact of cultural production and creative services on society (Cunningham and Flew, 2019). An edited volume on the effects the digital revolution, *Digital Transformation in the Cultural and Creative Industries: Production, Consumption and Entrepreneurship in the Digital and Sharing Economy*, points to its potential transformation of the cultural and creative industries (Massi, Vecco and Lin, 2021).

Scholarly research and museum exhibitions focused on individual companies and their efforts to practice cultural responsibility have increased over the past few decades. The ambitious exhibition *Knoll Textiles, 1945–2010*, for example, brought to light the important contributions of Florence Knoll and the evolution of design practice through textiles (Martin, 2011). The well-researched catalog documents the pivotal postwar decades, when design became critical to consumers and corporations alike. The show *Design for the Corporate World: 1950–1975* examined the critical history of midcentury design against the backdrop of corporate design integration and the role of the International Design Conference in Aspen (Iris and B. Gerald Cantor Center for Visual Arts, Stanford University, 2017). John Harwood's book *The Interface: IBM and the Transformation of Corporate Design, 1945–1976* provides an evocative glimpse into the evolution of design at a major company (Harwood, 2011).

A significant number of doctoral dissertations focusing on corporate support of the arts, architecture, and design have been completed in the last 30 years. Alexandra Quantrill's examination of the postwar "Architecture of Enclosure" presents a new framing of corporate interior spaces and how they mirror societal trends (Quantrill, 2017). Judith Barter's close look at corporate art collecting, "The New Medici: The Rise of Corporate Collecting and Uses of Contemporary Art, 1925–1970," is a welcome addition to the literature on the establishment of collections and why abstract art was a popular choice (Barter, 1991). Alexandra Lange's 2005 dissertation, "Tower Typewriter and Trademark: Architects, Designers, and the Corporate Utopia, 1956–1964," provides valuable insight into the broader motivations around corporate patronage of design and architecture (Lange, 2005). Shantel Blakely's 2011 dissertation, "The Responsibilities of the Architect: Mass Production and Modernism in the Work of Marco Zanuso, 1936–1972" portrays the context of the designer's work at Olivetti as well as Italy at midcentury (Blakely, 2011). Also published in 2011,

AnnMarie Brennan's "Olivetti: A Working Model of Utopia" furnishes new insights on the company's approach to design, management, and social responsibility while considering the following question: "What is the position of design in relation to the entire mode of production and the creation of value?" (Brennan, 2011) Finally, Alice Twemlow's thesis "Purposes, Poetics, and Publics: The Shifting Dynamics of Design Criticism in the US and UK, 1955–2007," details the context around the emergence of design publications and criticism (Twemlow, 2013). Her chronicle of the publication *Industrial Design* is particularly informative.

The number of archival documents made available on the MoMA website has greatly aided the discovery of the many contributions the museum has made to the relationship between art and commerce since its inception. The catalogs for the exhibitions *Machine Art* (1934) and *Organic Design in Home Furnishings* (1941) are readily accessible as are transcripts of insightful interviews with former employees of the Art Advisory Service. The Italian department store La Rinascente has created an invaluable archive including information on the many designers affiliated with the retailer's history and images from its Compasso d'Oro awards program.

One of the most exciting developments of the last decade has been the trend toward social-impact investing related to the art and cultural industries. Led by Laura Callanan and Upstart Co-Lab, this new movement is positioned to tap into the practice to support the development of new models that sustain the arts in a responsible way. Callanan argues that job creation and social well-being are the positive outcomes of investments in creative industries. In 2021, Creativity, Culture & Capital was launched as a global community forum advocating for more investment in culture and the arts. Founded by Upstart Co-Lab, NESTA, and Art & Culture Finance, the platform kicked off with a series of essays by various proponents of impact investing for culture, ranging from a textile museum's efforts to promote the yarns and textiles in Oaxaca, Mexico, to revitalizing public spaces in Cairo using art and culture as catalysts (Creativity, Culture & Capital, 2021).

The following chapters chronicle the evolution of business engagement with culture and provide a framework for a successful and sustainable CCR practice. The case studies provide compelling evidence of both the limits and potential of CCR. Although companies such as Container Corporation of America, Cummins Engine, and Olivetti have received a great deal of scholarly attention, little of it has focused on the context of social responsibility. Corning Glass deserves more attention for its commitment to community enrichment and long-term view. All of these companies integrated elements of Modernism into their management models to benefit key stakeholders through design, architecture, and a commitment to the creative spirit in the pursuit of CCR.

While the narrative around art and commerce since the 1950s is far from complete, this book attempts to offer a more holistic history of corporate interventions in art, design, and architecture. In the course of contributing to a new CCR narrative, it has become clear that the contributions of many individuals, communities, and companies are underappreciated and often excluded from the story. Hopefully, designers such as Anne Swainson, entrepreneurs such as Marie Cuttoli, and

companies such as Jaipur Rugs will become better known and appreciated for their innovative contributions. In constructing this narrative, several critical texts from the 1950s, 1960s, and 1970s are discussed as business support of the arts developed on a parallel path with the evolution of CSR. A reexamination of these texts reveals critical elements of CCR as well as basic motivations for business engagement with the arts. For example, while the Business Committee for the Arts (BCA), founded by David Rockefeller, was well known during the boom years of corporate collecting, there has been no critical study of its membership and influence. The material on the BCA is just as important for what it does not include. Its members included high-profile companies, but certainly not all of those embracing art and culture around the world.

While architecture is one of the most visible manifestations of corporate patronage in the world of design and culture, art collecting became a norm in the 1980s and 1990s. Many collections were created to enhance corporate campuses for employees and visitors; some rivaled museum collections and others enhanced a company's identity. The most culturally responsible corporations acquired and displayed art as a strategic means to build stronger relationships with their communities.

The story of art and commerce intersects with that of social and cultural capital. The leadership role Philip Morris played in the art world, for example, reveals the questionable ethics of corporate influence over arts organizations, and the dominance of corporate representatives on museum boards has only recently been examined with a critical eye. As the following chapters demonstrate, cultural institutions have provided a platform for business and its leaders to build, enhance, and sometimes deplete social and cultural capital.

There is no magic formula for sustainable unions of art and commerce. However, this book concludes with five recommendations to elevate, enhance, and evaluate the potential value of business and arts alliances. Climate change, social justice, economic inequity, and global pandemics offer challenges on a whole new level of complexity. Many business leaders believe that art and culture are at the core of our humanity and help us to see the world in new ways. Hopefully this book offers paths for further investigation and research as interest in the global creative economy rises. It certainly seems to be the perfect time to revisit, reimagine, and reinvent the relationship of art and commerce.

Bibliography

Allen, James Sloan. 2002. *The Romance of Commerce and Culture: Capitalism, Modernism and the Chicago-Aspen Crusade for Cultural Reform.* Boulder: University Press of Colorado.

Artforum. 2020. "UK and Germany Launch Emergency Funds for the Arts as US Museums Call for Aid." *ARTFORUM.* March 25. https://www.artforum.com/news/uk-and-germany-launch-emergency-funds-for-the-arts-as-us-museums-call-for-aid-82557.

Barter, Judith A. 1991. *The New Medici: The Rise of Corporate Collecting and Uses of Contemporary Art, 1925–1970.* Amherst: University of Massachusetts Amherst.

Bhattacharya, C. B., Sankar Sen, and Daniel Korschun. 2011. *Leveraging Corporate Responsibility: The Stakeholder Route to Maximizing Business and Social Value*. Cambridge: Cambridge UniversityPress.

Blakely, Shantel. 2011. *The Responsibilities of the Architect: Mass Production and Modernism in the Work of Marco Zanuso 1936–1972*. New York: Columbia University. https://academiccommons.columbia.edu/doi/10.7916/D86Q245S (Retrieved February 6, 2021).

Bogart, Michele. 1995. *Artists, Advertising, and the Borders of Art*. Chicago: University of Chicago Press.

Brennan, Ann Marie. 2011. *Olivetti: A Working Model of Utopia*. Princeton. https://login.proxy.libraries.rutgers.edu/login?url=?url=https://www-proquest-com.proxy.libraries.rutgers.edu/dissertations-theses/olivetti-working-model-utopia/docview/878893990/se-2?accountid=13626 (Retrieved February 15, 2021).

Creativity, Culture & Capital. 2021. *About Creativity, Culture & Capital*. March 28. https://www.creativityculturecapital.org/about-creativity-culture-and-capital/.

Cunningham, Stuart, and Terry Flew. 2019. "Introduction to a Research Agenda for Creative Industries." In *A Research Agenda for Creative Industries*, by S. Cunningham and T. Flew, eds., 1–20. Cheltenham: Edward Elgar Publishing.

Friedman, Hershey, and William Adler. 2011. "Moral Capitalism: A Biblical Perspective." *American Journal of Economics and Sociology*, 70(4), 1014–1028.

Friedman, Milton. 1970. "The Social Responsibility of Business Is to Increase Its Profits." *New York Times Magazine*, September 1970: 122–126.

Harris, Neil. 1985. "Designs on Demand: Art and the Modern Corporation." In *Art, Design, and the Modern Corporation*, by Smithsonian Institution, 8–30. Washington: Smithsonian Institution Press.

Harwood, John. 2011. *The Interface: IBM and the Transformation of Corporate Design, 1945–1976*. Minneapolis: University of Minnesota Press.

Herranz-de-la-Casa, José María, Juan Luis. Manfredi-Sánchez, and Francisco Cabezuelo-Lorenzo. 2015. "Latest Trends and Initiatives in Corporate Social Responsibility: A Communicational Analysis of Successful Cases of Arts and Culture in Spain." *Catalan Journal of Communication & Cultural Studies*, 7(2), 217–229.

Iris and B. Gerald Cantor Center for Visual Arts, Stanford University. 2017. *Design for the Corporate World: 1950–1975*. London: Lund Humphries.

Jacobson, Marjory. 1993. *Art for Work: The New Renaissnace in Corporate Collecting*. Boston: Harvard Business School Press.

Lamprecht, Wolfgang. 2015. *Arts Management Articles*. April 29. https://www.artsmanagement.net/Articles/Sponsoring-Long-Lives-Corporate-Cultural-Responsibility,3681.

Lange, Alexandra. 2005. *Tower Typewriter and Trademark: Architects, Designers and the Corporate Utopia, 1956–1964*. Ann Arbor: New York University, ProQuest Dissertations & Theses Global.

Maon, Francois, and Adam Lindgreen. 2014. "Reclaiming the Child Left Behind: The Case for Corporate Cultural Responsibility." *Journal of Business Ethics* 755–766.

Martin, Earl, ed. 2011. *Knoll Textiles, 1945–2010*. New Haven: Yale University Press.

Massi, Marta, Marilena Vecco, and Yi Lin. 2021. *Digital Transformation in the Cultural and Creative Industries: Production, Consumption and Entrepreneurship in the Digital and Sharing Economy*. London: Routledge.

Quantrill, Alexandra. 2017. *The Aesthetics of Precision: Environmental Management and Technique in the Architecture of Enclosure, 1946–1986*. New York: Coumbia University. https://login.proxy.libraries.rutgers.edu/login?url=?url=https://www-proquest-com.

proxy.libraries.rutgers.edu/docview/1993516113?accountid=13626 (Retrieved October 17, 2020).

Rectanus, Mark R. 2002. *Culture Incorporated: Museums, Artists and Corporate Sponsorships.* Minneapolis: Univeristy of Minnesota Press.

Sethi, S. Prakash. 1975. "Dimensions of Corporate Social Performance: An Analytical Framework." *California Management Review,* 17(3), 59–64. https://doi.org/10.2307/41162149 (Retrieved November 22, 2020).

Smithsonian Institution. 1985. *Art, Design, and the Modern Corporation.* Washington: Smithsonian Institution Press.

Twemlow, Alice. 2013. *Purposes, Poetics, and Publics: The The Shifting Dynamics of Design Criticism in the US and UK, 1955–2007 (Diss.).* London: The Royal College of Art. https://researchonline.rca.ac.uk/1659/1/TWEMLOW_THESIS_NOV_2013.pdf (Retrieved March 7, 2021).

United Nations. 2019. "United Nations General Assembly." *Seventy-Fourth Session, Second Committee Agenda Item 17, Macroeconomic Policy Questions.* November 8. https://undocs.org/A/C.2/74/L.16/Rev.1 (Retrieved September 17, 2020).

Walker, Georgina S. 2019. *The Private Collector's Museum: Public Good Versus Private Gain.* London: Routledge.

World Economic Fourm. 2020. "Measuring Stakeholder Capitalism." *World Economic Fourm.* September 22. https://www.weforum.org/reports/measuring-stakeholder-capitalism-towards-common-metrics-and-consistent-reporting-of-sustainable-value-creation (Retrieved November 1, 2020).

Wu, Chin-tao. 2002. *Privatising Culture: Corporate Art Intervention since the 1980s.* London: Verso.

Chapter 1

Defining a Role for Business in the Arts

Promising Patronage Practices

After all, "culture" is traditionally associated with meaning and creativity, with works of the imagination and aesthetic practices that are far removed from the pursuit of economic profit. "Commerce," on the other hand, has traditionally been regarded by social scientists with disdain, signaling a vulgar and materialistic world devoid of morality, where human agency is subordinated to the logic of capital.

Peter Jackson

The nineteenth century witnessed an increase in industrialist patrons committed to providing social, economic, and cultural resources to their employees and communities. The most notable examples include Saltaire, a model village established in 1851 by Sir Titus Salt, just outside of Bradford, West Yorkshire; Bournville, a suburb of Birmingham founded by George Cadbury in 1879; and William Lever's Port Sunlight, a company town including an art gallery and a theater, built in 1888. The self-contained community Port Sunlight represents a holistic approach to planning and design that provides for all aspects of employees' lives. A company publication paints a complete picture of the town, which incorporates manufacturing, housing, a church, sports facilities, and cultural amenities (Lever Brothers, 1953). Influenced by the Garden City movement, Bournville and Port Sunlight embodied an emerging corporate paternalism with a humanistic focus. Lever believed in the power of art, architecture, and design to foster a company culture that would inspire and galvanize

DOI: 10.4324/9781003099222-2

the workforce (Rowan, 2003). Saltaire, the Victorian village housing employees of Salts Mill, was designated a UNESCO World Heritage Site as "an outstanding example of mid-19th century philanthropic paternalism, which had a profound influence on developments in industrial social welfare and urban planning in the United Kingdom and beyond" (UNESCO, 2001).

These models from the United Kingdom reveal the aspirations of individual industrialists who sought to provide workers with optimal work-and-living experiences. Each example underscores a reaction to an urban context that was often viewed as inhumane, unhygienic, and dehumanizing. They leveraged architecture, design, and culture to alleviate the challenges faced by a growing corporate workforce. Humanizing the work environment in the wake of industrialization was the hallmark of an emerging corporate cultural responsibility in these early examples. These nascent alliances of culture and commerce highlight the use of art and architecture to improve conditions for workers while raising new questions about a company's obligations to society. A defining feature of these three large-scale efforts is their focus on long-term planning and the associated commitment of financial resources, reflecting a belief in the future success of the business as well as the legacy of the firm. These voluntary paternalistic models were admired and copied by other industrialists and many still exist today.

In Copenhagen, philanthropist J.C. Jacobsen developed a model of community and cultural responsibility in the Carlsberg brewery, named after his son, Carl. In 1876, Jacobsen set a visionary precedent when he transferred a controlling stake in the business to the Royal Danish Academy of Sciences and Letters, under the auspices of the Carlsberg Foundation. Although there are other Scandinavian companies governed by foundations, the Carlsberg Group remains the only global brewery owned entirely by a foundation. In 1902, Carl Jacobsen signed a deed transferring his own brewery, New Carlsberg, to the Carlsberg Foundation and founded the New Carlsberg Foundation, still a major funder of the arts in Denmark. He had already formalized his commitment to cultural responsibility with the New Carlsberg Glyptotek, an art museum opened in 1897 with his personal art collection at its core. According to the New Carlsberg Foundation's website, its grants (totaling some DKK 170 million in 2019) fund donations of artworks to museums, decorative projects, and art research, along with a non-earmarked fund available for other art-related purposes (New Carlsberg Foundation, 2021).

Italy's Crespi d'Adda was commissioned as a company town by a textile manufacturer in 1878 and, like Saltaire, became a UNESCO World Heritage Site, in 1995. Like Bournville, it included all the amenities of a self-contained community, including a health clinic, school, and theater. Although the company closed in 2004, descendants of workers still reside in the village (Figure 1.1). The story of Pirelli, founded in Milan, follows a similar path, except it remains a successful company today. Founded in 1872 by Giovanni Battista Pirelli, the company expanded outside of the city center to Bicocca. In the early 1920s, as the industry continued to grow, Pirelli developed the campus into a workers' village known as Borgo Pirelli,

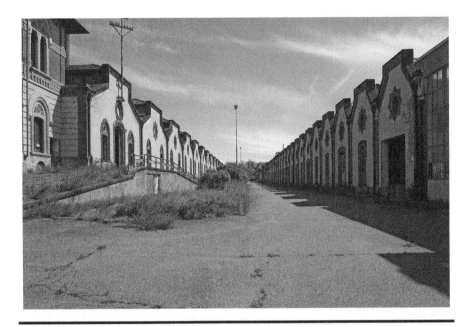

Figure 1.1 Cotonificio Benigno Crespi, 1878, Villaggio operaio di Crespi d'Adda. Photo courtesy of Luigi Matteoni

in collaboration with the Istituto Autonomo per le Case Popolari (IACP), where "principles of scientific management met those of industrial paternalism" (Kaika and Ruggiero, 2016). These examples from the early days of the industrial revolution underscore the humanistic possibilities of capitalism guided by the moral vision of individual corporate leaders acting on behalf of their employees.

Often labeled utopian, these initiatives reveal an emphasis on the human and cultural aspects of business. As industrialization expanded in the United States, the company town became an increasingly commonplace phenomenon. In 1880, George Mortimer Pullman, producer of the eponymous sleeping car, commissioned an architect and a landscape designer to plan a self-contained corporate community, with a bank, theater, and library, outside of Chicago (Crawford, 1995). Robber-baron philanthropy supported a range of civic and cultural efforts, most notably Andrew Carnegie's generous financing of more than 1,500 public libraries throughout the country, from 1886 to 1917. Douglas Klahr argues that Carnegie actually created a noncommercial brand along with these democratic civic spaces for learning and interaction. However, Carnegie's generosity came with conditions: in order to apply for a grant, a community had to demonstrate that it could sustain the library's operation. This usually meant that municipalities had to vote on a tax bond and, for many reasons, women were invited to participate in the vote—many years before the ratification of the Nineteenth Amendment, in 1920 (Klahr, 2019).

As industrialization became the norm in the early twentieth century, new opportunities were available to architects and designers. In 1883, Emil Moritz Rathenau formed the German Edison Society for Applied Electricity, which eventually became Allgemeine Elektricitäts-Gesellschaft (AEG), founded in Berlin in 1887 and inspired by Thomas Edison's experiments with electricity. In 1907, architect Peter Behrens was hired as design consultant, and his span of engagement included architecture and product design, as well as developing an overall corporate image. The iconic Turbine Factory, designed by Behrens in 1909, marked a new approach to monumental industrial architecture. In addition to its massive scale and lack of ornament, the building was inscribed with a logo cast in concrete in the gable. Behrens was responsible for innovative changes in overall design at AEG, including logos and products, creating a more progressive image for the company.

The idea of hiring a corporate artistic advisor was a novelty and came at a time when scientific management theories were popular among leading companies. Behrens's presence at AEG certainly helped to differentiate the company in an age of growing consumerism. His approach to design also signaled the private sector's receptivity to Modernism, furnishing a new design vocabulary along with an opportunity to demonstrate a progressive identity. It is no surprise that Walter Gropius was part of Behrens's circle, given his interest in developing a new language for industrial architecture. Behrens was grounded in the Darmstadt Artists' Colony, Düsseldorf Art Academy, and Deutscher Werkbund, where he was part of ongoing dialogues around concepts of utility and beauty in the contexts of industry and culture. A testament to his commitment to functional aesthetics, Behrens designed his own home in Darmstadt and all of its furniture and accessories, including a set of drinking glasses for the dining room, now part of the Corning Museum of Glass collection (Figure 1.2).

Unfortunately, little is known about AEG as a corporate patron or the company's motivations for engaging Behrens. The AEG case does, however, present an interesting precedent in the union of art and culture with industry and design. At the time industrial companies were faced with rapidly improving technology, a growing workforce, and an evolving responsibility to stakeholders. From the late nineteenth into the early twentieth century, scientific management became a tool for industries to increase efficiency and standardize work processes. As Modernism evolved, architects became aware of the changing nature of work and the workplace. Mauro F. Guillén sums it up: "Technology merged with style, science with history, efficiency with creativity, and functionality with aesthetics" (Guillén, 1997). Modernism as espoused by Behrens, Gropius, and others provided the private sector with both a new approach to design and the opportunity to bridge the gap between culture and industry.

The marriage of functionality and aesthetics was embraced in the United States just as architects such as Frank Lloyd Wright rose to prominence. The Wasmuth Portfolio—or more formally, Ausgeführte Bauten und Entwürfe von Frank Lloyd Wright—was published in Berlin in 1910–1911, marking Wright's influence on a number of individuals associated with the Bauhaus. Wright's work for industry, beginning in 1904 with the Larkin Building, may also have influenced the development

Figure 1.2 Peter Behrens, *Set of Drinking Glasses with Ruby Glass Feet* (1900–1901). CMOG 2007.3.118. Gift of the Ennion Society. Image licensed by The Corning Museum of Glass, Corning, NY (www.cmog.org) under CC BY-NC-SA 4.0

of corporate architecture in Europe. The design of the Larkin Building signaled the desire to offer comfort, dignity, and respect to employees with features such as access to natural light, a YWCA, a library, and a music lounge hosting weekly concerts. The building's interior was remarkable for its collection of allegorical sculptures and inspirational quotes inscribed on monumental columns; the art collection was one of the first corporate collections in the country, and the use of text in architecture was ahead of its time. Wright bridged modern industry with craftsmanship and design.

In Philadelphia, the Curtis Publishing Company, known for hiring artists to illustrate the *Ladies' Home Journal* and the *Saturday Evening Post*, also commissioned a new office and printing plant on Independence Square in Philadelphia in 1909. One of the highlights of the building was a mosaic mural in the lobby designed by Maxfield Parrish and executed by Tiffany representing an early effort at integrating art into corporate buildings. The Curtis Publishing Company established a Division of Commercial Research in 1911 which marked an early effort to establish marketing research as part of a publishing enterprise. Curtis also provides an interesting view into American consumers in the 1910s and 1920s where there continued to be

a chasm between the agrarian population and the urban and more industrial cities (Ward, 2005).

While America became known for rapid industrial expansion, Henry Ford and Fredrick Winslow Taylor were renowned for what became known as the "efficiency movement." In 1911, Taylor published *The Principle of Scientific Management*, setting off decades of debate among business and labor leaders. Taylor's approach was to seek improvements in all aspects of production through rigorous measurement of worker activity and movement. While not universally accepted in the United States, especially by labor activists, the theories were widely read elsewhere. Adam Arvidsson has shown, for example, how Taylorism was popular in Italy as early as 1914, while the country struggled to modernize its factories and economy (Arvidsson, 2003). As Guillén has pointed out, there are many elements of Taylorism that complement some of the foundational and aesthetic tenets of Modernism (Guillén, 1997). Taylor's ideas set the stage for subsequent efforts to organize and manage human labor, indirectly affecting the design of factories and offices.

Recognizing the growing demand for office space, the Metal Office Furniture Company, its name later changed to Steelcase, was founded in 1912. The company, decades later, collaborated with Wright on another important corporate commission: the S.C. Johnson Administration Building, in Racine, Wisconsin, completed in 1936. Herman Miller hired designer Gilbert Rohde, who later pioneered the office systems concept. After Rohde's unexpected death, the company hired architectural writer George Nelson as director of design; he went on to revolutionize company output, producing many icons of twentieth-century furniture design.

Car manufacturers provided the impetus for experiments in industrial design, engineering, and architecture. Albert Kahn's work for Ford Motor Company, also headquartered in Michigan, began with the multistory Highland Park Plant, in 1909. Kahn's use of reinforced concrete allowed increased spans, providing for the open floor space needed for large-scale equipment. Ford later commissioned a single-story plant for a complex housing every stage of car manufacturing and assembly, constructed between 1917 and 1928 on the River Rouge, in Dearborn, Michigan. At around the same time, Fiat commissioned Giacomo Matté-Trucco to design the massive Lingotto automobile factory in Turin, Italy, which became the largest car plant in Europe on its completion, in 1923. The five-floor design was celebrated for its functionality and scale, its defining feature the many ramps allowing raw materials to enter at the ground floor while vehicle assembly occurred progressively higher up to the roof, where finished cars were driven on an open-air test track.

The Role of Museums in Promoting Industry

As mass production collided with more established cottage industries, museums increasingly took on the role of advocating for good design. In 1897, Sarah and

Eleanor Hewitt established the Cooper Union Museum for the Arts of Decoration, inspired by the South Kensington Museum, in London, and the Musée des Arts Décoratifs, in Paris. The Hewitts endeavored to build a collection that would inspire new practices in industry through "individual objects that could be studied or copied, and collections of exemplary and typical objects—'specimens of art applied to industry'—that could be used to visually demonstrate the development of style and technique over time and national boundaries" (Keslacy, 2016).

One of the first museums to herald the importance of industrially produced objects was the Newark Museum in Newark, New Jersey. Its founder and first director, John Cotton Dana, organized an exhibition about the Deutscher Werkbund, *Modern German Applied Arts*, in 1912. Originating in Newark, the exhibition traveled on to several locations, including the National Arts Club in New York and the Art Institute of Chicago. The show was important for a few reasons: it was the first effort to introduce the Werkbund to American audiences; it revealed Dana's commitment to educating the public by integrating commercially manufactured objects in a museum context; it marked a shift from the elitism inherent in traditional American museum practice by showcasing design that could deliver value to society at large; and it featured local industry (Trask, 2012).

According to Nicolas P. Maffei,

> Dana believed that his displays could educate working people, liberate consumers from promoters of fashion obsolescence, and contribute to both a national art-in-industry movement and the development of a uniquely American aesthetic, a machine style rooted in the country's industrial prowess.
>
> (Maffei, 2000)

The Werkbund exhibition was one of many that the Newark Museum organized around manufactured and utilitarian objects with the goal of highlighting the symbiotic relationship between art and industry (Maffei, 2000). Dana pursued a deliberate strategy of celebrating the industrial accomplishments of local companies. The 1915 exhibition *New Jersey Clay Products*, for example, focused on the importance of the industry to both the consumer and the built environment; it was followed by exhibitions on textiles and leather, with demonstrations by craftspeople (*The American Magazine of Art*, 1916).

Dana's contributions were significant in at least three areas. According to Maffei,

> By assuming taste to be a necessary and significant part of social life, Dana addressed major issues of the early twentieth century: the degradation of labour in an industrial world, the autonomy of the individual in a consumer society, and the development of an independent American aesthetic and identity.
>
> (Maffei, 2000)

Dana's vision for promoting local industry and appreciation for European Modernism as exemplified by the Deutscher Werkbund was unique for the time. As a writer, curator, and thought leader, he helped to define the potential of the museum as a force for social good rather than a stale repository for high culture. Dana likely recognized the power of consumption and thus the growing need for good design as an element of social good. He also realized that while production was a critical force, educating consumers was even more important. In his embrace of the Deutscher Werkbund, Dana would have been aware of its aspiration to "demonstrate unity, vitality and, as the symbolic content of the shared good taste, the spiritual legitimacy of German ascendance" (Kogod, 2014). The Werkbund's involvement with commercial display windows is evidence of an interest in influencing taste and consumption. As early as 1909, the organization began a campaign to educate merchants while conducting three display-window competitions in Berlin. American department stores would soon follow in championing good design and innovative European practices.

The worthy efforts of Karl Ernst Osthaus, cofounder of the Deutscher Werkbund, are little known. In 1902, he established the Folkwang Museum and several years later the Museum for Art in Trade and Production, both in Hagen, Germany, where he lived. Through the latter he sought "to integrate the artist into the modern economy" by collecting examples of advertising, industrial design, and consumer goods. Presenting new ideas from outside of Germany, Osthaus viewed art "as a means of restructuring social life" (Schulte, 2009). Sharing this aspiration, Dana was in contact with Osthaus and became a vocal advocate for American museums to take an active role in promoting good design. He regularly chided the leadership of the Metropolitan Museum of Art for not being more relevant in acknowledging the criticality of industrial design in the United States. Historian Jeffrey Trask recently illuminated the complex inner workings of the museum to explain its reticence to get too close to business and industry (Trask, 2012).

Early evidence of the evolving field of industrial design was found in the "Art in Trade Exposition" organized by Macy's department store in 1927. Interestingly, the Metropolitan Museum of Art served as an advisor to the exhibition, lending it "artistic credibility" (Friedman, 2003). Macy's followed in 1928 with the "Exposition of Art in Industry," including works by Josef Hoffmann, William Lescaze, and Gio Ponti. The John Wanamaker Department Store, Abraham & Straus, and B. Altman and Company launched similar initiatives to introduce the public to Modernism and new trends in design. Lord & Taylor's 1928 "Exposition of Modern French Decorative Art" was the most ambitious effort to bring European decorative and industrial art to the department store, witnessing more than 300,000 visitors in its run of a little over a month. As part of the Lord & Taylor Modern French Decorative Art exhibition, French entrepreneur Marie Cuttoli was invited to display her rugs from her Paris fashion house Myrbor. Cuttoli is an interesting figure in that she was reviving a traditional artisan practice while at the same time engaging contemporary artists into textile design. Cuttoli's business ventures complemented the growing popularity of textiles in America as practiced by Bauhaus-inspired artists such as

Anni Albers at Black Mountain and Marli Ehrman from the School of Design in Chicago. In fact, Cuttoli was invited to exhibit Myrbor rugs at the Arts Club of Chicago in 1927 (Kang, 2020). Department stores and designers recognized that textiles were an effective means to bridge the craft tradition with industry as well as a means to introduce modernism into the home.

In promoting a modern lifestyle, Lord & Taylor executive Dorothy Shaver did not aspire to mimic European design but rather to inspire designers and manufacturers to shape an American version of modern design (McGoey, 2019). In 1937, Shaver also helped to create the Lord & Taylor American Design Awards. Several years later, she became president of Lord & Taylor and the first woman to lead a major retail establishment in the United States. Given her prominence in the American fashion retail industry, Shaver deserves more scholarly attention, particularly for her efforts to make Lord & Taylor more culturally responsible. To date, the only major examination of her career is a doctoral dissertation (Braun, 2009).

Shortly after Lord & Taylor's French decorative-arts exhibition, the Metropolitan Museum of Art launched the exhibition *The Architect and the Industrial Arts* as part of its "Art in Industry" series, begun in 1917. Until then, the museum's program had not been terribly forward looking, and there is still debate over how much Dana influenced the Met's stance (Laidlaw, 1988). According to museum communications, the 1929 show was in keeping with its 1870 charter to advance "the application of arts to manufacture and practical life" (Stern, Gilmartin, and Mellins, 1987). Judging by attendance figures and the critical attention it received, the exhibition was very popular, displaying the work of architects and designers such as Raymond Hood, Ely Jacques Kahn, Eliel Saarinen, Joseph Urban, and Ralph Walker (Laidlaw, 1988). The Museum of Modern Art (MoMA) opened a few months later and gradually became the institutional thought leader for Modernism in design and architecture.

Museums also played the role of prophets and conduits to the contemporary design world. In 1934, the MoMA's exhibition *Machine Art* demonstrated the possibilities of a modern American style evolving from commercial and industrial design. It displayed a wide variety of objects from industrial, scientific, and domestic contexts. In the foreword, Alfred H. Barr Jr. noted ominously:

> On every hand machines literally multiply our difficulties and point to our doom. If, to use L.P. Jack's phrase, we are to 'end the divorce' between our industry and our culture we must assimilate the machine aesthetically as well as economically. Not only must we bind Frankenstein—but we must make him beautiful.
>
> (Museum of Modern Art, 2021)

This exhibition, curated by Philip Johnson, set the stage for subsequent offerings from MoMA, and its legacy continues today.

Modernist architecture was officially introduced to American audiences with the show *Modern Architecture: International Exhibition*, organized by MoMA in 1932,

the same year it established its department of Architecture and Design. Three of the four founders of the International Style—Walter Gropius, Le Corbusier, and Mies van der Rohe—would play a role in translating the new approach to architecture into the American context. Among other European architects immigrating to the United States, William Lescaze arrived in Cleveland in 1920 and ultimately became a partner with George Howe in Philadelphia. In 1930, Howe & Lescaze submitted designs for a new building for the Museum of Modern Art in New York. In 1935, he established his own architecture firm, Lescaze & Associates.

Lescaze was a key figure in the innovative design of the PSFS Building in Philadelphia (1932), a skyscraper now known as the Loews Philadelphia Hotel. Recent research points to the progressive nature in at least two elements of its design. Grace Ong Yan revealed aspects of the design process that demonstrate a collaborative effort in which the patron played a major role. She also argued that PSFS was one of the first buildings in the United States to embody a brand with a large-scale sign installed on top of the structure. Architecture and design played a key role in the bank's identity. Inspired by European Modernism, the design offers a new vocabulary for commercial architecture combining industrial materials, planar surfaces, typography, signage, and lack of ornamentation to present an innovative building in a conservative urban context (Ong Yan, 2021).

Chicago as Art and Commerce Incubator

In the Midwest, Chicago was evolving as fertile ground for experimental architecture in America. Its late nineteenth-century experiments in skyscrapers proved the city to be both a capitalist powerhouse and a testing ground for innovation in architecture, design, and new materials. A reinterpretation of European Gothic architecture, the commercial building style forged by Burnham and Root, Louis Sullivan, and William Le Baron Jenney heralded a unique American contribution (Merwood-Salisbury, 2014). In fact, Sullivan's designs for the Schlesinger and Mayer department store (aka Carson Pirie Scott & Co.) represented a new building type that integrated "the genius of art with the genius of commerce" (Siry, 1988). The fact that the department store also included gallery space to host exhibitions of fine and advertising art also made Chicago and early adopter of making art more accessible to the broader public.

While it is difficult to determine whether the Newark Museum's Werkbund exhibition had any influence on the Chicago design community, the 1922 competition for the Chicago Tribune building was certainly a preview of what was to come, especially in the entries by Walter Gropius, Bruno Taut, Adolf Loos, and Eliel Saarinen. To celebrate its 75th anniversary, the newspaper company announced the international competition for a new downtown headquarters with $100,000 in incentive prizes, attracting 260 entries from 23 countries. The winning designs were published and all of the finalists' designs were displayed in a traveling exhibition (Milnarik, 2012).

In 1933–1934, Chicago hosted the exposition "Century of Progress," with more than 20 corporate pavilions. Most notably, Albert Kahn designed pavilions for both General Motors (GM) and Ford, and Walter Dorwin Teague contributed to the exhibition design (Marchand, 1991). A little-known element of "Century of Progress" was Italy's participation through both a pavilion and the historic presence of Italian aviators, who made a historic flight to the United States to mark the nation's presence at the event. Designed by Mario De Renzi and Adalberto Libera, the Italian pavilion reflected a progressive Modernist aesthetic that stood in stark contrast to the other fair buildings. The architecture and aviation feat underscored Italy's advancement in industrial production and technological progress amid an ever-increasing economic crisis. As Federica Dal Falco suggests,

> The new vision prevailing in Italy in the interwar period manifested itself through the integration between architecture and industrial production. This integrated approach led to a reflection on the modalities whereby industrial production could influence and renew the architectural culture.
>
> (Dal Falco, 2019)

Among exposition exhibitors was the Chicago-based Container Corporation of America, although the design of its booth was unremarkable and not terribly progressive.

Montgomery Ward, one of the first dry goods mail-order businesses in the US, was founded in Chicago in 1872. It was also was one of the first companies to embrace product design by hiring a design educator and architect to head its planning efforts. In 1931, Anne Swainson, became the first woman executive at Montgomery Ward and built a design practice that rivaled those of other design pioneers, such as Henry Dreyfuss and Raymond Loewy. Sears followed suit in 1938 by hiring German Modernist architect Karl Schneider to produce furniture and furnishings for the company. In the 1930s and 1940s, Chicago was a burgeoning center of European Modernism as architects and designers fled the turmoil in Europe. Mies was in the early stages of establishing the Illinois Institute of Technology, and the firm Skidmore, Owings & Merrill (SOM) was founded in Chicago in 1935.

In 1956, a special issue of *Industrial Design* devoted to Chicago put the city's remarkable role in the development of industrial design into context. Editor Jane Fisk Mitarachi's introductory essay traced the trajectory of Chicago's distinguished design history from the Great Chicago Fire to the New Bauhaus and Montgomery Ward, Sears, International Harvester, Armour & Company, and the Container Corporation of America. Business leaders played a decisive role in creating a culture of good design and nurturing a locally grown pool of talent. Mitarachi, later known as Jane Thompson, went on to lead the architectural planning firm Thompson Design Group, in Boston, and write a book on Design Research, the Cambridge store founded by her husband, architect Benjamin Thompson.

The Container Corporation of America

The Container Corporation of America (CCA), founded by Walter Paepcke, was one of the first companies in the United States to integrate European Modernism as part of its identity. CCA stands as a unique and powerful example of employing the corporate patronage of artists and designers to transform a company's image and influence while differentiating its brand. Paepcke's humanistic vision forged a new business model that evolved in the formation of a sustainable public forum now known as the Aspen Institute. In many ways, Paepcke's approach exemplifies the key elements of corporate cultural responsibility, especially his commitment to working in partnerships with artists, architects, and designers.

Rather than commission a company town, Paepcke brought creative talent inside the corporation. He integrated European Modernism and humanism into the company identity through advertising and graphic design. The ideas of Bauhaus émigrés such as László Moholy-Nagy and Herbert Bayer, as well as Paepcke's own wife, Elizabeth Nitze, heavily influenced him. As Michele Bogart states, Elizabeth convinced him that "the path to success was to burnish CCA's image by associating it with design excellence" (Bogart, 1995). This new type of patronage aspired to leverage design and cultural dialogue to the benefit of society.

In 1935, Paepcke hired Egbert Jacobson as company art director. With advertising agency experience at J. Walter Thompson and N.W. Ayer, Jacobson set out to create a new identity for CCA. Since early in his career he had advocated for commercial art as an element of the creative arts and a reflection of American culture. One of the founding members of the Art Directors Club of New York, Jacobson was instrumental in organizing a major exhibition of art in advertising in 1921. In the catalog's foreword, he explains:

> As commerce has engaged the best architects to meet the requirements of utility and by that has evolved a national architecture, it will engage the best artists to produce its advertising pictures, and thus a second great national expression based on usefulness will be developed.
>
> (The Art Directors Club, reprint 2018)

In 1937, CCA launched the company's first advertising campaign using the language of Modernism. The New Bauhaus opened its doors in Chicago the same year. Artists and designers working for CCA were able to express their individuality by signing their works. Paepcke took advantage of a time in history when companies were discovering that collaborations with leading artists could hone their image as "progressive, elite, sophisticated, educated, wealthy, and powerful" (Barter, 1991). Advertising was also becoming more important to corporations trying to reach a growing class of consumers. At the same time, there was a growing interest in the psychology of advertising among academics, artists, and business leaders. Paepcke's embrace of European Modernism was actually somewhat risky given his firm's product line.

Cardboard boxes were more of a commodity than a consumer product. Yet James Sloan Allen credits CCA's image campaign, as well as its "courageous" expansion, as the driver of the company's financial success in the late 1930s (Allen, 2002).

Chicago was home to the Association of Arts and Industries, founded by a group of business leaders in 1922 to promote the application of good design in industry. The organization sought to establish a school in partnership with the Art Institute of Chicago, an effort that failed. Its director, Norma K. Stahle, spearheaded the effort to establish a school aligned with Bauhaus principles, offering leadership to Walter Gropius, who in turn recommended Moholy-Nagy. The Hungarian artist accepted the role, and the New Bauhaus was launched in 1937, only to close the following year and reopen as the School of Design in 1939. As a loyal patron of Moholy-Nagy's efforts to recreate the Bauhaus education experience in Chicago, Paepcke endorsed his desire "to teach designers and industrialists alike to appreciate the social responsibilities inherent in their work" (Malherek, 2018). It is clear that this sense of social responsibility was the bond that sustained Paepcke's support of Moholy-Nagy.

Through various iterations of his school in Chicago, Moholy-Nagy was committed to educating aspiring designers as well as the business community in the principles of a New Bauhaus. The school struggled financially even as Paepcke stood by as a tireless patron, taking on more of a leadership role in 1939. In addition to their philanthropy and sharing of professional networks, Walter and Elizabeth Paepcke provided the use of their farm, where the school held three summer sessions (Engelbrecht, 2002). The school's legacy was carried forward by a large number of photographers who studied there and were influenced by the pedagogy advocated by Moholy-Nagy. With Paepcke's help, the school became the Institute of Design in 1944, with a new board of directors. Moholy-Nagy was diagnosed with leukemia and died in 1946, leading to the merger of the New Bauhaus, which had become the Institute of Design, with the Illinois Institute of Technology (IIT), headed by Mies van der Rohe, in 1949.

During his tenure, Moholy-Nagy realized an important milestone for photography when he convened some of the most celebrated photographers to teach at a six-week seminar, titled "New Vision in Photography," in the summer of 1946. Participants included Berenice Abbott, Beaumont Newhall, Paul Strand, and Roy Stryker. The workshop influenced the careers of many emerging photographers and contributed to Chicago's vaunted role in advancing art and design (Pohlad, 2000). Near the end of his life, Moholy-Nagy traveled to attend a conference on industrial design at the MoMA, where he declared: "Designers should be visionary, socially conscious leaders rather than mere consultants serving industry's capitalistic selling incentive" (Malherek, 2018).

Less known were the significant contributions of Moholy-Nagy's wife, Sibyl, who played a critical role in incorporating Bauhaus principles into the new school. She went on to teach in San Francisco and at the Pratt Institute, pursuing a career as a writer and critic. Stahle's work in creating the New Bauhaus is underappreciated as well (Engelbrecht, 2002). Katharine Kuh, a Chicago gallery owner, was also

an advocate for Modernism at the time, and she later became a curator at the Art Institute of Chicago. In 1941, Kuh organized an exhibition on Modernism and advertising in her Michigan Avenue gallery, with works by Moholy-Nagy, Herbert Bayer, and Paul Rand, and a catalog designed by György Kepes (Ross, 2020). Kuh moved to New York to pursue a career as an editor and critic and curated the exhibition *American Artists Paint the City*, in the U.S. Pavilion at the Venice Biennale of 1956. She later advised on the formation of one the great US corporate art collections, at the First National Bank of Chicago.

After the death of Moholy-Nagy, the University of Chicago became a critical influence on Paepcke, most notably through its president, Robert Maynard Hutchins, and faculty member Mortimer Adler. Hutchins was involved in another Chicago company, the Encyclopedia Britannica, whose publisher from 1943 to 1973, William Benton, was a longtime friend and supported public relations efforts on behalf of the University of Chicago. Benton was key to the encyclopedia company's purchase from Sears, Roebuck and Co. and its transformation into a more robust business. In 1943, Hutchins, Mortimer, and Benton led an effort to promote classic literature of Western culture with a university club for Chicago businessmen known as the "Fat Man's Great Book Course" (Allen, 2002).

Benton also developed a corporate art collection of American paintings, which was exhibited at the Art Institute of Chicago in 1948 and traveled to museums throughout the country. The company assembled the collection at its headquarters, on Wacker Drive, mostly for the benefit of employees. A lavish catalog was published in 1945 with a statement on the company's motivations for collecting and exhibiting the artworks (Encyclopedia Britannica, 1945). Beyond the patriotic tone of the statement, it is clear that the company wanted to democratize the experience of art and celebrate the uniqueness of American culture.

Encyclopedia Britannica's efforts, although little known, are laudable for at least three reasons. First, they championed the work of living artists while recognizing an emerging American style not dependent on Europe. Second, the company made efforts to share its collection with the broader public through a traveling exhibition program. Third, the collection featured the work of emerging and established artists, including a small number of women, working in a variety of styles. Ultimately, pieces from the collection were sold or donated with some of the major works ending up at the Memorial Art Gallery, in Rochester, New York, including those by Thomas Hart Benton, Stuart Davis, and Arthur Dove.

William Benton's and Hutchins's idea of developing a Great Books program eventually led to a broader campaign. It was this alliance that inspired CCA's unique visual campaign "Great Ideas of Western Man," marrying the work of contemporary artists with the history of Western thinkers and philosophers. The postwar economy provided companies with opportunities to grow their markets and brand identities among consumers and key stakeholders. The campaign, running from 1950 to the mid-1970s, is an early example of "corporate image advertising," where there is no apparent connection to a company's products (*Ad Age*, 2020). The campaign also

underscored Paepcke's interest in building relationships with stakeholders through design and bridging the gap between art and commerce.

Paepcke's dedication to European Modernism extended well beyond competitive advantage for his company. However, little is known about the effect integrating the arts and design into the business operations of CCA had on its employees and other stakeholders. It is equally difficult to determine how much influence the advertising agency N.W. Ayer & Son had on the company's progressive practices. Charles T. Coiner, one of Ayer's directors and a graduate of the Chicago Academy of Fine Arts, was responsible for some of CCA's most innovative campaigns, including "Great Ideas of Western Man." Leo Lionni, an Italian-American painter and illustrator, also worked for Coiner on the CCA account (Harris, 1985). Whether it was through an agency or CCA leadership, artists and designers were brought into direct contact with the company's executives. N.W. Ayer had been developing pioneering collaborations between artists and industry as early as 1928, most famously for Steinway & Sons, Dole Food Company, and Marcus Jewelers.

Herbert Bayer and Aspen

Herbert Bayer forged a symbiotic relationship with Paepcke that spanned many decades. In 1938, the Austrian designer emigrated from Germany to the United States to work at the Museum of Modern Art exhibition *Bauhaus: 1919–1928*, at the invitation of Alfred H. Barr Jr. The same year Bayer produced advertising work for CCA—his first project for a U.S. company—although he would not meet Paepcke until 1945. According to one scholar,

> as a result of his relationship with Paepcke, Bayer pioneered the concept of collaboration between the artist and a corporation. Their shared vision of a symbiotic relationship between corporate culture and an aesthetic philosophy was Bayer's realization of the true Bauhaus credo.
> (Floria and Ballinger, 2013)

Thus, it appeared that Bayer, who had studied at the Bauhaus, was committed to bridging the divide between art and commerce. He also brought a new vision in terms of employing techniques of collage, photomontage, and airbrush (Chanzit, 1985).

Alexander Dorner, a contemporary of Bayer's, offered insights into his approach to art, design, and advertising in the 1949 book *The Way Beyond Art*. Dorner makes a case for the potential of design and advertising to bridge the gap between industry and the arts. He advocates for the artist's role in industry as a "process of transformation" that will "not only make art a part of public life again but will also make of the designing and production of merchandise a public cultural act" (Dorner, 1949). Reminiscent of Behrens's efforts at AEG, Bayer created CCA's corporate identity

and served as architect and consultant for the establishment of the Aspen Institute, in 1950 (Logemann, 2011). Beyond advertising, CCA sought to bring design excellence to its facilities, including the architecture and interiors.

CCA also enjoyed a symbiotic relationship with mainstream art institutions. Most notably, the Art Institute of Chicago hosted an exhibition of CCA advertising, which later traveled to eight other major museums in the Midwest and Northeast (*Modern Art in Advertising*, 1946). Designed by Bayer, the show included 89 examples of advertising art. Bayer was an early thinker on the importance of exhibit design as a discipline and designed a number of exhibitions in Europe before his move to the United States.

In their effort to revive a dying Colorado mining town, Elizabeth and Walter Paepcke engaged Bayer to help transform Aspen into a cultural tourist destination. Their straightforward approach emphasized three areas: recreation, jobs, and a thriving cultural community. Bayer was invited to advise on the preservation and restoration of old buildings and the design of a new buildings (Figure 1.3). In 1949, Paepcke and his colleagues organized the Goethe Bicentennial Festival, which later evolved into the Aspen Institute for Humanistic Studies. The original vision was to commission Modernist architects such as Marcel Breuer and Harry Weese to also design houses in Aspen, but the aspiration fell short with Paepcke's passing, in April 1960. Paepcke's vision for Aspen stands as an enduring physical example of

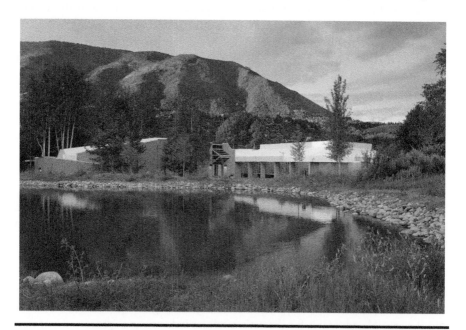

Figure 1.3 **Walter Paepcke Memorial Auditorium, Aspen Institute, Aspen, Colorado, 1962, Herbert Bayer. Image copyright © Mountain Home Photo, courtesy of Mills + Schnoering Architects, LLC**

corporate cultural responsibility since his humanistic aspirations have been sustained and nurtured there in year-round public programming. In a sense Aspen became CCA's company town, although the company name was never associated with it.

Another notable contribution by Paepcke was the establishment of the International Design Conference in Aspen (IDCA), an effort to bring the world of business into closer relationship with design. As James Sloan Allen describes it, the initiative was conceived to "awaken businessmen to their cultural responsibilities and bring wholeness—aesthetic and economic—to American culture" (Allen, 2002). Bayer supported Paepcke in the IDCA, which attracted major business leaders as well as artists and architects such as Josef Albers, Louis Kahn, and Eliot Noyes. According to the archives, in the belief "that modern design could make business more profitable, Paepcke set up the conference to promote interaction between artists, manufacturers, and businessmen" (Noruschat, Snoyman, and Nanol, 2020). In fact, Bayer's prominence at Aspen may have captured Olivetti's attention and led to his design of two posters for the company's adding machine in 1953 (Cooper Hewitt, 2021). Bayer's role in bridging the worlds of art and commerce is significant, from the Bauhaus to MoMA, CCA, and Aspen and back to Europe with Olivetti.

The first conference, held in 1951, was organized around the theme "Design as a Function of Management" and brought together representatives from prominent corporations as well as designers. CBS president Frank Stanton, architect Philip Johnson, and art director Leo Lionni were key to the planning process. Few executives of major corporations attended, especially those that might have influence on design becoming more a function of management. One exception was Stanley Marcus, president of Neiman Marcus, who supported the arts in Dallas and integrated art and fashion into his retail business model. An adherent of Modernism, Marcus helped to organize *Some Business Men Collect Contemporary Art*, a 1952 exhibition of abstract art from the collections of fellow businesspeople at the Dallas Museum of Fine Art. He saw it as a success in convincing museum leaders to be more adventurous in their acquisitions (Marcus, 2001).

Lionni, who was art director for *Fortune* magazine from 1948 to 1959, made sure Olivetti was well represented by its products and people at the conference (De Wit, 2017). Lionni's role in advancing Modernism deserves more attention in terms of his pivotal work at N.W. Ayer, *Fortune*, Olivetti and CCA. He also designed the catalog for the exhibition *The Family of Man*, at the Museum of Modern Art in 1955. Lionni's career as a successful children's book illustrator reveals his ability to marry art and commerce on another level. A publication of the American Institute of the Graphic Arts (AIGA) describes him as follows: "In word and deed, he has been an unfaltering rationalist, a devout humanist, and a passionate artist" (Heller, 2020).

The aspirations of the conference organizers were to integrate good design into the fabric of corporate America, from boardroom to factory floor. The dialogue initiated at the first IDCA sustained until the late 1960s, when social tensions and conflict between big business and the cultural community increased. As the conference continued, its original intention of bringing business closer to design was diminished.

In 1951, Paepcke organized the Aspen photography conference, which attracted leading practitioners such as Berenice Abbott, Minor White, and Dorothea Lange (Jones, 2009). This effort ultimately led to the establishment of the Aperture Foundation and served as a tribute to the work of Moholy-Nagy and the development of photography in Chicago.

Paepcke's biggest and most sustainable impact was in promoting the cross-fertilization of thought through gatherings large and small. As a business leader, Paepcke used his power and influence to bring many disparate partners together to advance his own beliefs and values. His humanistic crusade became less about advancing CCA and more about using the company to push his personal agenda. His commitment to European Modernism marked the beginning of a new chapter for corporate cultural responsibility in the United States, while Chicago became a pioneering nexus for the corporate embrace of design and Modernism. In essence, Bayer and Paepcke realized one of the goals of the Bauhaus with their integration of human-centered design throughout CCA.

Bayer also had a sustainable impact on bridging the divide between art and commerce through his work at CCA and Aspen. He later became a design consultant to the Atlantic Richfield Company (ARCO), where he helped assemble one of the largest corporate art collections in the world. A brochure published by ARCO heralds the company's commitment to art and design in six areas: architecture and interiors, the art collection, graphic design, art films, philanthropy, and the ARCO Center for Visual Art, from 1976 to 1984 (ARCO, 1980). The center focused on presenting contemporary art, and its records are now part of the Archives of American Art, at the Smithsonian Institution. After Paepcke's death CCA's visual art collection also landed at the Smithsonian, where scholars can access this critical contribution to modern American commercial advertising.

CCA benefitted greatly from its involvement with artists, designers, and architects. As a traditional patron, Paepcke had a vision and the resources to achieve it. Yet what value did those he engaged realize? Clearly Bayer's career was enhanced dramatically through his association with CCA. It could also be argued that the pioneering efforts of CCA introduced other companies to the burgeoning possibilities of European Modernism in advertising and product design. Ultimately, the public also benefitted from the creation of the Aspen Institute and its multiple conferences and conversations, made possible by Paepcke.

These nascent examples of corporate social responsibility point to a small group of individual business leaders with visions for creating and nurturing a more humanistic society while embracing Modernism. Elements of corporate cultural responsibility are evident in these early models as well, especially in terms of human development and long-term vision. A defining attribute is the fact that the corporate leaders worked directly with artists, designers, and architects to realize their visions. In particular, CCA stands out as a leader in practicing cultural responsibility at a high and authentic level.

Yet the incorporation of European Modernism into American commercial practice complicates the narrative. As one critic suggested, CCA's efforts might have been a case where "European art was formally reappropriated and theoretically adapted to create an avant-garde and a modernity that were specifically American and closely linked to the capitalist economy" (Jones, 2009). The radical use of collage, typography, and photo-based processes stood in stark contrast to the realism of Thomas Hart Benton and other artists popular at the time. The tension between art and commerce, in this case advertising, is best summed up by Jackson Lears:

> In the final account, though, it is difficult to escape the conclusion that much of the profoundest twentieth-century art has defined itself—at least unconsciously—against the symbolic universe of advertising. The artist may appropriate, reinterpret, or recombine image fragments from that realm, but the tension between the artwork and the advertising remains.
>
> (Lears, 1987)

While many viewed industry as leading the way in terms of the modernization of manufacturing and management, there were also lingering suspicions that the evolving improvements in technology and techniques would lead to the dehumanization and exploitation of workers. There was an inherent tension between the growth of big business and the essence of the creative arts. While the arts promoted individualism and creativity, business was seen as promoting conformity and mass production. Institutions such as the MoMA tempered the negative associations of mass production in their efforts to promote good design. A little-known example is a 1959 exhibition centered on the theme of packaging, titled *The Package*, curated by Mildred Constantine and Arthur Drexler. CCA and Reynolds Metals were among the sponsors, while Egbert Jacobson and Herbert Bayer were acknowledged for their "advice and technical guidance" (Museum of Modern Art, 2021). Since patrons such as Paepcke were rare, the growing divide between art and commerce provided opportunities for industrial patrons to seek out areas where both sides would benefit. In some cases, photography became a bridge between the worlds of art and commerce, as well as commerce and advertising.

Outside of the United States, Herbert Read had a formidable influence on the role of industrial design in modern culture in the United Kingdom. In 1934, he published *Art and Industry*, which was later revised and released to the American audience (Read, 1954). He also played a part in the formation of the Design Research Unit (DRU), in 1943, anticipating the postwar market for design and architecture. In 1944, the U.K. government established the Council of Industrial Design to promote excellence in product design and increase demand for better design by the general public. One of the first public projects the council organized, with guidance from the DRU, was the educational exhibition "*Britain Can Make It*" (1946), displayed at the Victoria & Albert Museum.

Photography as a Bridge between Art and Commerce

As David E. Nye has demonstrated, photography was increasingly important to corporations from the last decade of the nineteenth century. Many companies used photographs to convey a sense of corporate identity in communications to employees and other stakeholders (Nye, 1985). By 1930, photography was the preferred medium for advertising a wide variety of products and brands—it was used in almost 80% of illustrated advertisements. As Patricia Johnston wrote in *Real Fantasies*, "Photography could make beauty accessible, lead the way to a happier life, map out the possessions required to transcend class status, and project a perfect world and make it seem available" (Johnston, 1997). As agencies like J. Walter Thompson and N.W. Ayer proliferated, industry commissions for artists and photographers also grew. Johnston suggests that corporations saw the new advertising as a way to patronize the arts and convey high culture to a broader public (Johnston, 1997). Edward Steichen and Charles Sheeler were among the many artists and photographers drawn into the world of commerce. Their work also complicated the narrative of Modernism, industry, and the arts as it navigated the tense boundary between creativity and capitalism. Both photographers were considered fine artists who managed to work in the commercial realm of the arts, in the service of business. Steichen was also commissioned to design objects or patterns for Steuben Glass and Stehli Silk Company.

Embracing the new industrial capitalism took on religious overtones: "Business was the service, the ritual, of capitalism. Technology, especially industrial technology, became the iconography for business. Images of industry, as icons of business, acted as the vestments of capitalist piety" (Stomberg, 1999). Under the direction of Henry Luce, *Fortune* magazine was a leading voice in the promotion of photography as the ideal medium for a new vision of modernity. In 1926, Sheeler was hired by Steichen to work for the Condé Nast publications *Vogue* and *Vanity Fair*. At about the same time, Adriano Olivetti was making his study tour of American industry, including a visit to the Ford Motor Company. N.W. Ayer had helped Sheeler secure a commission to document the car company's manufacturing facilities in 1927. He produced twenty photographs, two drawings, and four oil paintings of the River Rouge Plant, the largest factory in the world at the time. Sheeler's work was intended to promote Ford while the company was launching the Model T. Although there has been much debate around Sheeler's personal views on the dominance of industry over labor and the dehumanization of the modern worker, his paintings and photographs portrayed the factory as aesthetically pleasing. For example, the photograph *Criss-Crossed Conveyors* (Figure 1.4) presents the River Rouge plant as a marvel of engineering, calling to mind a Gothic cathedral in size and grandeur. Its geometric composition of dynamic elements approaches abstraction. In 1928, the image appeared in *Vanity Fair* with the caption "By Their Works Ye Shall Know Them," likening mass production to the American God (Handy, 1991).

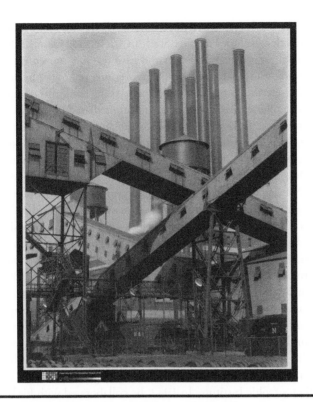

Figure 1.4 Charles Sheeler, (1883–1965). Criss-Crossed Conveyors, River Rouge Plant, Ford Motor Company, 1927. Gelatin silver print, 23.5 × 18.8 cm (9 1/4 × 7 3/8 in.). Ford Motor Company Collection, Gift of Ford Motor Company and John C. Waddell, 1987 (1987.1100.1). Image copyright © The Metropolitan Museum of Art

Source: Art Resource, NY

Yet in framing the factory as heroic and monumental, Sheeler may also have been alluding to, as Karen Lucic suggests, "human displacement as a general characteristic of a culture that has exploited workers and industrial methods to the maximum" (Lucic, 1991). Since Sheeler was hired by an agency, and not working directly for Ford, he may have felt free to incorporate an artistic critique of the industry, if subtle. Yet because his iconic images were published widely around the world, Sheeler became indelibly linked to industrial capitalism. Another reason behind Sheeler's exclusion of human figures from his compositions may relate to the history of photography itself: early photographers of cathedrals, for example, often left out the human presence to produce a pristine focus on the awe-inspiring scale of the architecture.

Soon after, in 1927–1928, Margaret Bourke-White was commissioned to document the production facilities of Otis Steel, in Cleveland, Ohio. Industry provided abundant material for artistic translation and gave rise to a movement known as Precisionism. According to Sharon Corwin, "Precisionist photography seems to be less about advertising specific commodities than advertising the forms of capitalist production that seem to offer endless, bountiful, and unmediated objects" (Corwin, 2001). These commissions actually came at time when industry was suffering the consequences of the Great Depression and served to bolster public-relations strategies aimed at promoting confidence in industrial America. Photographs were more credible than paintings or illustrations because they were perceived as presenting an objective view.

In 1938, Sheeler received a commission from *Fortune* to produce a portfolio around the theme of power. Terry Smith's discussion of the birth of the magazine, which debuted in 1930, reveals a self-conscious effort to create a business magazine that celebrated the modern corporation and its progressive use of photography and design (Smith, 1993). According to Smith, design, photography, and art were key elements of the new business culture promoted by *Fortune*. In 1939, the MoMA organized a major exhibition of Sheeler's work including paintings, drawings and photographs and titled *Charles Sheeler*. The museum began collecting photography in 1930 but did not establish a formal department until 1940, when it became the first in the world to recognize the medium as an art form. Steichen too played a key role in elevating photography during his service in the U.S. Navy by creating the Naval Aviation Photographic Unit, and in 1945, he was appointed director of the U.S. Navy Photographic Institute. In 1942, he collaborated with his brother-in-law, Carl Sandburg as well as Herbert Bayer, to organize the MoMA exhibition *Road to Victory*. Steichen led the museum's photography department from 1947 to 1962, and the 1955 exhibition *The Family of Man* became one of the hallmarks of his career.

At the time, the MoMA had become engaged in exploring how the museum could support pro-democracy efforts by the US government. Herbert Bayer's unconventional exhibition design, especially at MoMA, was highly influential, and somewhat overlooked. Bayer surrounded the viewer with imagery that empowered the viewer to interpret and integrate the photographs and text in their own way. According to Fred Turner:

> Bayer's field became a tool for the psychological and social integration of a new kind of American citizen. By granting American viewers high degrees of agency with regard to the visual materials around them and at the same time controlling the shape of the field in which they might encounter those materials, Bayer and Steichen could lead them to remake their own morale in terms set by the field around them. That is, American viewers could exercise the individual psychological agency on which democratic society depended and so avoid becoming the numb mass men and women of Nazi Germany.
>
> (Turner, 2012)

World War II also offered opportunities for the arts and design community to join the war efforts. This practice allowed both artists and the arts community to demonstrate patriotism in creative and collaborative ways. Moholy-Nagy and other leaders of the New Bauhaus seized the chance to engage with military experts to explore the ways design could contribute—for example, the use of photography as a surveillance tool and the development of a camouflage pattern.

Polaroid Corporation represents yet another example of how photography bridged the world of art and the world of commerce. In fact, one author summarized their efforts as, "one of the stellar examples in American business lore of corporate collaboration between a manufacturer and the consumer of its products" (Minkkinen, 2000). When the company launched its popular instant image camera in 1948 at Jordan Marsh's department store its target was wealthy amateurs. The company hired Ansel Adams as a consultant and over many decades became more closely associated with the fine arts. In the late 1960s, Polaroid initiated the Artist Support Program which donated materials to artists and in 1972, Polaroid opened the Clarence Kennedy Gallery at their headquarters building and in 1973 established the Polaroid Collections. Also in the 1970s, the company developed an in-house produced magazine known as *Close-Up*, or *Polaroid Close-Up* which served a number of purposes but in the end drew the company closer to the fine arts community (Buse, 2009). Finally, in 1976, Polaroid produced a larger format camera which produced 20 in. × 24 in. prints. A couple of these cameras were made available to artists including William Wegman who produced a number of iconic images in the Polaroid studio.

During and after World War II, many companies engaged in cultural activities, ranging from purchasing art and supporting arts organizations to using art in advertising. Most notably Abbott Laboratories, in Chicago, began partnerships with artists in the late 1930s, commissioning a number of projects related to documentation of the war, including a celebrated series by Thomas Hart Benton. Among other companies engaging in the arts, the Upjohn Company, Ciba-Geigy Corporation, and Pepsi-Cola undertook major initiatives (although none rose to the level of CCA). Pepsi-Cola stands out as the sponsor of "Portrait of America," an arts competition announced in 1944. Yet although it was innovative in its approach, the open call for artistic talent was deemed a failure. As Deidre Robson has pointed out, "The American art world of the 1940s was not yet in need of corporate support in the way it would be in later decades" (Robson, 2015). The Mead Corporation was another early pioneer in the sponsorship arena beginning with juried regional exhibitions that ultimately built a collection through purchase prizes and evolved to *Art Across America*, a touring, juried exhibition organized in the mid-1960s (Whalen, 1967). Art Across America marked the tenth anniversary of Mead's Painting of the Year program and signaled the company's commitment to both sponsorship and collecting (The Mead Corporation, 1965).

From 1949 to 1960, Hallmark held International Art Award competitions that were open to artists in France and the United States. Exhibitions of the winning artworks toured the country and, in a unique act of corporate philanthropy, the

proceeds benefitted the American Red Cross. The company acquired a selection of the works, which became the core of an emerging corporate collection. In 1964, Hallmark opened a gallery inside its retail store at 720 Fifth Avenue, in New York City, in one of the first efforts by a business in the United States to establish a museum-quality exhibition space. The company followed up by purchasing photography, amassing a significant collection over many decades. When the gallery ceased operation in 1973, the art collection was moved to its headquarters, in Kansas City, Missouri. While the Hallmark collection rivals that of many museums, one of its most powerful attributes has been its ability to reach the broader public through numerous exhibitions. In 2006, a significant part of the collection, valued at $65 million, was donated to the Nelson-Atkins Museum of Art (PND by Candid, 2006). Hallmark curator Keith Davis accompanied the collection to the museum, where he continued to expand one of the most important photography troves in the world.

Even in the postwar period, there was still tension between the increasingly commercial nature of the arts and the image of the artist as creative and independent in society. While companies were being called on to support the arts beyond advertising, there was still suspicion of the private sector as patron. In fact, most of the high-profile companies supporting art "were trying to recover either from scandals or from bad press arising from conflicts with the federal government" (Bogart, 1995). One of the most egregious examples is the American Tobacco Company's effort to enhance its reputation in light of the U.S. Justice Department's accusations of price-fixing and sector monopoly. The campaign involved commissioning regional artists to gloss the image of the Lucky Strike brand. Unfortunately, obscuring questionable company practices behind the cloak of corporate social responsibility practices raised questions around the motivations of business engagement with culture.

Accused of doing business with German company I.G. Farben, the Standard Oil Company of New Jersey employed its pioneering support of the arts to serve public relations. Roy Stryker, an economist turned documentary photography expert, was hired by Standard Oil in 1943, following a successful project he carried out for the Farm Security Administration (FSA), in 1935–1942. This was a critical time for the emergence of photography as a medium for advertising. In an innovative approach, Stryker commissioned Walker Evans, Dorothea Lange, Ben Shahn, and many others to document the living conditions of Americans in both rural and urban contexts for the oil company. The photos were used for in-house publications and made more broadly available to news outlets. In collaboration with Associated American Artists, Standard Oil also commissioned a series of paintings to document the role of oil in the war efforts, in 1944. Images from this project were reproduced in the company's magazine and displayed in exhibitions that toured museums and galleries.

Stryker's work at Standard Oil was built on his approach to hiring a variety of talented photographers to document the social and economic realities of postwar

America, the baby boom, and the growth of the suburbs. His roster of freelance photographers included Esther Bubley, Gordon Parks, and Edwin and Louise Rosskam. Known as the "humane propagandist," Stryker was at the forefront of photography as tool for both government and the private sector and moved easily between the realms of academia and business (Anderson, 1977). His approach to generating a volume of imagery with no specific end point or single purpose, as in the portfolios produced for the FSA and Standard Oil, was a departure from the use of photography in advertising to promote a specific product or personality. Stryker's conception of the photograph as a social document was unusual, especially in the corporate context. The Standard Oil archive of 85,000 photographs is now a public resource housed at the University of Louisville. After leaving the company in 1950, Stryker went on to an academic position at the University of Pittsburgh and took on at least one more corporate assignment, for the Jones & Laughlin Steel Corporation.

Stryker's work for Standard Oil can be seen as an effort to alleviate lingering tensions around the perceived gaps between an expanding corporate-industrial sector and humanitarian values. His team documented industrial settlements such as the Bayway Refinery, in the Port of New York and New Jersey—home to the largest catalytic cracker in the world during the twentieth century. Many of Stryker's freelance photographers were emerging professionals and were given the opportunity to expand their own styles and approaches in these assignments. One of these young talents, Esther Bubley, went on to a successful career after Stryker's departure from Standard Oil.

A turning point in the dynamics between art and commerce came in the decades before and after World War II. Growth in magazines featuring photography was staggering and launched the careers of many photographers. As Michele Bogart pointed out in her seminal work on the relationship between advertising and art,

> Control of the discourses of art meant more than just management of day-to-day activities. It meant the power to assert class and self-legitimacy in a society in which shifting economies, technologies, and social demographics were rapidly calling old ways of life and power relations into question.
>
> (Bogart, 1995)

These decades saw many opportunities for industrial designers to support business and more doors opening for different collaborations between the corporate community and the art world. As Patricia Johnston surmised astutely, "Advertising photography and industrial design, more than the fine arts, brought modernism to the general public" (Johnston, 1997). At a time when many companies were beginning to experiment with arts partnerships in the United States, a fascinating model in corporate cultural responsibility was evolving at Olivetti, near Turin, Italy.

Bibliography

Ad Age. 2020. "N.W. AYER & SON (N.W. AYER & PARTNERS)." *Ad Age Encyclopedia.* July 31. https://adage.com/article/adage-encyclopedia/n-w-ayer-son-n-w-ayer-partners/98334 (published September 15, 2003).

Allen, James Sloan. 2002. *The Romance of Commerce and Culture: Capitalism, Modernism and teh Chicago-Aspen Crusade for Cultural Reform.* Boulder: University Press of Colorado.

Anderson, James C. 1977. *Roy Stryker: The Humane Propagandist.* Lousville: Photographic Archives, University of Louisville.

ARCO. 1980. *Atlantic Richfiled: Art and Design.* Los Angeles: ARCO.

Arvidsson, Adam. 2003. *Marketing Mdernity Italain Advertising from Fascism to Postmodernity.* London: Routledge.

Barter, Judith A. 1991. *The New Medici: The Rise of Corporate Collecting and Uses of Contemporary Art, 1925-1970.* Ph.D. diss. Amherst: University of Massachusetts Amherst.

Bogart, Michele. 1995. *Artists, Advertising, and the Borders of Art.* Chicago: University of Chicago Press.

Braun, Sandra Lee. 2009. *The Life, Rise, and Success of Dorothy Shaver, President of Lord & Taylor Department Store, and America's "First Lady of Retailing".* Tuscaloosa: University of Alabama dissertation https://ir.ua.edu/handle/123456789/659 (Retrieved January 23, 2021).

Buse, Peter. 2009. "Polaroid, *Aperture* and Ansel Adams: Rethinking the Industry-Aesthetics Divide," *History of Photography*, 33(4), 354–369. 10.1080/03087290903283593 (Retrieved May 14, 2021).

Chanzit, Gwen F. 1985. *Herbert Bayer: Early Purveyor of Modernist Design in America (diss.).* Ann Arbor: Proquest. https://search-proquest-com.proxy.libraries.rut (Retrieved September 7, 2020).

Cooper Hewitt. 2021. *POSTER, DIVISUMMA.* February 10. https://collection.cooperhewitt.org/objects/18728283/.

Container Corporation of America. 1946. *Modern Art in Advertising.* Chicago: Paul Theobald.

Corning Museum of Glass. 2020. *Corning Museum of Glass.* October 11. https://www.cmog.org/artwork/set-drinking-glasses-ruby-glass-feet?image=0.

Corwin, Sharon Lynn. 2001. *Selling "America": Precisionism and the Rhetoric of Industry, 1916–1939.* PhD. diss. Berkeley: University of California, Berkeley. https://search-proquest-com.proxy.libraries.rutgers.edu/docview/304683961?pq-origsite=summon (Retrieved from https://login.proxy.libraries.rutgers.edu/login?url=?url, Retrieved December 20, 2020).

Crawford, Margaret. 1995. *Building the Workingman's Paradise.* London: Verso.

Dal Falco, Federica. 2019. "Italian Rationalist Design: Modernity between Tradition and Innovation." *Arts*, 8(1), 27." https://www.researchgate.net/publication/331291046_Italian_Rationalist_Design_Modernity_between_Tradition_and_Innovation#fullText FileContent (Retrieved October 3, 2020).

De Wit, Wim. 2017. "Claiming Room for Creativity: The Corporate Designer and IDCA." In *Design for the Corporate World*, by Wim De Wit, ed., 14–39. London: Lund Humphries.

Dorner, Alexander. 1949. *The Way Beyond 'Art'.* New York: Wittenborn, Schultz, Inc.

Elderfield, John. 1994. "Preface." In *The Museum of Modern Art at Mid-Centruy: At Home and Abroad*, by Museum of Modern Art, 6–11. New York: Harry N. Abrams.

Encyclopedia Brittanica. 1945. *Encyclopedia Brittanica Collection of Contemporary American Painting.* Chicago: Encyclopedia Brittanica.

Engelbrecht, Lloyd C. 2002. "Educating the Eye: Photography and the Founding Generation at the Institute of Design, 1937-1946." In *Taken by Design: Photographs from the Institute of Design, 1937-1971*, by David Travis and Elizabeth Siegal, eds., 16–33. Chicago: The Art Institute of Chicago.

Floria, David, and Lissa Ballinger. 2013. *The Legacy of Herbert Bayer*. Aspen: Aspen Institute.

Friedman, Marilyn F. 2003. *Selling Good Design: Promoting the Early Modern Interior*. New York: Rizzoli.

Guillén, Marco. 1997. "Scientific Management's Lost Aesthetic: Architecture, Organization, and the Taylorized Beauty of the Mechanical." *Administrative Science Quarterly*, 42(4), 682–715. https://www-jstor-org.proxy.libraries.rutgers.edu/stable/pdf/2393654.pdf?-refreqid=excelsior%3A851cdd124242c275d9846a9e21e789bb (Retrieved January 19, 2021).

Handy, Ellen. 1991. "The Idea and the Fact: Painting, Photogrpahy, Film, Precisionists, and the Real World." In *Precisionism in America 1915-1941: Reordering Reality*, by Montclair Art Museum, 4051. New York: Harry N. Abrams.

Harris, Neil. 1985. *Art, Design and the Modern Corporation*. Washington: Smithsonian Institution Press.

Heller, Stephen. 2020. *Leo Lionni*. September 19. https://www.aiga.org/medalist-leolionni.

Johnston, Patrica. 1997. *Real Fantasies: Edward Steichen's Advertising Photography*. Berkeley: University of California Press.

Jones, Julie. (2009) "Putting the European Avant-garde to Work for Capitalism." *Études photographiques*, 24, novembre. http://journals.openedition.org/etudesphotographiques/3432 (Retrieved December 30, 2021).

Kaika, Maria, and Luca Ruggiero. 2016. "Land Financialization as a 'Lived' Process: The Transformation of Milan's Bicocca by Pirelli." *European Urban and Regional Studies*, 23(1), 3–22. https://doi.org/10.1177/0969776413484166 (Retrieved January 24, 2021).

Kang, Cindy. 2020. *Marie Cuttoli: The Modern Thread from Miro to Man Ray*. Philadelphia: The Barnes Foundation.

Keslacy, Elizabeth M. 2016. *The Architecture of Design: The Cooper Hewitt, Smithsonian Museum of Design (1896-1976)*. Ann Arbor: ProQuest Dissertations Publishing https://search-proquest-com.proxy.libraries.rutgers.edu/docview/1875193859?pq-origsite=summon (Retrieved January 17, 2021).

Klahr, Douglas. 2019. "Civic Space and an Iconic Brand: Paradoxes of Corporate Patronage in the Carnegie Library Phenomenon." In *Corproate Patronage of Art & Architecture in the United States, Late 19th Century to the Present*, by Monica E. Jovanovich and Melissa Renn, eds., 171–189. New York: Bloomsbury Publishing Inc.

Kogod, Lauren. 2014. "The Display Window as Educator: The German Wekbund and Cultural Economy." In *Architecture and Capitalism: 1845 to the Present*, by Peggy Deamer, ed., 50–70. London: Routledge.

Laidlaw, Christine. 1988. "The Metropolitan Museum of Art and Modern Design: 1917-1929." *The Journal of Decorative and Propaganda Arts*, 8, 88–103.

Lears, Jackson. 1987. "Uneasy Courtship: Modern Art and Modern Advertising." *American Quarterly*, 39(1), 133–154. www.jstor.org/stable/2712634 (Retrieved March 5, 2021).

Lever Brothers. 1953. *The Story of Port Sunlight*. London: Lintas Limited.

Logemann, Jan. 2011. *Container Corporation of America*. March 6. http://www.transatlanticperspectives.org/entry.php?rec=11.

Lucic, Karen. 1991. *Charles Sheeler and the Cult of the Machine*. Cambridge: Harvard University Press.

Maffei, Nicolas. 2000. "John Cotton Dana and the Politics of Exhibiting Industrial Art in the US, 1909–1929." *Journal of Design History,* 13(4), 301–317. https://doi.org/10.1093/jdh/13.4.301 (Retreived September 20, 2020).

Malherek, Joseph. 2018. "The Industrialist and the Artist: László Moholy-Nagy, Walter Paepcke, and the New Bauhaus in Chicago, 1918–46." *Journal of Austrian-American History,* 2(1), 51–76. 10.5325/jaustamerhist.2.1.0051 (Retreived June 28, 2020).

Marchand, Roland. 1991. "The Designers Go to the Fair: Walter Dorwin Teague and the Professionalization of Corporate Industrial Exhibits, 1933-1940." *Design Issues,* 8(1), 4–17. https://www-jstor-org.proxy.libraries.rutgers.edu/stable/1511449?seq=1#metadata_info_tab_contents (Retreived August 21, 2020).

Marcus, Stanley. 2001. *Minding the Store.* Denton: University of North Texas Press ProQuest Ebook Central. https://ebookcentral.proquest.com (Retreived December 4, 2020).

McGoey, Elizabeth. 2019. ""To Live Is to Look and Move Forward": Lord and Taylor's 1928 Exposition of Modern French Decorative Art." In *Corporate Patronage of Art & Architecture in the United States, Late 19th Century to the Present,* by Monica E. Jovanovich and Melissa Renn, eds., 117–135. New York: Bloomsbury Publishing Inc.

Milnarik, Elizabeth A. 2012. ""Tribune Tower", [Chicago, Illinois]." *SAH Archipedia, eds. Gabrielle Esperdy and Karen Kingsley.* http://sah-archipedia.org/buildings/IL-01-031-0089 (Retreived January 13, 2021).

Minkkinen, Arno Rafael. 2000. "Treasures of the Moment: Thirty Years of Polaroid Photography in Boston." In *Photography in Boston: 1955-1985,* by Rachel Rosenfield Lafo and Gillian Nagler, eds., 136–153. Cambridge: The MIT Press.

Museum of Modern Art. 2021. "Machine Art." *Museum of Modern Art Mar 5–Apr 29, 1934.* January 21. https://assets.moma.org/documents/moma_catalogue_1784_300061872.pdf?_ga=2.141218226.143911720.1611443734-710889415.1607179029.

———— Museum of Modern Art. 2021. "The Museum of Modern Art's Exhibition History." *MoMA.* February 15. https://assets.moma.org/documents/moma_catalogue_1953_300190180.pdf?_ga=2.15627574.1630975695.1613323522-767898288.1612707850.

New Carlsberg Foundation. 2021. *About the Foundation.* January 2. https://www.ny-carlsbergfondet.dk/index.php/en/about/foundations-work.

Noruschat, Suzanne, Natalie Snoyman, and Emmabeth Nanol. 2020. *Finding Aid for the International Design Conference in Aspen Records, 1949-2006.* May 10. https://oac.cdlib.org/findaid/ark:/13030/c8pg1t6j/entire_text/.

Nye, David E. 1985. *Image Worlds: Corporate Identities at General Electric 1890-1930.* Cambridge: The MIT Press.

Ong Yan, Grace. 2021. *Building Brands: Corporations and Modern Architecture.* London: Lund Humphries.

PND by Candid. 2006. *Kansas City Museum Obtains $65 Million Photography Collection.* January 23. https://philanthropynewsdigest.org/news/kansas-city-museum-obtains-65-million-photography-collection (Retreived December 22, 2020).

Pohlad, Mark B. 2000. "A Photographic Summit in the Windy City." *History of Photography,* 24(2), 148–154. 10.1080/03087298.2000.10443385 (Retreived December 13, 2020).

Read, Herbert. 1954. *Art and Industry.* New York: Horizon Press.

Robson, A. Deirdre. 2015. "Industry: Art Angel? Pepsi-Cola's "Portrait of America" Art Annual as an Early Instance of Corporate Art Sponsorship." *The Journal of American Culture,* 38(4), 329–343. https://doi-org.proxy.libraries.rutgers.edu/10.1111/jacc.12437 (Retrieved December 6, 2020).

Ross, Randall. 2020. *Advance Guard of Advertising Artists.* September 18. https://www.paulrand.design/life/events-exhibits/exhibits/1941-advance-guard.html.

Rowan, Jeremy David. 2003. *Imagining Corporate Culture: The Industrial Paternalism of William Hesketh Lever at Port Sunlight, 1888-1925.* Baton Rouge: LSU Doctoral Dissertations.

Schulte, Birgit. 2009. "Karl Ernst Osthaus, Folkwang and the 'Hagener Impuls': Transcending the Walls of the museum." *Journal of the History of Collections,* 21(2), 213–220. https://doi-org.proxy.libraries.rutgers.edu/10.1093/jhc/f (Retrieved February 4, 2021).

Siry, Joseph. 1988. *Carson Pirie Scott: Louis Sullivan and the Chicago Department Store.* Chicago: University of Chicago Press.

Smith, Terry. 1993. *Making the Modern: Inustry, Art and Design in America.* Chicago: University of Chicago.

Stern, Robert A. M., Gergory Gilmartin, and Thomas Mellins. 1987. *New York 1930: Architecture and Urbanism between the Two World Wars.* New York: Rizzoli.

Stomberg, John R. 1999. *Art and "Fortune": Machine-Age Discourse and the Visual Culture of Industrial Modernity. (https://login.proxy.libraries.rutgers.edu/login?url=?url=https:// www-proquest.* Ann Arbor: Boston University. https://search-proquest-com.proxy. libraries.rutgers.edu/docview/304493395?pq-origsite=summon (Retrieved December 27, 2020).

The American Magazine of Art. 1916. "A Unique Textile Exhibit: In Newark, New Jersey." *The American Magazine of Art,* 7(6), 228–230 http://www.jstor.org/stable/20559386 (Retrieved December 28, 2020).

The Art Directors Club. 2018 (reprint). *The 1921 Annual of Advertising Art, The Catalog of the First Exhibition.* Mineola: Dover Publications, Inc.

The Mead Corporation. 1965. *Art Across America.* Dayton: The Mead Corporation.

Trask, Jeffrey. 2012. *Things American: Art Museum and Civic Culture in the Progressive Era.* Philadelphia: University of Pennsylvania Press.

Turner, Fred. 2012. "The Family of Man and the Politics of Attention in Cold War America." *Public Culture,* 24, 55–84. https://doi.org/10.1215/08992363-1443556 (Retrieved February 15, 2021).

UNESCO. 2001. *UNESCO World Heritage List.* https://whc.unesco.org/en/list/1028/.

Ward, Douglas B. 2005. "From Barbarian Farmers to Yeoman Consumers: Curtis Publishing Company and the Search for Rural America, 1910-1930." *American Journalism,* 22(4), 47–67 https://web-b-ebscohost-com.proxy.libraries.rutgers.edu/ehost/pdfviewer/ pdfviewer?vid=1&sid=ee35eb07-8e99-4ee2-8efd-e73cf628832d%40sessionmgr102 (Retrieved April 17, 2021).

Whalen, Richard. 1967. "Artist and Advocate." In *Artist and Advocate: An Essay on Corporate Patronage,* by Nina Kaiden and Bartlett Hayes, eds., 31–43. New York: Renaissnace Editions, Inc.

Chapter 2

Modernism and the Corporate Campus

Buildings, Design, and Responsibility

We have brought to all the towns of the community our secret weapons: books, cultural courses, technical assistance in the field of agriculture. Concerts, exhibitions, and debates are held continually in the factory. The library has tens of thousands of volumes and magazines from around the world. Olivetti employs intellectuals, writers, and artists, some in top positions. Culture has a lot of value here.

Adriano Olivetti

In 1933, Adriano Olivetti took over leadership of the typewriter factory founded by his father, Camillo, in the town of Ivrea, near Turin, Italy. The 32-year-old elevated the small family business to international prominence by the time of his death, nearly 30 years later. Under his guidance, the company became a global experiment in humanizing an industrial city and its region by means of art, architecture, and design. Adriano and his father both spent time in the United States studying factory production and the Taylorist and Ford methods employed by leading American companies. Adriano's thinking was progressive for an industrialist in the early twentieth century, especially his focus on taking care of employees as well as his attention to the local community. As Elisa Arrigo put it,

He succeeded in creating an 'Olivetti-system' through the creation of favourable attitudes and consensus for the firm, improving the quality of the life of his fellow citizens, developing shared value systems, generating

DOI: 10.4324/9781003099222-3

40

a strong sense of belonging to his firm, fostering the motivation of the individual, and constructing a strong brand with a very positive image.

(Arrigo, 2003)

This complicated agenda was achieved in significant ways through direct partnership with emerging and established artists, designers, and architects.

Marcello Russo describes Adriano's approach:

> The company, he argued, has a moral obligation toward its workers because through their intellectual contribution and physical efforts the company is able to grow and flourish. Therefore, the company must do the best it can to repay workers for the fatigue it causes them, for the competencies it exploits, for the time it takes from family life, and for the stress it causes them. This must happen not only with economic inducements but also by promoting cultural and social initiatives that help workers and their families to flourish, just as the company does.
>
> (Russo, 2013)

For Adriano, the cultural and social meant well-designed facilities, good housing and daycare, opportunities for personal development, and an extraordinary focus on design excellence.

Olivetti leaders delivered on their claims of improved working conditions for their employees. In other words, they did what they said they would do. One example was the company's Centro Formazione Meccanici (CFM), where students learned vocational skills while studying arts and humanities. Caterina Toschi also recently brought to light a little-known element of Olivetti's approach to sustaining the company idiom: In 1954, a sales training facility was created in Florence with a curriculum that went far beyond business administration, combining technical and humanistic instruction, to expose aspiring executives to the role of design in the company culture (Toschi, 2018).

The Olivetti example builds on earlier models such as Port Sunlight and CCA yet the Italian company's approach is differentiated by three practices. First, the level of attention paid to employees and communities is an early example of stakeholder engagement that became popular practice in the 1980s. Mauro Sciarelli and Mario Tani point out that Adriano Olivetti was practicing a form of stakeholder capitalism before the term existed (Sciarelli and Tani, 2015). Second, Olivetti went a step further by commissioning cutting-edge architects to design factories and employee housing as well as social services. As one DOMUS writer expressed it, Adriano

> consolidated the idea of a close-knit community founded on the awareness of the inalienability of the spiritual values of man's existence, capable of turning the challenges involved in the rise of industrial civilization and the endless opportunities of technological progress in man's favor.
>
> (Domus, 2012)

This industrial visionary reconciled the dualisms of man versus machine and science versus art. Clearly Adriano saw culture as a way

> to promote the development and empowerment of people so, between 1950 and 1964, the Cultural Center Olivetti was used to host 249 conferences, 71 concerts, 103 art exhibitions, and 52 other events such as political and social debates, and literary presentations, featuring prominent personalities such as Salvemini, Moravia, De Filippo, and many others.
>
> (Sciarelli and Tani, 2015)

Third, Olivetti pioneered management practices that have become commonplace in the private sector. For example, Adriano and his successors actively emphasized integrated design and rigor in defining corporate purpose and brand promise. In addition, Olivetti structured its design practice much the same way design is integrated into major multinational corporations today, almost 100 years later. Ahead of his time in thinking about corporate identity and design culture, Adriano was keenly aware that a company's image is an intangible asset warranting careful cultivation while leaving room for experimentation and innovation. Olivetti was also a pioneer in promoting and sponsoring culture and the arts outside of their facilities.

Adriano also led a very complicated political life, especially during and after World War II. During the war, he participated in an underground anti-Fascist movement and was arrested in Rome. He was able to escape to Switzerland, where he spent most of the war years. As a business, Olivetti had an ambiguous relationship with Italian Fascism. Although the company employed many artists, designers, and architects affiliated with the Futurist movement and Gruppo 7, it did not endorse the agendas of these movements any more than Mussolini endorsed Futurism or Rationalism.

Olivetti took a leadership role in introducing public relations to postwar Italy, then under American influence. Pirelli adopted a similar approach to building a corporate identity when it entrusted communications to poet and critic Leonardo Sinisgalli, who had worked as an art director at Olivetti beginning in 1938:

> In Sinisgalli's program, the aims of publicity had been brought to bear on the concept of industrial design. This sequence of events, and the associated order of these areas of design, was primarily due to two circumstances. The first was the determination to create a 'humanistic' publicity that would address the viewer gently, not aggressively. To this end, Sinisgalli emphasized the creation of narratives—sometimes on tangentially related themes—as a part of the presentation. The second was the involvement of artists and designers from the Milanese avant-garde, and the exchange of ideas between Olivetti culture and the commercial art avant-garde that revolved around the firm Studio Boggeri and the journal *Campo Grafico*, during the 1930s.
>
> (Blakely, 2011)

It was through this very deliberate strategy, as well as Adriano's vast social network, that Olivetti was able to create and nurture its company identity. The role of Studio Boggeri, founded in 1933, was also significant in the firm's attraction of a wide range of talent, including Walter Ballmer, Fortunato Depero, Max Huber, Lora Lamm, Enzo Mari, Marcello Nizzoli, Bob Noorda, and Xanti Schawinsky. Many artists and designers from Studio Boggeri went on to influential roles in culture and commerce. Lamm, for example, moved on to a productive role at La Rinascente, working with Max Huber to position the department store as a design champion. By engaging progressive designers and writers, Olivetti underscored the company's typewriters and office equipment as thoughtfully designed products enabling people to express themselves by both using and buying them.

Adriano articulated his political vision in the book *L'Ordine Politico delle Comunità* (1946), outlining an ideal political order based on three pillars: community, region, and factory. At the heart of his approach was a belief in humanity and the potential of industry to accelerate social progress. Although Adriano's vision was not fully realized, he set a new standard for Corporate Cultural Responsibility (CCR) through a steadfast belief in the potential of art, culture, and design to improve communities. In spite of the increasingly global span of the firm, he maintained a generous focus on Ivrea and the Canavese area (Arrigo, 2003). Recent research by Patrizia Bonifazio reveals just how strategically and rigorously Adriano approached the challenge of worker housing in Ivrea. For example, it is clear that Adriano made an effort to understand current approaches by other industrialists in other parts of the world. It is also clear that he was aware that what he was doing was somewhat without precedent in his attempt to apply Fordist and Taylorist principles beyond the factory and into the community (Bonifazio, 2018).

One of the only elements missing from the Olivetti case study is sustainability. Perhaps because he died at such an early age, Adriano never had the chance to plan a mechanism like a foundation to carry on his visionary work (Brilliant, 1993). In fact, some scholars have suggested that Adriano's personal approach to Corporate Social Responsibility (CSR) may have had negative effects for some stakeholders, mainly because it depended largely on one individual (Bartolomeo and Savoldi, 2002).

Like Walter Paepcke, Adriano was committed to supporting designers and architects working at the cutting edge of Modernist design. Among those Olivetti invited to join this new collaborative venture was Marco Nizzoli, whose best-known design project was the Lexicon 80 typewriter, which premiered in 1948. As Luisa James Orto noted,

> The importance Olivetti placed on social reform was united with his promotion of collaborative efforts, integration of the arts and industry, and the aesthetic factor, and would be maintained by the succession of other painters and sculptors who, like Nizzoli, were hired by Olivetti to participate in his design department.
>
> (L. J. Orto, 1995)

Prominent artists, architects, and designers that were part of the Olivetti stable range from Luigi Figini and Gino Pollini to Ettore Sottsass. The overriding approach was one of collaboration to achieve broader social goals. One architecture critic went so far as to claim that Adriano "was one of the first business leaders to challenge profit as the only proper goal of corporations" (Dixon, 1973).

Olivetti's commissions of emerging designers and architects earned the town of Ivrea a reputation for experimentation and innovation. As one writer surmised,

> the company's stunning designs are not a pretty but thin veneer that helps conceal the avarice on the face of a Corporate Giant; these stunning buildings and objects and graphics are only the most visible evidence of the company's total dedication to man's cultural heritage, and the company's total commitment to man's creative future.
>
> (Architecture Plus, 1973)

This statement reveals the strategy behind the company's sense of purpose and commitment to the aesthetic and human factors inherent in its approach to business. Emerging after years of the use of propaganda under Fascist rule,

> corporate communication focused more on the product than on the consumer and tried to compensate for a lack of industrial culture by striving to earn the goodwill of employees and public opinion by exposing them to the cultural side of business.
>
> (Bini, Fasce and Falconi, 2011)

Olivetti's emphasis on culture and design ultimately led to the company's signature Italian style.

Olivetti was evolving at a time when there was a rich cultural interplay between Italy and the United States in the wake of World War II. For example, the exhibition *Italy at Work*, organized by the Art Institute of Chicago in 1951, featured crafts and design that reflected the uniquely Italian traditions of ceramics, glass, textiles, and furniture. A small section devoted to industrial design included Olivetti and Fiat. The catalog presents artists and designers that were exemplars of historic traditions of craft and decorative arts, with the exception of Gio Ponti and the producers of industrial arts (Rogers, 1950). The presentation essentially reinforced American perceptions of Italy as a developing nation struggling to catch up with the industrial revolution. In a catalog essay, M. Reynold Rogers states,

> Italian individualism cannot however supply of itself the resources necessary to the total recreation of their economy. The world of today is too dependent on those things that mechanization and a high degree of organization alone can supply. For this capital resources are needed

beyond the power of individual or localized action. Italy's individualism is therefore her weakness as well as her strength.

<div align="right">(Rogers, 1950)</div>

This passage contains a chilling warning that these indigenous traditions of creativity are important but will not be enough to accelerate Italy's quest for modernization. It also points to the other implicit goal of the exhibition: to help create a US market for Italian goods. This type of exhibition ran counter to the aspirations of Olivetti, Fiat, Pirelli, and other forward-looking companies based in Italy. As Adriana Castagnoli suggests, "A cultural heritage that worked against modernity prevented the recognition of merit, promotion of technical and scientific skills, and vilified the very concept of work" (Castagnoli, 2014).

The company's influence well beyond Italy is evidenced in important building commissions in most major markets. Olivetti enjoyed a particularly rich and complicated relationship with the United States, where both Adriano and his father spent considerable time. After Adriano's exile in Switzerland, he was involved in the postwar rebuilding effort, bringing him into contact with key US government leaders. He was certainly influenced by the work of David Lilienthal, who led the Tennessee Valley Authority (TVA) under FDR. According to Federico Amidei Barbiellini Andrea Goldstein, Adriano "became close to David Lilienthal, chairman of the Development and Resources Corporation, previously a founding director of the Tennessee Valley Authority. Adriano Olivetti also maintained close contacts with CIA Director Allen Dulles, Ambassador Clare Boothe Luce, and Henry Kissinger" (Barbiellini and Goldstein, 2012). Regarding his experience at the TVA, Lilienthal asserted that

when the use of technology has a moral purpose and when its methods are thoroughly democratic, far from forcing the surrender of individual freedom and the things of the spirit to the machine, the machine can be made to promote those very ends.

<div align="right">(Drumright, 2002)</div>

This focus on the coexistence of humanity and industrialism would surely have resonated with Adriano and influenced his view of the interdependence of community, region, and factory. Lilienthal's thinking on democracy and technology may also have influenced Adriano's perspective on development of the Canavese region. Lilienthal espoused the symbiosis of human life and natural resources as well as local participation in politics, calling for a balance between centralized and decentralized governance. His book *TVA: Democracy on the March* (1944) was widely read, especially in postwar Europe, where the TVA approach was seen as an attractive model for promoting democracy and thwarting Communism (Drumright, 2002).

In the 1940s and 1950s, Adriano was involved with Istituto Nazionale di Urbanistica (INU), an organization focused on regional planning. Olivetti supported

INU's publication *Urbanistica*, which "became a key reference for Italian planners and architects and was certainly instrumental in advancing the circulation of ideas and models of American origin in Italy" (Scrivano, 2013). Adriano became director of *Urbanistica* in 1949 and president of INU in 1950. In 1952, he joined the American Management Association network, giving him access to current thinking in multiple disciplines (Castagnoli, *Across borders and beyond boundaries: How the Olivetti Company became a multinational*, 2014). In 1956, Adriano served as deputy chairman of the International Federation for Housing and Town Planning and was made an honorary member of the American Institute of Planners, as he continued to synthesize his political, social, and design interests. The same year, a team of Olivetti employees spent four months in the United States visiting 36 research laboratories. Scholars have pointed out the "modernity of Olivetti's thought, laying the foundations for a cutting-edge reflection about the desirable role of enterprise within the society" (Camoletto and Bellandi, 2019).

Adriano was apparently influenced by American Modernism and planning through publications such as Lewis Mumford's *The Culture of Cities* (1954) and *Italy Builds*, by G.E. Kidder Smith (1955), the latter a curious attempt to contextualize postwar Italian architecture within uniquely Italian traditions. Ernesto Nathan Rogers's introduction to the book includes a brief passage explaining architecture's coexistence with Fascism and the Resistance movement while underscoring the positive role architects played in postwar Italy. Smith featured four Olivetti projects: Figini and Pollini's day nursery, worker housing, and factory, and Nizzoli and Fiocchi's employee houses. Leo Lionni designed the cover, and Olivetti art director Giorgio Soavi is acknowledged for his help with the Italian edition (Kidder Smith, 1955). In 1948, Soavi had relocated to Ivrea to edit the journal *Comunità*, published by Olivetti, and married Adriano's daughter, Lidia, two years later.

Olivetti's influence on the United States became tangible in 1950, when the company opened an office at 580 Fifth Avenue, followed by a research facility in New Canaan, Connecticut. Remington Rand was the company's main competitor in the typewriter and calculator markets, yet Olivetti products were priced slightly higher and differentiated by "quality and innovation" (Barbiellini Amidei, Goldstein and Spadoni, 2010). According to Jim Carter, "Olivetti was promoted as the paragon of modern design, the pioneer and flag-bearer of a coordinated corporate image that American industry, in its role as cultural producer, was fervently encouraged to follow" (Carter, 2018).

In autumn 1952, the company funded, organized, and designed the exhibition *Olivetti: Design in Industry*, shown at the Museum of Modern Art. A 24-page member's bulletin, replete with images of Olivetti buildings and products, took the place of an exhibition catalog (Bulletin, 1952). Designed by Lionni, the publication was printed in black and white with exception of the cover, dominated by a large mustard-colored *O*. Like the CCA's *Modern Art in Advertising* (1946), which premiered at the Art Institute of Chicago, the Olivetti exhibition traveled to several states and to Canada, from 1953 to 1955 (Toschi, 2018). Yet the MoMA exhibition

was a more shrewd use of a major art institution to burnish the company's identity as a design leader. Olivetti's calculated choice to enter the US market hinged on the belief that the company could compete in an era shaped by politics, technology, and an evolving international trade climate. To this end, its leadership leveraged various intangible qualities to advantage. According to Adriana Castagnoli, "Olivetti's expansion also rested on Camillo's and Adriano's social and entrepreneurial vision, hence on advantages deriving from institutional assets such as the company's code of ethics and social responsibility (towards the environment, design, training, and work)" (Castagnoli, 2014). The Olivetti paradigm also differs from the CCA example in that company products were marketed directly to individual consumers, as well as corporate clients, at the time it was building a presence in the American market.

The 1954 design of the Olivetti retail and office space on Fifth Avenue, by prominent Milanese architecture firm Belgiojoso, Peressutti & Rogers, has been described as "one of the most daring and powerfully imagined designs in postwar New York" (Sherer, 2012). Employing a variety of materials, in features such as brass pedestals used to display office products, the space was dominated by a 75-foot sand-cast relief sculpture by Constantino Nivola. In 1954, the MoMA organized the exhibition *The Modern Movement in Italy: Architecture and Design*, with a section devoted to Olivetti (Carter, 2020). Olivetti leadership appeared to be consciously establishing the company's cultural influence and power as a way to fortify its brand in the United States. The focus on environmental, cultural, and design issues put Olivetti in a class of its own in terms of social responsibility. It would be decades before the larger corporate community adopted this progressive view of the role of business in society.

Olivetti prided itself on what its leadership termed "integrated design," along with its distinguished grounding in Italy. The company saw product design, corporate image, and the workplace as falling under a "single high standard of taste." The MoMA exhibition bulletin from 1952 details the elements of design related to advertising and promotional material, describing four characteristics: "(1) a sober use of language; (2) imaginative pictorial symbols; (3) presentation unified by one esthetic concept; (4) emphasis on the company's high standard of design" (Bulletin, 1952). Hardly a playbook for design, this ambiguous checklist does not reveal the secrets of Olivetti's approach to design or highlight the Italian roots of the company aesthetic.

Olivetti's approach to integrated design became one of the defining features of its global brand, an abstract quality known as the "Olivetti Touch" or "Olivetti Idiom" (Toschi, 2018). The company's focus on the abstract notion of an identity rooted in Italy was commensurate with the country's efforts to promote

> the highly marketable idea of a 'national creative essence' which, together with the artisanry which enabled the Italian designer to readily adapt his production to consumer tastes and industrial innovations, allowed the designer to compete in the rigorous international marketplace.
>
> (Orto, 1995)

At Olivetti

> design promoted not just technical values, but cultural, intellectual, and artistic values as well. Its aesthetic style was also progressive: it was modern and rational, apparently against the decorative aesthetics prevalent at that time, much in the manner of Behrens in AEG, and with possible anti-fascist overtones in the thirties.
>
> (Järvinen and Koskinen, 2001)

In an interesting nod to the Bauhaus influence, Olivetti commissioned Herbert Bayer to design two posters for the Divisumma adding machine, in 1953 (Figure 2.1).

In 1955, Olivetti established the Olivetti National Prize for Architecture. Deeply rooted in Italian culture, the Olivetti approach gave voice and power to Italian architects, known for their contributions to all aspects of design, beyond just buildings, of objects for the broader consumer market. Another element of the Olivetti design process was, according to Sibylle Kicherer, its embrace of "Italian drama"—in other

Figure 2.1 Herbert Bayer, "Poster, Divisumma", 1953, © 2021 Artists Rights Society (ARS), New York/VG Bild-Kunst, Bonn. Photo: Matt Flynn © Cooper Hewitt, Smithsonian Design Museum

words, the unplanned and spontaneous elements of working collaboratively under pressure (Kicherer, 1990). This all-encompassing embrace of design, an experiment that evolved into a competitive advantage, underscores the value of corporate cultural cachet. After Adriano's sudden death, in 1960, Renzo Zorzi took responsibility for sustaining the company's approach to its design practice and, most importantly, commitment to design by senior leaders, for the next 20 years.

As Olivetti continued to expand globally, it paid a premium for the design of its retail spaces. After New York, shops opened in San Francisco, Dusseldorf, Paris, and Venice, each created by a different team of architects and designers. As Manfredo Tafuri noted,

> Olivetti's stores, in Italy and abroad, became precious spatial coffers whose character was entrusted to an architectural surrealism that suspends the project in a void that isolates it from its material context in an attempt to cancel its mercantile character.
>
> (Tafuri, 1990)

His description of the retail showroom as a work of art is no coincidence. The integration of sculpture, traditional and unexpected materials, and organic forms in the New York store created an exotic experience. Olivetti was selling more than office equipment; it was (literally) exporting a style that was clearly "made in Italy." As Paola Antonelli explains, "The whole store was almost completely prefabricated in Italy and sent across the Atlantic for final assembly" (Antonelli, 2001).

Museum exhibitions became an integral part of Olivetti's strategy for building its brand, as evidenced by the 1961 *Stile Olivetti: Geschichte und Formen einer Italienischen Industrie*, displayed at the Kunstgewerbemuseum, in Zurich. This comprehensive show chronicled all aspects of the Olivetti business. Unlike the MoMA show, it attempted to reveal the philosophical, moral, political, and aesthetic underpinnings of a unique approach to business. *Olivetti Formes and Recherche*, at the Musée des Arts Décoratifs, in Paris, followed in 1969, traveling to Barcelona, Madrid, Edinburgh, and London. The exhibitions were intellectually rigorous and well designed. The company collaborated on these projects to shape the narrative and maintain the mystique of the "Olivetti Touch." The shows promoted work by emerging and established designers while cementing Olivetti's reputation as a thought leader in all aspects of design. The number of these exhibitions highlights the museum community's receptivity to showcasing corporate products, design, advertising, and architecture.

Yet the 1960s proved challenging for Olivetti's global business. Adriano's death was followed by disruptions in management and business challenges in the wake of its acquisition of Underwood, in 1959. Although the company's increased presence in the United States was solidified following the brand's introduction to the American public in the late 1950s, broader economic challenges hindered Olivetti's ability to leverage the purchase of Underwood. Nonetheless, there were bright spots as Olivetti

leaders, most notably Zorzi, attempted to maintain the company's commitment to cutting-edge architectural design. In 1969, Louis Kahn completed a new facility in Harrisburg, Pennsylvania, with Renzo Piano as consultant. Although business pressures were mounting and the project was delayed, Kahn remarked, "They do honor the artist, and they honor the building that will carry the message. They were always interested in that" (Dixon, 1971). The company became a major sponsor of the Metropolitan Museum of Art, in New York, providing funds for *The Great Age of Fresco*, in 1968–1969, and sponsoring *Before Cortés: Sculpture of Middle America*, in 1970–1971. This level of engagement earned Olivetti distinction as the museum's first official corporate benefactor (Schwarz, 1970). Clearly, the company sought to maintain its preeminent position as a patron of the arts not just in Italy but abroad.

Although the acquisition of Underwood cost the company time in the race for a new generation of office equipment, including the personal computer, it remains one of the few examples of an Italian company successfully acquiring a U.S. company. Yet ultimately the strong identity Adriano and his peers established for Olivetti through its employment practices and focus on design integration was not sustainable in the rapidly changing industry. In 1979, 20 years after Olivetti took over Underwood, the company was invited to organize an exhibition at UCLA chronicling its design process. Two years later, the exhibition catalog was repurposed for the 1981 International Design Conference in Aspen, themed "The Italian Idea." The focus on Olivetti was almost poetic given its high-profile participation in the first IDCA, in 1951, now attending as a struggling firm. More akin to a playbook, the extensive catalog traces some of Olivetti's key innovations in architecture, corporate identity, and product and exhibition design. Although the introductory essay by Zorzi is rambling and a bit abstract, the catalog's chronological entries provide fascinating details on the practical and aesthetic aspects of the design process.

The timing of the UCLA exhibition and the company's appearance at Aspen is questionable in light of the fact that Olivetti had already closed 90 offices in the United States by the late 1970s (Barbiellini and Goldstein, 2012). As Olivetti faced severe business challenges, the New York showroom was shuttered in 1970, and its corporate presence in the city ended in 1978 with the termination of its lease at SOM's Pepsi-Cola building, first signed in 1967. Although Olivetti's U.S. presence was diminished, its legacy lived on through the myriad designers, artists, and architects who continued to create and contribute to industry. Today, even though the company's reputation for design continues to intrigue design scholars, there is barely a trace of Olivetti's presence in the United States.

Cummins Engine

The second example of CCR comes from Columbus, Indiana, where leadership at Cummins Engine embraced the idea that a vital company depends on a healthy community. J. Irwin Miller, the great-nephew of the founder, joined the company

in 1934 and remained actively involved in its management until his death, in 2004. Miller's progressive views on the role of business in society, similar to those of Adriano Olivetti, garnered a positive image for the company as a responsible corporate citizen. In the 1950s, Miller began a crusade to bring modern architecture and design to his community of 43,000, which now has more than 70 Modernist buildings and serves as a significant cultural tourism destination. In 1954, he created a charitable foundation and earmarked 5% of profits for philanthropic purposes. From 1957 to 1973, Cummins paid the fees for accomplished architects chosen to design civic projects; of the 17 building projects, 11 were schools. One of the earliest examples is the L.C. Schmitt Elementary School which was designed by Harry Weese and opened in 1957 (Figure 2.2).

According to a National Historic Landmark study, Miller "recognized, long before the term became fashionable, that a livable city benefits its business and industry by attracting and sustaining a high-quality workforce" (Laura Thayer, Margaret Storrow and John Kinsella, 1999). The document also remarks that this example of corporate architectural patronage is the most "extensive and long-term program of its kind." It was not only Columbus that benefitted from Miller's visionary approach to architecture. In 1964–1966, Kevin Roche John Dinkeloo and Associates (KRJDA)

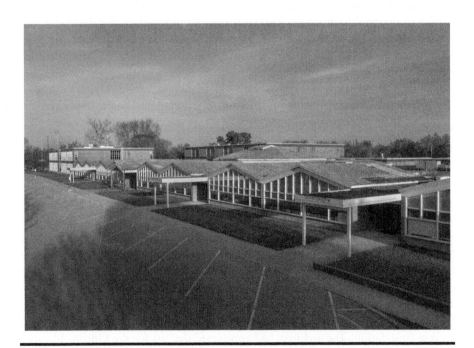

Figure 2.2 L.C. Schmitt Elementary School, Harry Weese, 1957, Columbus, Indiana. Photo courtesy of Landmark Columbus Foundation/Hadley Fruits

and landscape architect Dan Kiley teamed up to create a Modernist corporate campus for Cummins in Darlington, United Kingdom, which was recently placed on the National Heritage List for England. The 1960s were a critical period for Cummins as it sought international expansion and economic growth. Meanwhile, Miller embraced good design as a hallmark of the company identity in its role as a manufacturer of precision products, along with leadership in social and environmental responsibility.

Miller's success in business and community building can be attributed to his understanding that business is accountable to multiple stakeholders. His broader engagement with society was unusual for a corporate leader at the time. Miller also realized the importance of building his own social capital, serving on the boards of MoMA, Yale University, and the Ford Foundation. His work with the Ford Foundation may have fueled his commitment to community responsibility and human rights. Miller's responsiveness to multiple stakeholders was unusual for management practice in the 1950s. In fact, it can be claimed that Miller was well ahead of his peers in recognizing that shareholder primacy was not an ideal approach for progressive business leaders. In a speech he delivered at Dartmouth College in 1956, Miller outlined the responsibilities of managers in modern corporations (J. I. Miller, 1956). His remarks, very forward looking, focused on the multiple stakeholders that a company was required to address and was a strong rebuke to shareholder primacy. Formal study and promotion of stakeholder theory did not emerge until the 1980s, in publications such as Ed Freeman's *Strategic Management: A Stakeholder Approach* (Freeman, 1984). As Minda Zetlin observed,

> Rather than focusing only on investors or shareholders, Miller believed that to be successful, a company had to satisfy five different sets of stakeholders: customers, employees, partners, investors, and the community. It was with a view to this last set of stakeholders that he decided to reshape the city where his company was located.
>
> (Zetlin, 2020)

It is well known that Miller played a significant role in the American civil-rights movement and participated in the March on Washington. He was a leader of the National Council of Churches and worked with presidents John F. Kennedy and Lyndon Johnson in support of the Civil Rights Act. "Martin Luther King Jr. once called Miller 'the most socially responsible businessman in the country'" (Kriplen, 2019). For example, in 1965 Tougaloo College, in Jackson, Mississippi, engaged Gunnar Birkerts to design a master plan with a $75,000 grant from the Cummins Engine Foundation. The architect had completed designs for the Lincoln Elementary School in Columbus the same year. One of Tougaloo's most celebrated graduates, civil-rights activist Joyce Ladner, received support from Cummins to advance her academic work on racism.

Miller was also an early voice for more environmentally conscious decisions around architecture. As Alexandra Quantrill suggested, Miller was an early adopter of reducing a building's energy footprint as well as engaging employees in architecture and design decisions. Quantrill made an important connection between Kevin Roche's work at the Ford Foundation and his firm's design of a new production facility for Cummins in Indiana: "Its convoluted relationships between technical, social, and natural spaces provided a model for larger scale environments of social integration, of the kind supported by philanthropic organizations such as the Ford Foundation" (Quantrill, 2017). Given his work in social activism, it seems logical that Miller would be intrigued by the idea of design as an element of social integration.

Cummins's commitment to diversity was reflected in its hiring practices, especially in the representation of African Americans at all levels of management. In order to institutionalize many of its practices, in 1972 Cummins created the Corporate Action Division (CAD), which was "dedicated to corporate philanthropy, governmental relations and public affairs, community relations, human resources development, and affirmative action programs" (Quantrill, 2017). Miller and Cummins also took up the issue of LGBT rights well before society at large recognized this issue. As Heidi Reed notes,

> Although Cummins' initial efforts around diversity may have been considered controversial, society now increasingly expects such behaviour. Times have evolved, and the modern view is that the promotion of diversity by corporations can in fact be a way to solve increasing social problems.
>
> (Reed, 2017)

Most important, Miller consistently used architecture and design as critical elements in developing the company's image as a socially and culturally responsible corporation, making Cummins one of the most progressive companies of its time.

Miller's greatest achievement was the development of Columbus, Indiana. He came up with the idea to support modern architecture in his community as a way to attract and retain talent for the company. His idea was simple and elegant: the Cummins Foundation would pay the architecture fees for all new schools in the community if the city picked an architect from a list developed by Miller and his advisors. The program resulted in a world-renowned collection of schools and other civic buildings by I.M. Pei, César Pelli, Eliel and Eero Saarinen, Harry Weese, and many others. One indicator of Miller's success came in 2012, when the American Institute of Architects ranked Columbus as the sixth-best architectural destination in the United States (*ArchDaily*, "AIA Ranks Columbus, Indiana as US's 6th Most Architecturally Important City 2012"). As Aaron M. Renn writes in *The Atlantic*,

> Still, thanks to Miller's and Cummins's decades-long commitments, Columbus is in a place most other Midwest manufacturing towns can

only envy. America has a lot to relearn from them about what it actu-
ally takes to build long-term community prosperity. It's not just about
macroeconomic policy, but also about the behavior of corporations and
local elites.

(Renn, 2019)

Miller was forging his own brand of cultural responsibility at a time when corporate
support of the arts was rare. His approach was a unique blend of paternalism with a
progressive social agenda and an embrace of Modernism.

Unlike Cummins Engine, Adriano Olivetti focused its projects almost entirely
on Olivetti manufacturing, employee housing, and worker-related buildings such as
daycare centers and schools. The city of Ivrea certainly benefited, but the focus was
primarily on the company, its employees, and image building. In Columbus, the pri-
mary focus of architectural patronage was civic architecture, although there are a few
examples of significant Cummins buildings. Today Olivetti's legacy in its local com-
munity is under question, with Ivrea is struggling after the decline of the company,
whereas the positive impact Cummins has had on Columbus as a thriving destination
remains strong. Yet as historian Richard McCoy cautions, "Focusing on Miller under-
sells a 'collaborative community process' that supported so much notable architecture"
(Karaim, 2016). Evidence of community ownership and pride can be found in a 1974
publication produced by the Columbus Area Chamber of Commerce and Visitors
Center that chronicles all of the key buildings in great detail and evidences the pop-
ularity of the city as a cultural destination ("A Look at Architecture: Columbus Indi-
ana; Columbus Area Chamber of Commerce, Inc.," 1974). While Adriano Olivetti
spent most of his life advocating for local engagement, regional planning, and modern
design, it seems that the Cummins approach has been much more sustainable.

As a patron Miller sought out leading Modernist architects to design buildings
for his company and community, most notably the many schools and excellent pub-
lic buildings in Columbus. Unlike Olivetti, he did not integrate Modernism into
product design but focused on the built environment. Olivetti was publicly outspo-
ken on architecture and design, whereas Miller championed art and culture through
his leadership. According to Stephen Fox,

Miller sought to perform modernity consistently as a corporate execu-
tive, labor employer, community leader, cultural patron, and religious
activist, combining responsiveness to democratic egalitarianism with
wealth and power in ways that were represented in media accounts as
foresighted and socially responsible.

(Fox, 2019)

By contrast, Olivetti performed modernity as more of a radical act out of a self-
conscious sense of trailblazing. He integrated design principles into all aspects of the
business, while Miller was more focused on the community around his headquarters.

Cummins developed a corporate art collection and was committed to landscape architecture, engaging Dan Kiley for 25 projects in Columbus alone. In 1980, Emilio Ambasz was appointed chief design consultant for the company. He had a distinguished reputation in the field of design, most notably as curator of the landmark MoMA exhibition *Italy: The New Domestic Landscape*, in 1972. The show featured, among the many companies and designers, Olivetti products and its design approach. In 1983, Miller's company created the Cummins Engine Company Corporate Museum, designed by KRJDA, and Rudolph de Harak was hired as exhibition designer. Renowned art director Paul Rand was a longtime consultant to Cummins, a relationship memorialized in 1997 when the company donated funds to Yale University in support of the Paul Rand Lectureship in the School of Art (Yale University, 2020).

Corning Glass Works

A third, and underappreciated, example of an early adopter of CCR is Corning Glass, founded in southern New York State in 1868. As the company evolved, its relationship to multiple stakeholders became a critical factor in its commercial and social decision-making. At the heart of Corning's success was the acknowledgment that science and art were interdependent and good design warranted deliberate attention. Corning Glass was led by five generations of the Houghton family, who realized the importance of a strong relationship with community stakeholders. The company played a significant role in supporting culture and art, establishing a non-profit museum on the headquarters site as well as various residency programs for artists. The company's CCR outreach extended to the city of Corning, where its leaders and employees were involved in all aspects of the community. In 1960, Corning Community College expanded to a new campus, thanks to a generous gift of land by Arthur A. Houghton Jr. and a $2,250,000 donation from the Corning Glass Works Foundation (SUNY, 2006). Ongoing support from Corning has allowed the college to grow both physically and in terms of its reputation.

Two significant events highlight the company's commitment to its local context and the promotion of culture. The Corning Museum of Glass (CMOG) opened in May 1951 to mark the 100th anniversary of the company. Founded by Arthur Houghton Jr. and his cousin Amory Houghton, the museum has been consistently popular with the public, drawing nearly half a million visitors in 2015 and 2016, for example. Designed by Wallace K. Harrison, the mid-century modern building was a very simple collection of rectangular spaces with the main exterior façade comprising various types of glass providing the only ornamentation (Figures 2.3, 2.4, and 2.5). In essence, Corning Glass helped to establish the city of Corning, New York, as a cultural and educational destination. According to Robert Fogarty, CMOG gets three-quarters of its funding from the Corning Corporation and "is the centerpiece of the local $140 million annual recreation and tourism industry" (Fogarty, 2016).

Figure 2.3 Corning Glass Center. Visitors to the Glass Center see glass blown and formed by hand by the world's most expert craftsmen. The magnificent Museum and Library tell the whole story of glass from 1500 B.C. to the present time. A feature of the Glass Center is the famous 200 in. telescope glass. Genuine Curteich-Chicago. "C.T. Photo-Finish" Post Card—(Reg.U.S. Pat.Off)

Figure 2.4 The Corning Glass Center Corning, New York. Front view of the Glass Center where the public may see under one roof a complete record of the history, art, science, and manufacture of glass. Open Tuesday through Sunday 9:30 a.m. to 5 p.m., Admission Free

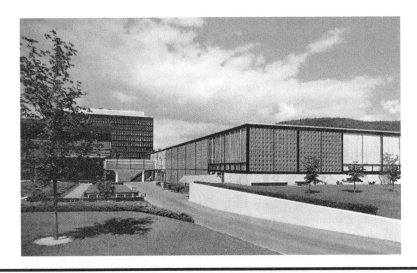

Figure 2.5 **The Corning Glass Center Corning, New York. Rear view of the Glass Center where the public may see under one roof a complete record of the history, art, science, and manufacture of glass. Open Tuesday through Sunday 9:30 a.m. to 5 p.m.**

The institution has also garnered a reputation as a thought leader in the field of glass scholarship and research in both the artistic and scientific fields.

The same year Corning Glass leaders organized a conference, in collaboration with the American Council of Learned Societies (ACLS), to examine life in the industrial age. Hosted in the new museum and library, the forum featured a diverse group of participants from all sectors of society, with a large concentration of representatives from business and academia. Prominent scholars, artists, and corporate leaders explored issues of human values in an industrial civilization.

Not surprisingly, Paepcke, Lionni, and Wallace K. Harrison were among the conference contributors, along with Julian Huxley, Margaret Mead, and Lilienthal, who was celebrated for his views on development and the role of democracy and individualism. Topics ranged from "Work and Human Values" to "The Individual's Sense of Community in Industrial Civilization." Based on the proceedings of the event, published in 1952, the conversations featured many differences of opinion as well as tensions between business representatives and academics. The role of the arts was addressed in a number of sessions, mainly in the context of the humanities as an element of civil society, art making as an element of leisure, and creative activity as an element of building self-awareness and confidence (Staley, 1952). According to conference participant Rene d'Harnoncourt, then director of MoMA, "Creative work in any form and medium tends to make people aware of their individual ways of doing things. It helps them to discover their own personalities, and by doing so contributes greatly to a sense of security" (Frank, 1952).

With the 1949 founding of the Aspen Institute still fresh, Paepcke spoke out at the Corning conference to underscore the value of this type of gathering. As the conference notes state,

> Cross-fertilization is needed to dispel distrust and to build more under-standing. One of theories at Aspen was that some good might be accom-plished by bringing together people from these different class groups to discuss things related to our American heritage and to participate in common cultural experiences.
>
> (Denny and Riesman, 1951)

The idea of cross-fertilization was at the core of the Aspen Institute and continues to be a defining theme in its programming to this day. Arthur Houghton honored Paepcke's legacy by donating his estate in Wye River, Maryland, to the Aspen Insti-tute in 1978.

Although the conference did not issue a set of actionable recommendations, it served as evidence of the private sector's recognition of its growing responsibility to society. Business leaders increasingly saw their leadership potential in organiz-ing cross-disciplinary gatherings focused on humanist topics. The conference also marked a time when society was still coming to grips with globalization, the postwar economy, and Cold War tensions. Although it received very little media attention, recaps of the conference were published in both *Business Week* and *Fortune*. Accord-ing to the latter,

> Unlike the rulers of ancient Rome and modern Russia, who enlisted intellectuals by subsidizing them completely or threatening to dispose of them completely, the businessman in a free society has no other course than to induce intellectuals to understand him, and in turn to try to understand them. The conference at Corning suggests that it can be done.
>
> (*Business Week*, 1951)

A number of attendees deserve special attention: Lilienthal, Huxley, and Eugene Staley represented liberal views of the roles of business and government in modern society and saw development as a means of achieving a more harmonious world economy. Their perspectives reflected elements of global development in the 1950s. All three were staunch supporters of the Tennessee Valley Authority as a model of development, described as follows:

> A total project designed to foster social change as much as technological development, it reached deeply into peoples' lives to transform where and how they lived and worked, and how they saw the world. To fore-stall political controversy arising from Germany's and the Soviet Union's

use of similar infrastructure projects for social engineering, the TVA emphasized the US political tradition of the public-private partnership to show why its programmes should be viewed as exceptional variants of international developments and distinguished from similar endeavours in Fascist Italy, Nazi Germany, the Soviet Union, and Japan.

(Ekbladh, 2010)

Their participation, along with that of Paepcke, Harrison, and Lionni, reflected Corning's understanding that it was a critical time for rethinking the role of business leadership in a humanistic society.

The company marked its centenary with a conscious effort to engage the broader community through the conference and establishment of the Corning Glass Center.

In anticipation of this occasion, the company searched for several years for a program that would be enduring and sufficiently broad to interest not only Corning's employees, stockholders, customers, and suppliers, but also the scientific, artistic, and educational professions and the general public in our own community, the nation, and the world.

This forward-looking attention to multiple stakeholders reflects Corning's aspiration to be seen as a responsible company with an impact on both society and business:

Corning has the conviction that this center will be a significant and enduring cultural and educational contribution to the nation, constituting as well an efficient instrument of public relations and a highly effective means of stimulating the development of new markets for glass. Estimates by competent authorities indicate that we may expect an attendance of more than 500,000 visitors each year. In addition, untold numbers of other persons will become aware of the Glass Center and Corning's position in the industry. As this center becomes more widely known and used, its value to Corning and the glass industry will grow cumulatively greater over the years.

(Corning Glass Works Annual Report, 1950)

Much like Paepcke's initiatives in Aspen, the conference's discussion of shared responsibility, corporate citizenship, and humanism shifted the conversation away from profit toward social responsibility. It also highlighted the perceived divisions between academia and industry and the idea that industrial development was not synonymous with human progress. Beyond enhancing Corning's image as a good corporate citizen, these gestures (conference and museum) signaled its commitment to CCR. Hosting the conference in Corning also brought attention to the company's dedication to the local community. Unlike Aspen, the city was neither retreat nor resort. Corning repeated this effort ten years later with a conference on the theme

"The Individual in the Modern World," also in collaboration with ACLS (Dyer and Gross, 2001). The meeting followed a similar format but leaned more toward international issues, with less emphasis on the creative industries.

Corning had another motivation for practicing CCR after its acquisition of Steuben Glass, in 1918. Cofounded in 1903 by Frederick Carder, a glass artist coming out of the English Arts & Crafts movement, and Thomas Hawkes, owner of crystal company T.G. Hawkes & Co., Steuben operated almost autonomously within Corning Glass until the Depression and presents a fascinating story within a story in terms of CCR. In 1933, management decided to refine its product with a focus on the pure crystal for which Steuben is known. Arthur A. Houghton Jr. became president of Steuben in 1937 and began to assert his own ideas, moving the company to New York City and engaging external architects and designers to develop a new identity. Corning commissioned Geoffrey and William Platt to design a monumental *moderne* showroom at 781 Fifth Avenue, featuring thousands of ridged glass blocks. Produced by Steuben-Corning, it was the "first true hollow glass block for building" and was referred to as a "Pyrex glass construction unit" (*Architectural Forum*, 1937).

One of the earliest known uses of Pyrex glass in architecture was for a 1931 bas-relief sculpture by Lee Lawrie at the Rockefeller Center, in New York. Titled *Wisdom with Sound and Light*, the sculpture can still be found above an entrance at 30 Rockefeller Plaza (Jablonski, 2010). The hand-poured Pyrex blocks form a screen through which daylight illuminates the lobby dramatically. Another type of Pyrex glass was used as the primary material in a bas-relief sculpture by Attilio Piccirilli, installed over the entrance of 636 Fifth Avenue, also part of Rockefeller Center. The allegorical *Youth Leading Industry* depicts a young male figure leading a charioteer toward the heavens. Above the glass sculpture, another relief by Piccirilli portrays the allegorical figures of Commerce and Industry separated by a large caduceus, a symbol of Mercury. The artist "sculpted idealized, superhuman figures, reinforcing the concepts of divinity and patronage, and by applying them here conceptually elevated the worlds of industry and commerce" (Gayle and Cohen, 1988). The innovative use of glass at the Rockefeller Center, a massive embodiment of art and commerce, was remarkable for its integration of classicism, allegory, experimental materials, and humanism.

Corning's visibility in New York City was bolstered by its presence at the 1939 World's Fair, where the company shared a Modernist pavilion designed by Shreve, Lamb, and Harmon with the Owens-Illinois Glass Company, Pittsburgh Plate Glass Company, and Owens Corning Fiberglass. Herbert Matter, a designer involved with efforts of the Container Corporation of America, assisted in the design of the Corning exhibit. The pavilion featured live glassblowing, perhaps inspiring the establishment of the Corning Museum of Glass. A key element of the glass pavilion was the 300-pound cast sculpture *Atlantica* (1938–1939), created for the fair by Steuben designer Sidney Waugh and now in the permanent collection of CMOG. The artwork depicts "a mermaid riding on the waves of the Atlantic Ocean commemorates the start of glassmaking in America by European immigrants" (Corning Museum of Glass, 1972).

Houghton began working with Walter Dorwin Teague, who had gained a reputation for his ability to bridge the worlds of art and commerce as an industrial designer. Teague designed a number of objects for Steuben in the early to mid-1930s, but his role as consultant was more critical. During Teague's one-year contract (1932–1933) with Steuben and Corning, he is credited with,

> contributing thirty-two new patterns to the Steuben offerings, Teague also analyzed production and sales problems, offering possible solutions at the factory level. Teague specified colorless glass in his designs for Steuben, reflecting a trend exhibited by Scandinavian glass of the period that was often pale in color or colorless with simple decoration.
>
> (Cooper Hewitt, n.d.)

In 1948, Houghton initiated a partnership with the Institute of Contemporary Art in Boston to organize a leadership program known as the Corning-Steuben Design Development Program. Soon after that he helped to establish design departments at Corning Glass and Steuben, the latter based in New York City (Robbins, 2019). Corning sold the company in 2008 only to buy it back again three years later. The long-standing association with Steuben, a prestigious brand in the art glass industry, lent Corning status in the art world. The Steuben legacy lives on in three significant ways. First, recent additions to the Corning Museum of Glass include a reconstruction of the original Steuben glass furnace to evoke the brand's place in the history of glass. Second, an important collection of art glass assembled by Frederick Carder is on permanent display in a building adjacent to the CMOG, on the Corning corporate campus. The collection actually belongs to the Rockwell Museum, a city cultural institution whose success is due largely to its association with Corning Glass. Steuben also helped bring an industrial sector into the realm of design culture. Third, Steuben was celebrated in a 2003 exhibition at the Museum of the City of New York, sponsored by Corning Incorporated to mark its centennial (Museum of the City of New York, 2003). Focusing on the period 1930–1960, it positioned Steuben as a champion of Modernism, with a lavish exhibition catalog including an essay by Donald Albrecht. The exhibition was another example of a museum validating the products of a commercial company.

As a high-profile arts philanthropist, Houghton played a significant role in the development of Lincoln Center and served on the boards of a number of major cultural institutions. His social capital was enhanced by his engagement with numerous cultural and educational organizations. Houghton was a member of the Board of Overseers of Harvard College and the Visiting Committee for the Harvard Library. He was a trustee of the Pierpont Morgan and New York Public Libraries, Rockefeller Foundation, New York Philharmonic Orchestra, Cooper Union, and the Parsons School of Design. From 1952 to 1974, Houghton served on the board of the Metropolitan Museum of Art and was its president for five of those years.

As corporate philanthropy matured in the United States, more and more companies created foundations as conduits for charitable community work. The Corning

Glass Works Foundation was incorporated in 1952, and in its first 15 years, it contributed $5 million to cultural and arts organizations such as libraries and museums, largely the Corning Museum of Glass. In 1964, the company sponsored a program to train African youth in leadership skills, in partnership with the Foundation for Youth and Student Affairs (Corning Glass Works Foundation, 1968).

Another milestone for Corning came in the form of its response to a natural disaster. In 1972, Hurricane Agnes brought catastrophic flooding to the city of Corning and the Corning Glass campus. In the wake of the monumental destruction, the company proved its unwavering commitment to the community by creating an organization to steer redevelopment in a thoughtful and culturally responsible manner. With support from Corning Glass, architectural preservation and design professionals were brought in to spearhead the redevelopment process. The flood prompted Corning Glass to lead the campaign to establish the Rockwell Museum in the former city hall building, which was severely damaged. The development and preservation efforts earned Corning a reputation as a pioneer for what was to become the Main Street Program of the National Trust for Historic Preservation.

Art, design, and culture continue to figure prominently in the economic development of the city of Corning and the surrounding region. An Economic Development Plan was published in 2018, with the participation of multiple stakeholders including Corning Glass, in a process facilitated by TIP Strategies (TIP Strategies Inc., 2018). Not surprisingly, the plan included recommendations to build on the strong presence of the arts, culture, and design cultivated by Corning Glass. The CMOG and Rockwell Museum have become sustainable assets, exemplifying a model similar to that of Columbus, Indiana, where the community is an equal partner in cultural development. In line with Corning's commitment to progressive design and cultural patronage, Harrison & Abramovitz designed the company headquarters, museum, and library in the International Style. Gunnar Birkerts designed an addition to CMOG in 1978. The building featured various types of architectural glass produced by the company, and the Birkerts addition honored the stark Modernism of the original design, although later renovations obscured its purity.

In 1956, Corning commissioned Harrison & Abramovitz to design a New York City headquarters building for Steuben that was considered a stellar example of International Style Modernism and was "the first glass-walled skyscraper on Fifth Avenue" (*New York Architecture*, 2020). The building replaced an earlier structure by Geoffrey and William Platt and exemplified Corning's commitment to developing innovative materials. The company's Pyrex products were also used as a key building material in Frank Lloyd Wright's Johnson Wax Headquarters, in Racine, Wisconsin. Corning boosted its visibility in New York when it organized *Glass 1959*, the first in a series of collaborative exhibitions hosted by The Metropolitan Museum of Art. In 1980, The Met also hosted a major exhibition, *New Glass, A Worldwide Survey*, organized by the Corning Museum of Glass (R. C. Miller, 1990).

In 1993, a new Corning corporate headquarters, designed by KRJDA, opened across the river from the museum and former headquarters. The building hosts a site-specific art collection commissioned by Corning, and a small public park

designed by Dan Kiley lies adjacent to the complex. Featuring glass walls and mini-mal ornamentation, the headquarters was closely integrated into the historic section of the city, sending a signal that the company embraced the community. The choice of KRJDA may have been the result of the Houghton family's long-term engage-ment with the Metropolitan Museum of Art; Jamie Houghton, ten years younger than his brother Amory Jr, took over as Corning chairman in 1983, served on the Met's board of trustees beginning in 1982 and became chairman in 1998. Kevin Roche began work at the Metropolitan Museum of Art in 1967 and south side addi-tion was completed in 1982.

Corning Museum of Glass continued to expand, and an addition designed in 2000 by Smith-Miller & Hawkinson included a performing-arts facility and a digital theater. In 2005, Thomas Phifer designed a new wing dedicated to con-temporary art and design with monumental spaces showcasing contemporary glass art (Minutillo, 2015). All of these choices reflected an ongoing commitment to design integrity and a sense of cultural responsibility where company stakeholders are consulted and the effects on the community are taken into consideration. The CMOG is a remarkable example of a public cultural resource supported entirely by a corporation.

All three of these companies—Cummins, Olivetti, and Corning—embody many elements of the principles of CCR. Yet the Italian case points to an overdependence on the donor, Adriano Olivetti, and the success of the business. There are remarkable similarities between Adriano Olivetti and J. Irwin Miller: both inherited company leadership roles from their families, had a strong spiritual/religious grounding, cared deeply about the well-being of their workers, and were involved in local and national politics. Olivetti, for example, led studies for the Valle d'Aosta regulatory plan and had a detailed vision for postwar Italy (Brilliant, 1993). Yet the leadership styles of these two patrons differed significantly in several respects. Corning did not rely on the guidance of one individual but on generations of the Houghton family and a group of senior leaders that sustained a long-term engagement with the arts, culture, and community. Unlike Olivetti and Cummins, Corning's basic product had a rich history in the decorative arts spanning thousands of years. Glass has long played a major role in architecture and as a primary material for many artists working in traditional crafts as well as experimental sculpture.

Olivetti, Corning, and Cummins have all demonstrated a clear commitment to the fundamental framework of CCR by balancing economic, cultural, and social values while addressing multiple stakeholders. The key difference among them is the level of attention given to sustainability. Miller and the Houghtons carefully nurtured ownership of the city's architectural heritage among the community and conceived their philanthropic legacies to incorporate continuing stewardship for the future. At Corning in particular, community and cultural responsibility are embed-ded in the business, as evidenced by the work of Corning Enterprises and the Corn-ing Incorporated Foundation.

Corning Glass and Cummins Engine have similar patronage relationships to their cities. Corning has supported many projects related to education, health care,

and the arts, with the Glass Museum and related public buildings becoming major community assets and strong drivers of economic development. Local involvement by both Cummins and Corning is characterized by partnership at all levels of the community that leverages the social capital of the company to improve the public sphere. It is no surprise that Corning Glass executives visited Columbus to see the results of Cummins Engine's cultural responsibility initiatives. In 1960, Columbus had 20,000 residents and Corning had 17,000, the latter's population declining in the past 60 years while Columbus has grown dramatically.

Olivetti was much more explicit in using its commitment to cultural responsibility as a business advantage, demonstrated by the company's presence in New York City, where it sought more a global identity based on a commitment to product design, architectural patronage, and the "Olivetti idiom." Adriano's death may have been a factor in the ultimate decline of the company and the town of Ivrea. Cummins Engine's approach was more local, with a primary focus on Columbus, although it reflected a global commitment to design in buildings outside of the United States. Humanitarian and community development were clearly high priorities for all three companies. Indeed, Corning Glass was one of the first corporations to offer health insurance. Miller was also clearly ahead of his time in consciously embracing a progressive approach to cultural diversity in the workplace and community.

Although none of these models were replicated directly, all of them provided inspiration to other corporate leaders in terms of their innovative approaches. Olivetti arguably influenced IBM's embrace of Modernism and design. Both Olivetti and Cummins were outspoken and successful in engaging their workforces. In terms of sustainable community development, the legacies of Cummins and Corning have withstood the test of time as enduring sources of pride and economic drivers for their regions. Olivetti was celebrated for its integrated design approach, whereas Cummins and Corning have always ranked high on reputation and citizenship indices, not only attributable to the arts.

One stark contrast, of course, is that Olivetti has disappeared as a corporate entity. With a population of 23,000, Ivrea became a UNESCO World Heritage Site in 2018. While the city is struggling, there are positive signs that the Olivetti legacy will be preserved in light of this recognition. Yet

> 44% of the former industrial and corporate buildings of the property are vacant or underused, and there are short-term needs for maintenance strategies. Engagement with residents and other users is an ongoing priority. Currently visitor levels are low, and there are plans to increase tourism capacity.
>
> (UNESCO, 2001)

In terms of architecture, all three companies espoused a new language inspired by European Modernism. The corporate leaders understood that "modernist architecture was considered to embody modern modes of living, thinking, and production

based on rationality, efficiency, calculation, the obsession with novelty and abstraction, as well as the moral pretension of advancing social and political goals through design practices" (Lu, 2011). Olivetti was the most experimental, engaging Italian architects and designers for all functional areas of the company. Cummins was open to new and experimental designs, whereas Corning was more conservative in its corporate Modernism, although recent investments in the museum have been more adventurous. Above all these companies advanced a more integrated notion of design as an element of their corporate brands—a defining feature reflected in architecture, design aesthetics, and engagement with multiple stakeholders that spilled over into the community to become a public good.

As the Corning conference made clear, the 1950s were a time of tension and change. One section of the discussion dealt with a perceived lack of confidence in industrial civilization in terms of three perceived threats: the looming possibility of war, economic insecurity, and rapid change (Staley, 1952). Scholars such as Lilienthal were known for their views on the societal fragmentation caused by Modernism and industrialization. The 1950s also marked a turning point for the marriage of art and commerce in the United States. The entry of Olivetti into the U.S. market, the Aspen Institute's conference "Design as Management," Corning's museum of glass and conference, and Miller's tenure at Cummins (1951–1977) all marked the emergence of CCR. Modern design became a norm in terms of objects made for the home and everyday use. These three companies blazed a trail for corporate architecture, and other progressive companies recognized that good design could enhance their reputations and serve as a competitive advantage. Most important, these companies recognized that a CCR program was a powerful means to engage with a diverse set of stakeholders.

In the postwar United States, large companies were beginning to see the value of engagement in, and sponsorship of, the arts. Sponsorship of classical music and opera programs on TV and radio became a popular strategy of corporate visibility for companies like Texaco and AT&T. Roland Marchand sums up this trend as follows: "Corporations that aspired to an ascribed role of national leadership were recognizing the value of 'covering all the bases,' culturally as well as socially, politically, and economically, as they looked toward the postwar world" (Marchand, 1998). Business leaders were beginning to realize that they could build social capital through deeper relationships with cultural organizations. Changes to the tax code also made cultural philanthropy more attractive to corporations. Taking cues from institutions like the Bauhaus, corporate leaders began to experiment with European Modernism in the design of products, corporate campuses, and research and development buildings as part of a holistic approach to serving and inspiring the larger community.

Leading companies were growing increasingly more conscious of the importance of building design. As Alexandra Lange has argued,

> The final alchemy for the successful headquarters project—efficient, humane, well publicized, and iconic—was to transform a business

necessity into a philanthropic enterprise. Good design, as Paul Rand would say, could become good will. The theme that crosses all of my case studies is the sense of corporate patronage, and the creation of modern Medici, as executives gave back to their cities or towns by building a better landmark and to their employees by building a better workplace.

(Lange, 2005)

The corporate campus, the next step in the evolution of the company town, presented an opportunity for a firm to make a public statement about its identity and design savvy. While scholars often invoke the Medici as the paradigm of patronage, not all efforts by corporate leaders were accordingly philanthropic.

Advocates for Good Design

The Museum of Modern Art has a rich history in elucidating the virtues of good design, especially in everyday functional objects, signaled in the 1934 exhibition *Machine Art*. The next year the museum launched a series of related shows to help consumers understand the principles of good design. Organized by John McAndrew, *Useful Household Objects under $5.00* "was the first of a series of 'service' exhibitions specifically intended to help the public in its selection of well-designed inexpensive household equipment" (La Rinascente, 1958). A more ambitious project led by Eliot Noyes, *Organic Design in Home Furnishings*, was based on a 1940 contest inviting designers to submit furniture, lamps, and textiles under the heading of "Organic Design," defined as "harmonious organization of the parts within the whole, according to structure, material, and purpose." In addition to being featured in an exhibition, the winners were "awarded contracts for manufacture and distribution with major department stores."

Twelve department stores were engaged as sponsors, including Kaufmann Department Stores, in Pittsburgh; Marshall Field & Company, in Chicago; and Gimbel Brothers, in Philadelphia. Other museums explored the relationship of design and business as well. As part of programming for its Everyday Art Gallery, the Walker Art Center, in Minneapolis, organized the exhibition *Ideas for Better Living*, in 1946; the Albright Art Gallery, in Buffalo, launched *Good Design Is Good Business*, in 1947 (Ward, 2011). Beyond department stores, a small number of entrepreneurs saw potential in establishing retail shops dedicated to selling and promoting good design. Baldwin Kingrey, a Chicago furniture store founded in 1947 by architect Harry Weese and his wife, Jody, was one of the first shops in America to sell furniture and objects designed by architects at affordable prices. It also hosted exhibitions of work by leading Modernists such as Adolph Gottlieb, György Kepes, and László Moholy-Nagy. Opened in 1953 in Cambridge, Massachusetts, Design Research realized the same promise of making good design accessible to consumers. Its founder, architect and planner Benjamin Thompson, was a colleague and friend of Walter Gropius and brought some of the early ideals of the Bauhaus to fruition.

An early influence on the MoMA's relationship with industry and commerce was Edgar Kaufmann Jr., the son of the founder of Pittsburgh's largest department store. Before working at the museum he apprenticed with Frank Lloyd Wright and worked in the family business. Kaufmann's department store hosted exhibitions highlighting current advances in industrial design and decorative arts. In the late 1920s, Kaufmann embarked on a study of European retailers and concluded that Germany was a leader in retail design, unveiling a radically modern department store interior inspired by his findings in 1930 (Longstreth, 2010). As part of the renovation, Boardman Robinson was commissioned to paint a series of murals depicting the history of commerce and industry.

Kaufmann contacted the MoMA in 1940 to propose a collaboration with department stores in the United States to identify good design in home furnishings. Kaufman served in the armed forces in the early 1940s and was later appointed head of the department of Industrial Design upon his return to the MoMA, in 1946. In the interim, the museum continued its quest to advocate for affordable and well-designed objects. In 1944, the exhibition *Design for Use*, part of the series "Art in Progress: 15th Anniversary Exhibitions," underscored elements of technology, form, and function in objects ranging from scissors to typewriters and juice extractors (Museum of Modern Art, 2020). Kaufmann spearheaded the "Good Design" series of exhibitions in partnership with Chicago's Merchandise Mart, from 1950 to 1955. The exhibitions highlighted current objects and furnishings from manufacturers, designers, and retailers including Herman Miller and Knoll Associates. Charles and Ray Eames and Alexander Girard were involved in the exhibition design. At the heart of these efforts to bridge art and commerce was the belief that, beyond the economic potential, good design would result in positive impacts on culture and society. Sustained by the Chicago Athenaeum Museum of Architecture and Design and Metropolitan Arts Press Ltd., the "Good Design" project still conducts an annual competition "for the most innovative and cutting-edge industrial, product, and graphic designs produced around the world" (Good Design, 2021).

In 1950, the Museum of Modern Art published a series of small books in which Edgar Kaufmann Jr. defined and illustrated modern design, outlining "Twelve Precepts" that prescribe integrity in terms of materials, process, and functionality. The last principle makes the case that modern design should be accessible to "as wide a public as possible" (Kaufmann, 1950). The rambling essay concludes on a more abstract note, citing Thomas Aquinas's three qualities of beauty: integrity, clarity, and harmony. The text is complemented by 70 photographic illustrations of furniture, textiles, pottery, and tableware produced mostly in the 1940s. Kaufmann's tenure at the MoMA is quite remarkable given that he had no college degree, although it is unclear how much influence his father had with the museum. After Kaufmann left the museum once again, Arthur Drexler became director of the department of Architecture and Design and was responsible with Mildred Constantine for organizing the exhibition *Olivetti: Design in Industry*, in 1952. Drexler began at MoMA in 1951 to reorganize the Department of Architecture and Design; more concerned

with the theories behind corporate design than with "pricing and retailing," Drexler led the museum program in a more international and less commercial direction (Eigen and Riley, 1994).

The MoMA and the Rockefeller family were involved in a number of international development efforts where art and culture were seen as tools of economic development and diplomacy. In 1939, Nelson Rockefeller was appointed by President Roosevelt to lead the U.S. government's Office of Inter-American Affairs (OIAA). Through his engagement, for example, the museum was

> strategically focusing on the development of art infrastructures in Latin America: if modernism was to be the banner under which America would deploy its international cultural policy in Brazil, it was necessary, to begin with, to induce the appearance of modern art museums similar to, and guided by, the MoMA.
>
> (Söderlund, 2019)

Wallace K. Harrison's presence in this social circle is fascinating given his involvement with a number of important architectural commissions for companies like Corning and Alcoa, as well as his high-profile engagement with the United Nations and many New York City cultural projects. As Victoria Newhouse pointed out, his relationship with Nelson Rockefeller led to his election to the board of trustees of the Museum of Modern Art and his engagement with the Rockefeller Institute of Government, Rockefeller Brothers Fund, Rockefeller Foundation, and most interestingly, the Point Four Program.

The Point Four Program, announced by Harry Truman at his January 1949 inaugural address, deserves more attention for its influence on the practice of international development. According to Stephen Macekura, "As the first formal government program explicitly designed to ameliorate social, economic, and political conditions in any 'underdeveloped' nation, Point Four brought international development policy into the U.S. foreign policy apparatus to an unprecedented extent" (Macekura, 2013). A key element of Truman's proposal was involvement of the private sector in global development efforts. It is safe to say that this approach to development influenced the practices of what was to become known as Corporate Social Responsibility. The Ford Foundation and the Museum of Modern Art partnered with the United States Information Agency (USIA) to organize the major exhibition *Design Today in America and Europe*, shown in India in 1959. Modeled on the "Good Design" series, it showcased more than 300 domestic objects including furniture and dinnerware that embodied MoMA's standards of good modern design at affordable prices. The exhibition host, the National Small Industries Corporation, had aspirations beyond mere cultural diplomacy to inspire good design among India's manufacturers (Karim, 2010). Shown in Amritsar and New Delhi, it was seen by more than 190,000 visitors (Franc, 1994).

The theme of international development and cooperation was also highlighted in terms of the Rockefeller family's interest in postwar Japan. In 1951, after John

D. Rockefeller III and his wife, Blanchette, visited Japan as cultural consultants to the Peace Treaty Mission, a plan was put in place to create a series of cross-cultural exchanges. In a clear demonstration of the value of social and cultural capital, MoMA was again called upon to act as a cultural diplomat at the behest of the Rockefellers and the U.S. government by hosting three exhibitions (Kida, 2012). The Japan Society, created in New York in 1907 to foster cultural exchange, ceased operations during the war, and when operations resumed in 1952, Rockefeller took over as president.

The MoMA's efforts to establish thought leadership in design were recognized in 1956, when La Rinascente awarded the museum its prestigious Gran Premio Internazionale la Rinascente Compasso d'Oro. Since the annual award was chiefly an opportunity to recognize Italian design leadership, it was unusual for the jury to select an American institution. The department store published an elaborate publication designed by Lora Lamm with an essay by Arthur Drexler (La Rinascente, 1958). Herbert Read's rambling introduction concludes with sobering thoughts on the public's lack of good taste, yet he expresses measured optimism that efforts by MoMA and others will help society discover a new sense of beauty. Drexler's essay, on the other hand, chronicles the achievements of the museum in elevating architecture and design through numerous examples of programming and internal administrative structuring. In subsequent years, entrepreneurs such as Benjamin Thompson helped to promote a new aesthetic sensibility in society by creating retail spaces exhibiting and selling objects produced by emerging and established Modernists.

While the Museum of Modern Art demonstrated how an institution could advocate for good design in the United States, Milan's Triennale served as a venue for design-related exhibitions in Italy. Since 1933 the Triennale has played a critical role in international dialogue around the role of the arts and industry in society. The 10th Triennale, held in 1954, inspired the term *stile industria* ("industrial style"), leading to the creation of the magazine *Stile Industria* the same year. Franca Santi Gualteri played an influential role as editor at the magazine from 1954 to 1963, later joining the editorial team at *Abitare*. Her 2003 book, *A Trip through Italian Design*, chronicles the development of Italian design during its most critical years (Gualteri, 2003). Gualteri was the only woman invited on the jury of *New Glass: A Worldwide Survey*, a major exhibition organized by the Corning Museum of Glass (Corning Museum of Glass, 1979). Finally, *Domus* magazine set a new standard for design criticism and helped to elevate Italian design to a global leadership position.

The British Design Centre, opened in 1956 under the auspices of the British Council of Industrial Design, served as an avenue for exhibitions and public programming. Eager to elevate its own national industrial design identity, Belgium launched the design awards Signe d'Or in 1956 and a permanent exhibition space in 1964 (Gimeno Martínez, 2010). Countries such as Greece, New Zealand, and Norway established design exhibition spaces to promote industrial design as an economic engine. As the industrial design community grew, the idea to create an international body representing the interests of industrial designers culminated in the founding of the International Council of Societies of Industrial Designers, in 1957.

Corporate Modernism

The 1950s saw the advent of a new corporate architecture style influenced by European Modernism. The Lever House, Connecticut General Life Insurance, and Inland Steel buildings all marked new experiments in material, scale, and plan. Inland Steel hired Skidmore, Owings & Merrill (SOM) to design its new Chicago headquarters, completed in 1958 to become one of the first Modernist skyscrapers in the city, with a thematic collection of sculpture and paintings incorporated into its interior. Much like the Alcoa skyscraper project in Pittsburgh, the Inland Steel headquarters flaunted the use of materials associated with the company's products as well as the International Style. Inland Steel and its related companies manufactured all of the building's structural steel and cladding. Writing in *Art in America*, Edgar Kaufmann Jr. highlighted the unique quality of the art collection, which included works by Georgia O'Keeffe, Ben Shahn, and Hedda Sterne (Kaufmann, 1957–1958). The collection was assembled through a collaborative effort between the architects and the patron to reflect both the architecture and the steel industry. The completion of the General Motors Technical Center later in the decade signaled a new era in corporate campus planning and design. Greater attention was paid to landscape design and amenities for employees, including an art collection with works by Alexander Calder, Antoine Pevsner, and Charles Sheeler (N. A. Miller, 1999).

The boom in Modernist office buildings led to the rapid growth of Knoll Inc. Founded in 1940 by Hans Knoll, the company was propelled into a leadership role in the design of textiles for corporate interiors under the influence of Florence Schust, who married Knoll in 1946. Trained at Cranbrook Academy as a student of Mies van der Rohe, Florence led the company to create the industry's first textile division. In the late 1950s, German management consultancy Quickborner developed new ways of looking at how interior design could influence human interactions in the office, coming up with the concept *Bürolandschaft* ("office landscape") and exploring the possibilities of the open plan. According to John Walsh, "Bürolandschaft favored a more random, organic, and democratic floor plan that would encourage interaction and communication and ultimately help companies innovate" (Walsh, 2015). This experimentation, which continues into the twenty-first century, led to the development of modular office furniture by Herman Miller and others. These changes in the corporate office sphere had a particularly positive effect on Knoll's contract accounts (Ward, 2011) (Figure 2.6).

The early 1950s witnessed the proliferation of new U.S. state laws that allowed corporations to engage more in philanthropic efforts to improve the common good. The 1953 legal case A.P. Smith Manufacturing Co. v. Barlow found that charitable contributions by corporations do not have to demonstrate a direct business benefit to companies (*Washington Law Review*, 1954). In other words, companies are free to support broader community efforts such as education, social services, and the arts. As Baumol and Bowen pointed out, the establishment of company foundations for charitable giving grew dramatically: in 1939 there were 20, and in 1962 more than

Figure 2.6 **Florence Knoll, Knoll Showroom, 601 Madison Avenue, New York, NY, 1948. String screen by Herbert Matter. Photograph Robert Damora ©**
Damora Archive, all rights reserved

1,500. While tax laws surely were a factor, companies were also taking on more responsibility for community needs (Baumol and Bowen, 1966).

There was also a growing awareness that American culture was not keeping up with economic progress in terms of intellectual and humanistic values. Louis Kronenberger's *Company Manners*, published in the early 1950s, was a critical examination of American attitudes toward culture and the humanities, and the negative effects of business on society. Among other works, Dwight Macdonald published "The Book-of-the-Millennium Club" in the *New Yorker*, a scathing review of the Encyclopedia Britannica's "Great Books" project. In essence, he attacked the commercial nature of the venture, which lost money until it employed a different marketing approach: "That the public bought less than 2,000 sets of the Great Books in 1952 and 1953 while last year they bought 25 times as many—this shows that Culture, like any other commodity, must now be 'sold' to Americans" (Macdonald, 1952).

Criticism of the corporation mounted as tensions between business and society escalated during the Cold War. William H. Whyte, editor of *Fortune* and a

participant at the 1951 Corning conference, published an intriguing critique of business, conformity, and social engineering. One of the core themes of *Is Anybody Listening?* is the perception that American culture is perceived as too reliant on consumption and capitalism and not enough on the humanities and individualism (Whyte, 1952). His book *The Organization Man*, published in 1956, painted a picture of a dehumanizing corporate culture. Conformity was seen as a weakness and an actual threat to American democracy. International development was on the minds of many thought leaders, such as those gathered at the Corning and Aspen conferences, where concerns around national security were evident. Efforts to highlight the virtues of American democracy during this time often involved the arts. The promotion of Jackson Pollock as a hero of creative individualism is one example of government efforts to highlight the freedoms at the heart of the American way of life. American individualism soon became associated with the emergence of Abstract Expressionism, reflected in the proliferation of major collectors "from two dozen in 1945 to 200 in 1960, and 2,000 by 1970. Sales of postwar American art skyrocketed after the Metropolitan Museum of Art purchased Pollock's *Autumn Rhythm* for $30,000 in 1957" (Doss, 2002).

The 1950s also saw a growing interest in the concept of creativity as an element of humanity and, in turn, a potential asset for business innovation. As Jamie Cohen-Cole writes in *The Creative American*:

> The importance of creativity to postwar Americans was significant enough that there were as many creativity studies published between 1950 and 1965 as there had been in the previous two hundred years. ... Creativity, the trait central to interdisciplinary collaboration, provided the lubrication that allowed for communication and understanding among the brightest individuals, even if they possessed different modes of expertise. And just as creativity was central to the cohesion of the academy, as the characteristic that was deemed to enable autonomy and tolerance, it would also enable a well-functioning liberal, pluralist American society.
>
> (Cohen-Cole, 2009)

Emerging from the social, political, and academic environment of the era, this conception of creativity enabled corporate leaders to embrace it as a business imperative since it had gained validity in the public discourse.

Beyond the patronage of visual art and culture, the corporation now had the opportunity to integrate creativity into its identity and business practices. At the core of this transformation were leaders such as Jamie and Amo Houghton, Miller, Olivetti, and Paepcke, who shared a commitment to broader issues of social cohesion, humanism, and of course, business success, and thinkers such as Bayer, Lilienthal, and Lionni. Key elements in this shift to CCR were openness to the cross-fertilization of thought, evidenced by the Corning and the Aspen forums, and the

increasing role of the United States in postwar Europe. It is no surprise, for example, that Edward Kaufman was an active participant in the Aspen Design Conferences.

One great example of the cross-fertilization envisaged by Paepcke and the Houghtons was Douglas Haskell's presence at the Corning conference. Considered a thought leader in architecture and design during the critical decades of 1920–1960, he wrote for *Architectural Record*, *Architectural Review*, and *Harper's Magazine*. In 1949, Haskell became editor of *Architectural Forum*, retiring in 1964. He was an early supporter of Modernism and served on the advisory panel for the Cummins Foundation's architecture program in Columbus, along with Pietro Belluschi and Eero Saarinen. Haskell was critical in highlighting the architectural patronage aspect of Cummins's CCR programs, and it is no surprise that he featured Columbus projects in *Architectural Forum* throughout the 1960s and 1970s.

A consequence of cross-fertilization is the formation of small networks that might be seen as exclusive. Saarinen arguably had a great deal of influence over Miller, who selected architects from among his network. One example, Gunnar Birkerts, was building his career in the 1950s beginning with work on the General Motors Technical Center as part of Saarinen's firm. After a stint at Minuro Yamasaki's office, Birkerts was part of the effort to bring Modernism to corporate America, as demonstrated in his work for both Cummins Engine and Corning Glass. Saarinen's successor firm, KRJDA, played a role in sustaining the corporate Modernism developed in the 1950s well into the 1980s.

Corporate Social Responsibility was officially recognized in 1953 by American economist Howard Bowen in his publication *Social Responsibilities of the Businessman* (Bowen, 2013 (1953)). The formalization of a broader mandate for business beyond profit was a key building block of a nascent CSR that allayed shareholder objections to broader philanthropic and employee engagement practices. In Chapter 2, Bowen discusses the goals of business in the context of social responsibility and the effects of business on the attainment of social goals. His 11 goals are: High Standard of Living; Economic Progress; Economic Stability; Personal Security; Order; Justice: Freedom; Development of the Individual Person; Community Improvement; National Security; and Personal Integrity. Although each is fascinating and many are forward-looking, "Development of the Individual Person" and "Community Improvement" contains references to "creative activity," "cultural advancement," and "aesthetic values." A new edition of Bowen's book was published in 2013 and in the Introduction, Jean-Pascal Gond explains that "For Bowen, social responsibility is an innovation that is worth exploring because it can potentially address the failure of the free market while being a partial alternative to socialism."

In terms of supporting the arts, businesses had at least three motivations. First, it was recognized that arts were a reflection of current societal thinking and reflect freedom of thought, individual expression and cultural advancement. Companies were beginning to see the value of aligning with innovation and creativity within their own workplaces. The growth of high-profile corporate campuses and the increase in corporate cultural philanthropy are two indicators of this trend. The embrace

of European Modernism led to innovations in advertising and product design, signaling a new era in art and commerce collaborations and an embrace of "aesthetic values." Finally, museums were increasingly involved in advocating for better industrial design through direct relationships with the production potential of companies. Many artists, in turn, were interested in the technological advances taking place in the modern corporation. Many saw industry as a means to advance new aesthetic principles, such as those espoused by the Bauhaus and the concept of Gesamtkunstwerk. The early philanthropic models of Carnegie, Rockefeller, and Ford were becoming institutional rather than individual practices. Surprisingly, it was the leaders of the steel, oil, and car industries who were taking the lead in advocating for more freedom in corporate engagement with societal issues (Walton, 1967).

No discussion of art and commerce would be complete without noting the contributions made by Andy Warhol. He began his career in the corporate world when photography was gaining ground as the preferred medium for advertising. However, Warhol's "line art" style remained popular for art directors working on specific campaigns. Will Burtin tapped Warhol for a campaign for a rheumatoid arthritis drug produced by Upjohn Company. The fashion industry also saw value in Warhol's style, as exemplified by his iconic shoe illustrations for I. Miller & Sons. The company's goals were to market its products to an upscale audience through the use of the whimsical imagery created by Warhol.

Warhol was active at time when the advertising industry was evolving. For example, Doyle Dane Bernbach (DDB) was founded in 1949 and heralded a new type of advertising geared toward a more sophisticated audience that embraced the tension between the verbal and visual. Push Pin Studios, founded in New York by Seymour Chwast, Milton Glaser, and Edward Sorel in 1954, joined later by Reynold Ruffins, broke new ground by blurring the lines between popular culture, commercial art, and elements of art history. The same year Warhol began to create window displays for Bonwit Teller, working under former painter Gene Moore, whose first display job was with I. Miller & Sons, at Broadway and 46th Street, now a historic landmark. Moore also collaborated with Jasper Johns and Robert Rauschenberg. In 1955, he joined Tiffany & Co., where he held the positions of display manager, artistic director, and vice president before retiring in 1994.

Warhol's transition from successful commercial artist to pop art superstar is attributable to a mixture of his own vision and the cultural context of the 1950s. It was during his stint with Bonwit Teller that Warhol produced five paintings as a window-display backdrop that became known as his "first major appearance as an artist in 1961" (McShine, Introduction, 1989b). As Lupton and Miller explained,

> Warhol's success as a commercial artist coincided with a gradual shift in the professional standing of illustrators, prompted by the increasing use of photography. While his exuberant decorative style contributed spontaneity and playfulness to commercial graphics, it also directly exploited the techniques of mechanical reproduction.
>
> (Lupton and Miller, 1989)

His immersion in the commercial art world and exposure to the technical aspects of photomechanical reproduction were likely contributing factors but surely do not tell the whole story. Warhol's work became widely collected in the 1970s and has fittingly become a staple of many corporate art collections. The 1989 MoMA exhibition *Andy Warhol: A Retrospective* brought together the various strands of work by this exemplar of the coexistence of art and commerce (McShine, 1989a).

Perhaps aware that a great shift in attitudes toward culture and the arts was underway, in June 1954 Aline Saarinen published a curious story in the *New York Times* focused on the Art Lending Service of the MoMA and its new practice of lending art to companies. The core of the article, however, was an admonishment of the Young Presidents' Organization for its symposium on business and the arts held in New York. Saarinen challenged the group to

> recognize that a country's cultural maturity—in fact, the existence of a country's culture at all—has to do not with a few surface embellishments or isolated acts of patronage, but with an unselfconscious, convinced, continuing concern with the sponsorship and creation of beauty in an entire environment. It is to approach art (in its largest sense) in a relaxed and easy and understanding way, embracing it, not because it offers a passport to heaven, nor is a means of noblesse oblige, nor even (as so many of the speakers at the symposium pointed out) because it 'pays off' for business.

Her critique continued with a suggestion that business should embrace the arts in the manner demonstrated by Olivetti's recently opened showroom in New York. Saarinen also cited Corning Glass, Container Corporation of America, and Columbia Broadcasting as models of enlightened corporate citizens. The article presaged the greater acceptance gained by CCR in the following decades.

It is clear that Adriano Olivetti was a prophet in integrating social and cultural responsibility, yet Cummins Engine and Corning Glass contributed equally distinctive CCR models. S. Prakash Sethi's framework outlines three elements of responsible behavior: social obligation, where each company respects legal and market norms; social responsibility, where each company demonstrates its values, traditions, and expectations; and social responsiveness, whereby a company answers to society's expectations and anticipates social needs (Sethi, 1975). Sethi, and others, advocated for more engagement from business to play a role in solving challenges experienced by society. At the core of these three case studies from Olivetti, Corning and Cummins, is the belief that supporting culture, design and architecture was a critical social responsibility. Each of the three companies clearly believed that business exists for reasons beyond mere profit. Each of these innovation-oriented companies espoused a humanistic belief that art, culture, and design were integral to generating business and social value. Yet these companies were also aware, to varying degrees, of the intangible nature of cultural responsibility in terms of reputation and equity. For Olivetti, it provided a competitive advantage for entering the U.S. market.

For Cummins and Corning, it helped to attract talent and make their communities sustainable and desirable. The places these companies called home—Ivrea, Columbus, and Corning—were all transformed in different ways. Each of these companies presents a lesson in cultural leadership and the importance of a long-term vision that balances the needs of multiple stakeholders.

Bibliography

2012. "AIA Ranks Columbus, Indiana as US's 6th Most Architecturally Important City." *Arch-Daily*. December 4. https://www.archdaily.com/299356/aia-ranks-columbus-indiana-as-uss-6th-most-architecturally-important-city. ISSN (Retrieved April 7, 2021).

Antonelli, Paola. 2001. "Italian Design between Globalism and Affectivity." In *Italy: Contemproary Domestic Landscapes 1945–2000*, by Giampiero Bosoni, ed., 22–37. Milan: Skira.

Architectural Fourm. 1937. "Building for Corning Glass Works, New York City." *Architectural Forum*, 67(6), 457–460. https://usmodernist.org/AF/AF-1937-12.pdf (Retrieved October 11, 2020).

Architecture Plus. 1973. "The Olivetti Story." *Architecture Plus* 20–27.

Arrigo, Elisa. 2003. "Corporate Responsibility in Scarcity Economy: The Olivetti Case." *Symphonya. Emerging Issues in Management*, 1, 114–134.

Barbiellini Amidei, Federico, Andrea Goldstein, and Marcella, Spadoni. 2010. *European Acquisitions in the United States: Re-examining Olivetti-Underwood Fifty Years Later*. Rome: Bank of Italy Economic History Working Paper.

Barbiellini, Federico Amidei, and Andrea Goldstein. 2012. "Corporate Europe in the US: Olivetti's Acquisition of Underwood Fifty Years On." *Business History*, 54(2), 262–284.

Bartolomeo, Matteo, and Paola Savoldi. 2002. "Corporate Social Responsibility and Local Competitiveness. The Case of Olivetti Spa and Ivrea Region." *10th International Conference of the Greening of Industry Network*. Goteberg. https://www.semanticscholar.org/paper/Corporate-social-responsibility-and-local-The-case-Bartolomeo-Savoldi/781999e-538008caa7250f23940defcc26d34adb0 (Retrieved December 29, 2020).

Baumol, William J., and William G. Bowen. 1966. *Performing Arts-The Economic Dilemma*. New York: The Twentieth Century Fund.

Bini, Elisabetta, Ferdinando Fasce, and Toni Muzi Falconi. 2011. "The Origins and Early Developments of Public Relations in Post-War Italy, 1945–1960." *Journal of Communication Management*, 15(3), 210–222. http://dx.doi.org.proxy.libraries.rutgers.edu/10.1108/1363254111115 (Retrieved December 13, 2020).

Blakely, Shantel. 2011. *The Responsibilities of the Architect: Mass Production and Modernism in the Work of Marco Zanuso 1936–1972*. New York: Columbia University. https://academiccommons.columbia.edu/doi/10.7916/D86Q245S (Retrieved February 6, 2021).

Bonifazio, Patrizia. 2018. *Le Case Olivetti A Ivrea*, by Carlo Olmo, Patrizia Bonifazio, and Luca Lazzarini, eds. Bologna: Societa Editrice il Mulino, pp. 17–36.

Bowen, Howard R. 2013 (1953). *Social Responsibilities of the Businessman*. Iowa City: University of Iowa Press.

Brilliant, Eleanor L. 1993. "Theory and Reality in the Vision of Adriano Olivetti." *Voluntas: International Journal of Voluntary and Nonprofit Organizations*, 4, 95–114.

Bulletin, The Museum of Modern Art. 1952. *Olivetti: Design in Industry*. New York: The Museum of Modern Art.

Business Week. 1951. "Highbrows-Bait for Top Busniess Brass." *Business Week.* May 26: 22.

Camoletto, Stefania, and Marco Bellandi. 2019. *A Communitarian Definition of Shared Value Rooted in Local Development Studies and in the Olivettian Experience.* Florence: DISEI, Universit`a degli Studi di Firenze.

Carter, Jim. 2020. *Communities of Labor Adriano Olivetti and the Humanization of Industrial Society (diss).* Ann Arbor: University of Michigan deepblue.lib.umich.edu (Retrieved September 6, 2020).

Castagnoli, Adriana. 2014. "Across Borders and Beyond Boundaries: How the Olivetti Company Became a Multinational." *Business History,* 56(8), 1281–1311. https://www.tandfonline.com/doi/abs/10.1080/00076791.2013.876534 (Retrieved September 5, 2020).

Cohen-Cole, Jamie. 2009. "The Creative American: Cold War Salons, Social Science, and the Cure for Modern Society." *Isis,* 100(2), 219–262. https://doi.org/10.1086/599554 (Retrieved December 12, 2020).

Columbus Area Chamber of Commerce, Inc. 1974. *A Look at Architecture: Columbus Indiana.* Columbus: Visitors Center, Columbus, Indiana.

Cooper Hewitt. n.d. "Explore the Collection." *Cooper Hewitt.* https://collection.cooper-hewitt.org/objects/404536673/ (Retrieved May 13, 2021).

Corning Glass Works Foundation. 1968. *Corning Glass Works Foundation—A Report of 1967 Activities and Summary of 15-Year Program.* Corning: Corning Glass Works Foundation.

Corning Museum of Glass. 1972. *Atlantica.* https://www.cmog.org/artwork/atlantica (Retrieved May 13, 2021).

———. 1979. *New Glass: A Worldwide Survey.* Corning: Corning Museum of Glass. https://www.cmog.org/sites/default/files/collections/31/31937339-E65D-4EE8-9976-296B9289A565.pdf (Retrieved April 2, 2021).

Denny, Reuel, and David Riesman. 1951. *Notes from 'Creating an Industrial Civilization'.* Corning (Raskow Library): unpublished Chareles Henry Sawyer Papers.

Dixon, John Morris. 1971. "More Than Just a Volume." *The Architectural Forum,* 134(3), 20–26.

———. 1973. "Olivetti Builds." *Progressive Architecture,* 8, 50–57.

Domus. 2012. *Adriano Olivetti Tomorrow.* August 27. https://www.domusweb.it/en/photo-essays/2012/08/27/adriano-olivetti-tomorrow.html (Retrieved June 21, 2020).

Doss, Erika. 2002. "The Visual Arts in Post-1945 America." In *A Companion to Post-1945 America. Williston,* by Jean-Christophe Agnew and Roy Rosenzweig, eds., 113–133. Williston: John Wiley & Sons, Incorporated. https://ebookcentral-proquest-com.proxy.libraries.rutgers.edu/lib/rutgers-ebooks/reader.action?docID=214138&ppg=5 (Retrieved December 13, 2020. ProQuest Ebook Central).

Drumright, William W. 2002. "His Search for a Viable Middle Ground: A Reappraisal of David E. Lilienthal's TVA—Democracy on the March." *The Princeton University Library Chronicle* 467–495. http://www.jstor.org/stable/10.25290/prinunivlibrchro.63.3.0467Copy (Retrieved November 27, 2020).

Dyer, Davis, and Daniel Gross. 2001. *The Generations of Corning: The Life and Times of a GLobal Corporation.* New York: Oxford University Press.

Eigen, Edward, and Terence Riley. 1994. "Between the Museum and the Marketplace: Selling Good Design." In *The Museum of Modern Art at Mid-Century: At Home and Abroad, Studies in Modern Art,* by The Museum of Modern Art, 150–175. New York: Harry N. Abrams.

Ekbladh, David. 2010. "Meeting the Challenge from Totalitarianism: The Tennessee Valley Authority as a Global Model for Liberal Development, 1933–1945." *The International*

History Review, 32(1), 47–67. http://www.jstor.org/stable/25703878 (Retrieved December 30, 2020).

Fogarty, Robert S. 2016. "The Future of Museums: Challenges and Solutions." *Antioch Review,* 74(2), 221–226. https://www-jstor-org.proxy.libraries.rutgers.edu/stable/pdf/10.7723/antiochreview.74.2.0221.pdf?ab_segments=0%2Fbasic_search_SYC-5462%2Fcontrol&refreqid=fastly-default%3A98bc26701b1febeeed4315cc5f6162d0 (Retrieved October 12, 2020).

Fox, Stephen. 2019. "Patronage and Modernism." In *Avant-Garde in the Cornfields: Architecture, Landscape, and Preservation in New Harmony,* by Ben Nicholson and Michelangelo Sabatino, eds., 39–63. Minneapolis: University of Minnesota Press.

Franc, Helen M. 1994. "The Early Years of the International Program and Council." In *The Museum of Modern Art at Mid-Century: At Home and Abroad,* by The Museum of Modern Art, 108–149. New York: The Museum of Modern Art.

Frank, Lawrence K. 1952. "Confidence in Life in Industrial Civilization." In *Creating an Industrial Civilization,* by Eugene Staley, ed., 152–198. New York: Harper & Brothers Publishers.

Freeman, R. Edward. 1984. *Strategic Management: A Stakeholder Approach.* Boston: Pitman.

Gayle, Margot, and Michele Cohen. 1988. *Guide to Manhattan's Outdoor Sculpture.* New York: Prentice Hall Press.

Gimeno Martínez, Javier. 2010. "The Signe d'Or Award Scheme from 1956 to 1960: The Economic Reasons for "Good Design"." *Konsthistorisk Tidskrift,* 79(3), 127–145. https://www.tandfonline.com/doi/abs/10.1080/00233609.2010.487570 (Retrieved February 27, 2021).

Good Design. 2021. *About Good Design.* February 13. https://www.good-designawards.com/about.html.

Gualteri, Franca Santi. 2003. *A Trip Through Italain Design: From Stile Industria Magazine to Abitare.* Mantua: Maurizio Corriani.

Jablonski, Mary. 2010. "Cast Pyrex Glass Block: Illuminating Its History and Conservation Issues." *APT Bulletin: The Journal of Preservation Technology,* 41(2–3), 37–45. https://www-jstor-org.proxy.libraries.rutgers.edu/stable/pdf/20749122.pdf?ab_segments=0%2Fbasic_search_SYC-5462%2Fcontrol&refreqid=fastly-default%3A95f2f-6bc0a911a95800fd2979941724f (Retrieved October 12, 2020).

Järvinen, Juha, and Ilpo Koskinen. 2001. *Industrial Design as a Culturally Reflexive Activity in Manufacturing. f.* Helsinki: University of Art and Design Helsinki UIAH. https://core.ac.uk/download/pdf/80710846.pd.

Karaim, Reed. 2016. "Is Columbus's Modernist Legacy at Risk?" *Architect Magazine.* July 26. https://www.architectmagazine.com/design/is-columbuss-modernist-legacy-at-risk_o.

Karim, Farhan Sirajul. 2010. "Modernity Transfers: The MoMA and Postcolonial India." In *Third World Modernism: Architecture, Development and Identity,* by Duanfang Lu, ed., 189–210. London: Taylor & Francis Group (Retrieved March 30, 2021. ProQuest Ebook Central).

Kaufman, Edgar Jr. 1954. *What is Modern Design.* New York: The Museum of Modern Art.

———. 1957–1958. "The Inland Steel Building and Its Art." *Art in America,* 45, 23–27.

Kicherer, Sibylle. 1990. *Olivetti: A Study of the Corporate Management of Design.* New York: Rizzoli.

Kida, Takuya. 2012. "Japanese Crafts and Cultural Exchange with the USA in the 1950S: Soft Power and John D. Rockefeller III during the Cold War." *Journal of Design History,* 25(4), 379–399. http://www.jstor.org/stable/23353 (Retrieved December 30, 2020).

Kidder Smith, G.E. 1955. *Italy Builds.* New York: Reinhold Publishing Corporation.

Kriplen, Nancy. 2019. *J. Irwin Miller, The Shaping of an American Town*. Indianapolis: Indiana University Press.

La Rinascente. 1958. "Rinascente Archives." *FONDAZIONE ADI COLLEZIONE COMPASSO D'ORO*. February 2. https://archives.rinascente.it/en/funds/fondazione_adi_collezione_compasso_doro?item=2570&pdf_viewer=true (Retrieved February 7, 2021).

Lange, Alexandra. 2005. *Tower Typewriter and Trademark: Architects, Designers and the Corporate Utopia, 1956–1964*. Ann Arbor: New York University, ProQuest Dissertations & Theses Global.

Longstreth, Richard. 2010. *The American Department Store Transformed, 1920–1960*. New Haven: Yale University Press.

Lu, Duanfang, ed. 2011. *Third World Modernism: Architecture, Development and Identity*. Milton Park: Taylor & Francis Group ProQuest Ebook Central. http://ebookcentral.proquest.com/lib/rutgers-ebooks/detail.action?docID=667868 (Retrieved March 30, 2021).

Lupton, Ellen, and J. Abbott Miller. 1989. "Line Art: Andy Warhol and the Commercial Art World of the 1950s." In *Success Is a Job in New York: The Early Art and Business of Andy Warhol*, by Donna M. De Salvo, 28–43. New York: Grey Art Gallery and Study Center, New York University.

Macdonald, Dwight. 1952. "The Book-of-the-Millennium Club." *The New Yorker*. November 29. https://www.writing.upenn.edu/~afilreis/50s/macdonald-great-books.html (Retrieved November 1, 2020).

Macekura, Stephen. 2013. "The Point Four Program and U.S. International Development Policy." *Political Science Quarterly*, 128(1), 127–160. http://www.jstor.org/stable/23563372 (Retrieved December 30, 2020).

Marchand, Roland. 1998. *Creating the Corporate Soul: The Rise of Public Relations and Corporate Imagery in American Business*. Berkeley: University of California Press.

McShine, Kynaston. 1989a. *Andy Warhol: A Retrospective*. New York: The Museum of Modern Art.

———. 1989b. "Introduction." In *Andy Warhol: A Retrospective*, by Kynaston McShine, 13–23. New York: The Museum of Modern Art.

Miller, J. Irwin. 1956. *The Responsibilities of Managemet*. Hanover: Dartmouth Alumni Magazine.

Miller, Nancy Ann. 1999. *Eero Saarinen on the Frontier of the Future: Building Corporate Image in the American Suburban Landscape, 1939–1961*. Philadelphia: University of Pennsylvania. https://www-proquest-com.proxy.libraries.rutgers.edu/dissertations-theses/eero-saarinen-on-frontier-future-building/docview/304518187/se-2?accountid=13626 (Retrieved January 4, 2021).

Miller, R. Craig. 1990. *Modern Design in the Metropolitan Museum of Art*. New York: Harry N. Abrams.

Minutillo, Josephine. 2015. "Corning Museum of Glass Contemporary Art + Design Wing." *architecturalrecord.com*. May 16. https://www.architecturalrecord.com/articles/7528-corning-museum-of-glass-contemporary-art-design-wing (Retrieved August 28, 2020).

Museum of Modern Art. 2020. "Musuem of Modern Art." *https://www.moma.org/calendar/exhibitions/2750?* December 5. https://assets.moma.org/documents/moma_master-checklist_332972.pdf?_ga=2.202952401.1701448949.1607179029-710889415.1607179029.

Museum of the City of New York. 2003. *Glass + Glamour: Steuben's Modern Moment, 1930–1960*. New York: Harry N. Abrams, Inc., Publishers.

New York Architecture. 2020. "The Corning Glass Building." *nyc-architecture.com*. October 11. https://www.nyc-architecture.com/MID/MID155.htm (Retrieved October 11, 2020).

Orto, Luisa James. 1995. "Design as Art: "Design" and Italian National Identity (Order No. 9603172)." *ProQuest Dissertations & Theses Global. (304215162).* https://search-proquest-com.proxy.libraries.rutgers.edu/docview/304215162?acc.

Quantrill, Alexandra. 2017. *The Aesthetics of pPrecision: Environmental Management and Technique in the Architecture of Enclosure, 1946–1986.* New York: Coumbia University. https://login.proxy.libraries.rutgers.edu/login?url=?url=https://www-proquest-com.proxy.libraries.rutgers.edu/docview/1993516113?accountid=13626 (Retrieved October 17, 2020).

Reed, Heidi. 2017. "Corporations as Agents of Social Change: A Case Study of Diversity at Cummins Inc." *Business History,* 59(6), 821–843 https://www-tandfonline-com.proxy.libraries.rutgers.edu/doi/pdf/10.1080/00076791.2016.1255196?needAccess=true (Retrieved April 7, 2021).

Renn, Aaaron M. 2019. "The Rust Belt Didn't Have to Happen Columbus, Indiana, Thrived While Other Cities Declined. Why?" *The Atlantic.* https://www.theatlantic.com/ideas/archive/2019/12/the-rust-belt-didnt-have-to-happen/603523/ (Retrieved April 7, 2021).

Robbins, Amy S. 2019. *Experimental Expertise: Glass at the Intersection of Art and Science.* Binghampton: State University of New York, ProQuest Dissertations Publishing, 2019. 13861088 (Retrieved October 12, 2020).

Rogers, M. Reynold. 1950. *Italy at Work: Her Renaissance in Design Today.* Rome: Published for The Compagnia Nazionale Artigiana.

Russo, Marcello. 2013. *Adriano Olivetti (1901–1960) and the Relationship between Work and the Rest of Life.* May 22. http://worklife.wharton.upenn.edu/2013/05/adriano-olivetti-1901-1960-and-the-relationship-between-work-and-the-rest-of-life/.

Schwarz, Jane. 1970. "Olivetti to Become the Museum's First Corporate Benefactor." *The Metropolitan Museum of Art Bulletin* 163–164. https://www-jstor-org.proxy.libraries.rutgers.edu/stable/3258889 (Retrieved August 23, 2020).

Sciarelli, Mario, and Mario Tani. 2015. "Sustainability and Stakeholder Approach in Olivetti from 1943 to 1960: A Lesson from the Past." *Sinergie Italian Journal of Management,* 96, 19–36. https://ojs.sijm.it/index.php/sinergie/article/view/83/149 (Retrieved November 22, 2020).

Scrivano, Paolo. 2013. *Building Transatlantic Italy: Architectural Dialogues with Postwar America.* Surrey: Ashgate.

Sethi, S. P. 1975. "Dimensions of Corporate Social Performance: An Analytical Framework." *California Management Review,* 17(3), 59–64. https://doi.org/10.2307/41162149 (Retrieved November 22, 2020).

Sherer, Daniel. 2012. "BBPR on Fifth Avenue: The Olivetti Showroom in New York City." In *The Experience of Architecture. Ernesto Nathan Rogers 1909–1969; (Proceedings of the Conference at the Milan Polytechnic),* by Chiara Balione, ed., 255–260. Milan: Franco Angeli.

Söderlund, Kalinca Costa. 2019. "Culture War in Brazil with the Opening of the Museum of Modern Art of São Paulo (MAM-SP) and the Official Arrival of Abstraction." In *IX Jornadas de Historia y Cultura de America.* Montevideo: Universidad De Montevideo. https://www.academia.edu/40347515/Culture_War_in_Brazil_with_the_Opening_of_the_Museum_of_Modern_Art_of_S%C3%A3o_Paulo_MAM_SP_and_the_Official_Arrival_of_Abstraction (Retrieved December 2–30, 2020).

Staley, Eugene, ed. 1952. *Creating an Industrial Civilization: A Report on the Corning Conference.* New York: Harper & Brothers Publishers.

SUNY. 2006. "The SUNY Community Colleges: An Oral History of the First 30 Years Corning Community College." *The SUNY Digital Repository.* August 18. https://dspace.sunyconnect.suny.edu/handle/1951/41256 (Retrieved October 27, 2020).

Tafuri, Manfredo. 1990. *History of Italian Architecture, 1944–1985.* Cambridge: MIT Press.

Thayer, Laura, Margaret Storrow, John Kinsella, Louis Joyner and Malcolm Cairns. 1999. *Modernism in Architecture, Landscape Architecture, Design and Art in Bartholomew County, Indiana, 1942–1999, National Historic Landmark Theme Study.* Washington: National Park Service.

TIP Strategies, Inc. 2018. "Economic Development Strategic Plan Corning New York." *cityofcorning.com.* https://www.cityofcorning.com/vertical/sites/%7BBE0E976C-81B9-4F4C-8763-A90E76CF4D33%7D/uploads/2018.11_Corning_Economic_Development_Strategic_Plan-_Final(1).pdf (Retrieved November 3, 2020).

Toschi, Caterina. 2018. *The Olivetti Idiom 1952–1979.* Florence: NYU Florence.

UNESCO. 2001. *UNESCO World Heritage List.* https://whc.unesco.org/en/list/1538/ (Retrieved May 16, 2021).

Walsh, John. 2015. "Designing Work: A Study of Collaboration and Concentration in Open-Plan Offices." *Iterations* 44–49 https://arrow.tudublin.ie/cgi/viewcontent.cgi?article=1005&context=desigpart (Retrieved January 4, 2021).

Walton, Clarence C. 1967. *Corporate Social Responsibilities.* Belmont: Wadsworth Publishing, Inc.

Ward, Susan. 2011. "The Design, Promotion, and Production of Textiles in the USA, 1940–60." In *Knoll Textiles, 1945–2010*, by Earl Martin, ed., 36–73. New Haven: Yale University Press.

Washington Law Review. 1954. "Corporations—Powers—Charitable Contributions, A.P. Smith Manufacturing Co. v. Barlow, 98 A.2d 581 (N.J. 1953), 1954 WASH. U. L. Q. 85 (1954)." *Washington Law Review.* https://openscholarship.wustl.edu/cgi/viewcontent.cgi?referer=https://www.google.com/&httpsredir=1&article=3489&context=law_lawreview (Retrieved October 25, 2020).

Whyte, William H. 1952. *Is Anybody Listening?* New York: Simon and Schuster.

Yale University. 2020. *Cummins Engine Funds Lectureship in Memory of Paul Rand.* June 7. https://news.yale.edu/1997/05/14/cummins-engine-funds-lectureship-memory-paul-rand.

Zetlin, Minda. 2020. "How Irwin Miller, Former CEO of Cummins, Redefined Success and Transformed a Midwestern City." *INC.* February 28. https://www.inc.com/minda-zetlin/irwin-miller-columbus-indiana-cummins-corporation-architecture-im-pei- (Retrieved April 6, 2020).

Chapter 3

Formalizing and Normalizing Business Patronage of the Arts

> Mainly through the impetus provided by our business, we have achieved in the United States a material abundance ... unprecedented in history. Corporations ... must [now] face up to the task of bringing our cultural achievements into balance with our material well-being through more intimate corporate involvement with the arts.
>
> David Rockefeller

As David Vogel has suggested, by the 1960s, corporate philanthropy had become a norm and an implicit responsibility of being a good corporate citizen and by 1964, corporations accounted for about 5% of all private philanthropy while support for the arts increased by 150% between 1965 and 1970. Large companies commonly budgeted a percentage of pretax profits and used a corporate foundation as the vehicle for philanthropy, giving rise to the term "enlightened self-interest" (Vogel, 2005). The beginnings of formal scholarship on corporate social responsibility began to take shape in the 1960s with authors such as Clarence Walton describing the deepening relationship of the corporation to society as a business imperative. Walton offers various "models" of corporate responsibility reflecting a broader mandate for business involvement in society including the arts (Walton, 1967). Philanthropy shifted from a focus on individual donors as more businesses engaged with the arts as part of their strategies around civic responsibility. Business leaders increasingly represented the interests of their stakeholders in patronage practices, and support for the arts experienced a growth trend similar to that of education in the previous two decades.

DOI: 10.4324/9781003099222-4

In his unique chronicle of the evolution of American art museums, Daniel Fox described, among other findings, the role of the patron in bringing high culture to the masses (Fox, 2017). As art institutions evolved in the 1960s, the divisions between high and low art started to dissolve. This shift became especially apparent as arts organizations were increasingly brought into urban renewal and development efforts (Strom, 2002). The government had not yet become a funder of the arts, and as suggested in the quote (above) by David Rockefeller, there was a growing tension between material wealth and supporting culture. There was also an interesting dialogue taking place around the concept of "high culture" in the arts and humanities. As discussed in the previous chapter, these issues had their roots in the 1950s.

One of the voices in this conversation was Edward A. Shils, a professor of sociology at the University of Chicago. His 1964 essay "The High Culture of the Age" was published in a comprehensive volume edited by Robert N. Wilson bridging the social sciences with the arts and humanities (Wilson, 1964). Shils outlined three responsibilities of custodians and practitioners of high culture: to discover or create something of value to human culture; to take care of and reinterpret art and culture; to maintain and extend the influence of high culture to other segments of society (Shils, The High Culture of the Age, 1964). He was concerned that the advent of mass culture and communication posed a threat to the sustainability of what he termed "superior" or "refined" culture (Shils, 1960). Pointing out some of the tensions emerging in the early 1960s, Shils examined the role of institutions like the university in nurturing high culture in the face of rapidly growing consumerism.

The 1960s witnessed several shifts in public attitudes toward the arts. The idea of the arts as part of the social fabric also implied a collective responsibility for supporting the arts. As James Heilbrun and Charles Gray argued, "In the modern era, the making of art has occupied a special position among human activities. Some might rank it as the highest of all callings, above mere commerce" (Heilbrun and Gray, 2001). As corporate support of education expanded, more companies began to fund arts-related activities both locally and nationally. A 1965 Rockefeller Panel Report on the future of theater, dance, and music in the United States revealed an increasing expectation for corporate support of the arts. Arguing that arts are vital to the communities where businesses are located, the authors make the case that "support of the arts is a part of community responsibility" (Rockefeller Brothers Fund, 1965). It was a time when higher education took steps to address the growth of the arts. According to James Abruzzo, "University-based arts management training began in the US in 1966, almost concurrently with the beginning of the modern era of widespread professional arts in the US" (Abruzzo, 2009).

The publication of William Baumol and William Bowen's *Performing Arts: The Economic Dilemma* marked the emerging field of cultural economics (Baumol and Bowen, 1966). Published in 1966 by the Twentieth Century Fund (later renamed the Century Foundation), this research study was one of the first to look at all of the economic aspects of theater, opera, music, and dance. The Twentieth Century Fund is part of the fascinating story of quiet philanthropy by businessman Edward Filene,

who ran William Filene's Sons Co., in Boston, Massachusetts. In 1906, he created the Cooperative League to study economic and industrial issues. While Filene's primary goal was the establishment of credit unions in the United States, he widened the scope and renamed the group the Twentieth Century Fund in 1922. According to its charter, the organization's new purpose was "the improvement of economic, industrial, civic, and educational conditions by means of study, research, publication, and the support of charitable institutions" (New York Public Library, 2020). David Lilienthal, John Kenneth Galbraith, and Arthur Schlesinger Jr. were among the notable individuals serving as trustees. The philanthropic motivations behind the Twentieth Century Fund—much like those of the Aspen Institute—were to create dialogue, research, and cross-fertilization to promote an understanding of the interdependence of business, society, and civic life.

One of the most important contributions of Baumol and Bowen's study was to examine the sources of financial support for arts organizations. The economic study delivered three major outcomes: First, the authors concluded that the perceived "cultural boom" that was suggested to have occurred from the early 1950s to 1960s was overstated. Second, the audience for the performing arts was basically wealthy and highly educated. Third, sustainable funding for the arts was projected to be a challenge. In essence, Baumol and Bowen were among the first to point out the irrational nature of the business model for arts organizations, where income would never cover the costs of operation. The authors looked specifically at the growing trend of (and need for) corporate support for the arts, which was still in its infancy. They also explored how local and national governments played an instrumental role in sustaining the arts in countries such as Austria, Italy, Germany, France, and Great Britain. Ultimately, the study made a case for the increased arts funding by the US government.

Under the leadership of Governor Nelson Rockefeller, New York State signaled the beginning of state support for the arts by creating the New York State Council on the Arts, in 1960. Five years later, the US government established the National Endowments for the Arts (NEA) and the Humanities (NEH). Some of the arguments for government arts subsidies were based on the economic concept of "merit good," whereby society deems something so important it is worth paying for on behalf of the public. In other words, the arts produce benefits for society beyond those for which consumers would pay. James Heilbrun and Charles Gray list these as "the cultural legacy preserved for future generations, the contribution made to a liberal education, and the collective benefits produced by artistic innovation" (Heilbrun and Gray, 2001). As chair of the NEA, Nancy Hanks can be credited with increasing the organization's funding dramatically and applying the resources of the Rockefeller Commission, where she worked early in her career (Sanders, 2005). As a participant in the Baumol and Bowen study, she was well versed in the complexities of public and private support for the arts.

The intangible benefits generated by arts organizations made funding of the arts attractive to many companies, especially those that prioritized cultural responsibility. In general, there was a growing awareness that as American culture matured so

should the arts. As corporations played a larger and larger role in society, it was only natural that companies were called to do more to support education, social services, and the arts. In a nod to the earlier role of museums in promoting good design, Hanks prodded the private sector to embrace "good design" not just as a matter of competitive advantage but also as a more fundamental element of humanity (Hanks, 1975). While the establishment of the NEA complemented the growing trend of business support for the arts, there was a groundswell of advocacy for corporate funding of education and culture.

In 1967, Richard Eells, a business school professor at Columbia University and former executive at General Electric, published *The Corporation and the Arts*, under the aegis of Studies of the Modern Corporation, to elucidate the common ground shared by the arts and business (Eells, 1967). Inspired by his participation in the Rockefeller Panel Report, Eells attempted to move the discussion beyond corporate philanthropic support of the arts. He documented a time in business history when social responsibility was just beginning to be formalized and developed an elaborate argument for business and the arts to join forces for mutual benefit. Exploring the coexistence of altruism and self-interest in corporate giving, he positioned it as "a special use of corporate assets for prudent expenditures that will benefit the payer as well as the payee" (Eells, 1967). The tension around supporting the arts was grounded in the perceived elitism of art and culture in a postwar industrial society focused on advancing science and technology.

Eells revives Shils's idea of the need for corporations to align with "high culture" as an almost patriotic duty, discussing a company's role in enhancing and preserving national excellence in "arts, science, philosophy, literature and scholarship" (Eells, 1967). The author argues that investing in the arts and humanities will create value for society and the corporation similar to the economic progress achieved by investing in basic scientific research. One of his most memorable quotes, "Beauty can help liberate us from our prisons of ugliness," reflects his belief that art can be a way of knowing the truth in both practical and ethical senses. In his conclusion, Eells points to the tension between the sciences and arts, offering yet another argument for business to embrace the latter: "Perhaps the artist can help us to discard the blinders, to see realities where words, logic, and science have failed in getting at the kernel" (Eells, 1967). René Dubos and Lewis Mumford were among those who underscored the necessity to shift focus more on the qualitative and less on the quantitative nature of human existence. At the heart of this increase in interest and support of the arts was a focus on the fundamental humanism at the heart of society.

The Business Committee for the Arts

Seeing the need to normalize and formalize the role of corporate support for the arts, David Rockefeller established the Business Committee for the Arts (BCA) in 1967. The new organization had five goals: (1) to gather and disseminate information on

corporate support of the arts; (2) to provide counseling for business firms seeking to initiate new arts programs or to expand existing ones; (3) to carry on a public information program to keep corporations informed of opportunities for support of the arts; (4) to work to increase the effectiveness of cultural organizations in obtaining support from business; and (5) to increase the personal involvement of business executives with cultural organizations (Koch, 1979). While the BCA aspired to increase arts funding from the private sector, it was not so clear to what end: Would increased support of the arts by business help make culture a right and not a privilege? Would it lessen dependence of the arts on the government? Would business be viewed as a better citizen? It seems that the BCA disregarded Eells's suggestion that the arts community make an argument for business engagement beyond philanthropy. The topic of design was also missing from the BCA agenda.

The shift in corporate social responsibility of the 1960s and 1970s is captured by Frank Koch in *The New Corporate Philanthropy*, a book advocating for an increase in private-sector philanthropy (Koch, 1979). Arts funding saw steady increases throughout the 1970s, most visibly in the sponsorship of museum exhibitions, for which corporations drew praise as well as suspicion, and often resentment from institutional curators (Alexander, 1996). Koch's book makes the case for more corporate engagement with society and provides a practical how-to guide. One of his key conclusions is that the status quo is not sustainable and that business has a role to play in improving society.

To his credit, Koch was among the first to call for a dramatic increase in corporate giving and to argue that business benefits from more generosity. His book presents a patchwork of examples of companies engaging with society, along with evidence of an early shift away from shareholder primacy. According to Koch, "Between 1972 and 1975 the percentage of business cash contribution dollars going to the arts nearly doubled—from 4.1% to 7.5%—making the arts the fastest growing field of corporate philanthropy in recent years" (Koch, 1979). Not surprisingly Koch's book includes a chapter on supporting the arts, chronicles the work of the BCA, and devotes a small section to the Cummins Engine Company.

Leaders like J. Irwin Miller and James R. Houghton were drawn to the BCA and, like so many other CEOs of the time, publicly advocated for the arts. At the BCA annual meeting in 1972, Miller offered an impassioned case for support of the arts framed in humanistic terms, using phrases such as "personal feeling," "expression of our deepest thoughts and needs," and "a new sense of community" (Chagy, The New Patrons of the Arts, 1973). He also described what his generation might leave behind: "a legacy of the spirit and mind, a flourishing of all the arts in our time such as would truly give release to the creative potential within us" (Miller, Business, Society and the Arts, 1972). In a 1977 speech, Miller appeared even more convinced that the arts were key to the future of American democracy. Citing John Donne, King Lear, Aristotle, and Milton Friedman, he advocated for creativity over consumption and business responsibility over shareholder primacy (Miller, Business in the Arts… A New Challenge, 1977). Another CEO, Robert O. Anderson, chairman of the

Atlantic Richfield Company and, for a time, chairman of the Business Committee for the Arts as well as the Aspen Institute of Humanistic Studies, invoked the importance of the humanism promoted by Walter Paepcke:

> During the many years of my association with the Aspen Institute of Humanistic Studies, few things impressed me as much as the fact that the first intimations of tensions in society, the first portents of social change, and the clearest reflection of the human condition are to be found in contemporary works of art.
>
> <div align="right">(Anderson, 1971)</div>

The BCA advocated for more support of the arts on four levels: improving quality of life in communities; promoting academic achievement in the K-12 school population; driving business among customers and employees; and inspiring cultural literacy, diversity, and creative thinking. Looking critically at these areas of engagement, it is clear that two are geared toward bringing value to society and the other two toward returning value to the business. Although difficult to quantify, some research points to the effectiveness of using corporate art collections as a tool for both differentiating the company to stakeholders and engaging employees (R. &.-C. Kottasz, 2008). The surge in collecting coincided with the construction of lavish corporate headquarters and the relocation of many companies from the city to the suburbs.

As part of its strategy, BCA encouraged the growth of regional affiliates to encourage local support of the arts. Although regional expansion was not entirely successful, the BCA prompted important conversations among business and arts leaders throughout the United States, publishing personal testimonials by CEOs from companies scattered throughout North America. In a 1984 speech, Winton Blount, chairman and CEO of Blount Inc., revived a popular convention that art represents freedom: "Art is the innocent carrier of the germ of freedom. It helps to maintain and enrich freedom. And freedom in turn helps art to thrive and prosper" (Blount, 1984). The BCA's most visible program was its annual awards program for outstanding efforts to support the arts. Not surprisingly Corning was honored by the BCA: James R. Houghton, chairman emeritus, was granted a leadership award in 2008, following the company's induction into the BCA 10 Hall of Fame in 2003.

Beyond the awards program, BCA sponsored a series of books and published speeches in the interest of promoting corporate sponsorship of the arts, including Arnold Gingrich's *Business in the Arts: An Answer to Tomorrow* (Gingrich, 1969), followed by *The State of the Arts and Corporate Support*, edited by Gideon Chagy (Chagy, The State of the Arts and Corporate Support, 1971), and *The New Patrons of the Arts*, written by Chagy (Chagy, The New Patrons of the Arts, 1973). It is unclear whether these publications had any impact on increasing business support for the arts. Certainly, they served as public-relations tools for companies already contributing and/or represented in the BCA membership roster. Clearly directed to the business community, these publications made a strong case for corporate

support of the arts. At least one scholar took issue with the premises of the arguments presented by Gingrich, for example: "In any case, making the arts and cultural messages dependent upon corporate standards—understood as either profit or interest—should hardly be the kind of goal destined for, or espoused by, a vigorous society with humanist roots" (Guback, 1970). At the heart of resistance to corporate intervention in the arts is the belief that the arts are a public and not a commercial good. In fact, the motivations for profit-seeking enterprises to engage with the arts were not always clear.

In 1997, the BCA inaugurated an annual David Rockefeller Lecture series to mark the organization's 30th anniversary. In 2002, Alberto Vilar was invited to deliver the Rockefeller lecture, "Business Success as a Platform for Generating Private Philanthropy for the Arts," at the BCA annual Arts Awards event (Vilar, 2002). His remarks mainly covered his own motivations for supporting the arts while admonishing the media for their disparagement of private giving by those achieving success in business. Vilar, President and Founder of Amerindo Investment Advisors Inc., was a very high-profile arts philanthropist who believed in publicizing his philanthropy to inspire others to give. Unfortunately, he was convicted of defrauding his investment clients in 2008 and served ten years in prison.

In 2008, the BCA became a unit of the much larger Americans for the Arts (AFA) and has since become much less visible as a champion of the arts in the private sector. Other than the awards and an occasional research paper, the organization's advocacy role has steadily declined over the past decade. Although the BCA raised awareness of the burgeoning practice of business support for the arts, it is difficult to quantify its effects on increasing donations or new practices. The model of an invitation-only group of CEOs banding together to advocate for an issue has its pros and cons. It represents a symbolic show of corporate leadership solidarity around but is limited in its ability to demonstrate how a company is engaging with the arts on a more practical level. Arguably, this top-down approach is not sustainable if continued support for a cause is up to the whims of changing leadership. Too much power in the hands of a few can also lead to unfair and inequitable decisions and practices. Finally, many business leaders may feel that while high-profile companies like Chase and PepsiCo carry the flag, it is not really necessary for others to follow.

Once affiliated with BCA, the late Eli Broad exemplified the highly philanthropic powerbroker. The CEO-driven, predominantly white male model perpetuates the capitalist patronage model forged by Andrew Carnegie and his contemporaries. The focus on US-based multinational companies also limited BCA's ability to advocate for the arts in an era of globalization. On the occasion of its 30th anniversary, David Rockefeller Jr. delivered a keynote speech highlighting the accomplishments of the BCA (D. J. Rockefeller, 1997). While the speech was mostly unremarkable, Rockefeller posed the following questions: Will the geographical location of customers or employees be what defines a business's community? How will national or global companies balance their impulse toward focused giving with the instinct to be more political and diffuse support of the arts? Unfortunately, these questions were never addressed by BCA leadership.

Outside of the United States, Business/Arts was founded in Canada in 1974 as the Council for Business and the Arts with a mission to "champion business investment in the arts and build strong, lasting partnerships between the arts, business, and government in Canada" (Business/Arts Canada, 2021). In 1976, the Association for Business Sponsorship of the Arts (ABSA) was created to pioneer business sponsorship of the arts in the United Kingdom. Colin Tweedy, its executive director for many years, established ABSA as a successful intermediary between the art world and business and government. The organization later became Art & Business and merged with Business in the Community in 2011. In 1979, ADMICAL was founded in France to promote philanthropy and sponsorships through a network of more than 190 members (ADMICAL, 2020). In the Netherlands, the Stichting Sponsors voor Kunst was launched soon after in 1983, followed by the European Committee for Business Arts and Culture in 1990. Arts South Africa (NPC) was founded in 1997, as a joint initiative of the Department of Arts and Culture and the business sector, to promote the private sector's engagement with art and culture. In 2007, the International Association of Corporate Collections of Contemporary Art was founded to create a community for professional curators of high-profile corporate collections.

Beyond philanthropy, the relationship of design to corporate culture seems to have taken root in the United States after the 1950s, under the influence of European Modernism. The early experiments of the Container Corporation of America, Cummins Engine, Corning Glass, and Adriano Olivetti were precursors to the widespread adoption of progressive design by American corporations. Walter Hoving, Chairman of Tiffany & Co., was an early advocate for a more holistic approach to design, including his recommendation to incorporate instruction in good design principles as part of MBA curriculums. Earlier in his career, as vice president of sales at Montgomery Ward, Hoving championed the company's Bureau of Design and hired designer Anne Swainson. Later, Thomas Watson Jr. publicly evangelized "Good Design Is Good Business," but his public statements reflect a one-sided commitment to design as a means of advancing business interests and profit. Both Hoving and Watson participated in a unique series of lectures sponsored by the Wharton School at the University of Pennsylvania and documented in a 1975 publication (Schutte, 1975). The focus on serving the needs of business may have been inspired by Milton Friedman's 1970 essay "A Friedman Doctrine: The Social Responsibility of Business is to Increase its Profits," arguing for the importance of shareholder primacy (Friedman, 1970). Outside of the United States, The British Council of Industrial Design (established in 1944) led the institutionalization of design standards in Europe, and other countries soon followed. The French Institute of Industrial Design (Institut d'Esthétique Industrielle) was founded in 1951, and the German Design Council (Rat für Formgebung) in 1953.

From its roots in the pioneering efforts of the Hewitt sisters in the late nineteenth century, the Cooper Hewitt has sought to reframe the discussion around industry and design. Now part of the Smithsonian since 1968, the museum evolved into a public institution devoted to design as a human activity. Most important, it expanded the definition of design beyond the traditional framework by embracing

design thinking as an element of environmental sustainability. Forging partnerships with companies like Target and Coach, the Cooper Hewitt engages judiciously with the private sector. Similarly, the Design Museum in London, founded in 1989, has come to be considered the cultural champion of design in the United Kingdom, presenting exhibitions on modern design history and innovations in contemporary practice.

The Corporate Campus

During the 1950s, many US corporations left urban centers to seek green settings for their headquarters. In what has been termed "pastoral capitalism," companies created campus-like facilities in the suburbs (Mozingo, 2011). This corporate flight from cities stands in contrast to Miller's long-term approach in Columbus, Indiana, and Corning Glass's sustained commitment to the city of Corning. The decade also gave birth to the development of shopping malls and business parks, models ultimately exported to Britain (Wetherwell, 2020). In terms of stakeholder engagement, these campus facilities were attractive to potential employees, with physical fitness and access to nature promoted as benefits. As Louise Mozingo noted in her book *Pastoral Capitalism*, "The landscape surround fit neatly into the attempted recontextualization of corporate endeavors to create goodwill across a spectrum of publics" (Mozingo, 2011). In many cases, local communities benefited from the well-appointed new headquarters. The suburban complexes often evoked the romantic notion of traditional university campuses and enhanced the companies' images as stewards of the common good as well as attractive places to work. These new sites also provided a recruiting advantage, often drawing individuals transitioning from university studies to corporate careers.

Not surprisingly, pharmaceutical, chemical, and technology companies were among the first to consider suburban campuses to accommodate a heavy reliance on research facilities. One of the earliest examples is Ciba, a chemical company founded in Switzerland, which moved to Summit, New Jersey, in 1937. The campus included a central building designed with little ornamentation and attributed to architect John Floyd Yewell set in a landscape design with the ambience of a park. The towering tripartite opening of the main building featured the company logo as well as the name CIBA in relief and reminiscent of European Modernism. The use of window walls, soaring glass brick, and Indiana limestone projected an impression that "this group of buildings, because of their dignified architecture and fine landscaping, looks more like a civic center than a manufacturing plant developed by private enterprise" (American Architect and Architecture, 1937). Summit was an interesting choice since it had become a summer resort after the Civil War due to its natural beauty and proximity to New York City.

One of the most celebrated examples of corporate migration was the AT&T Bell Laboratories move in 1942 from Manhattan to Murray Hill, New Jersey, a few

miles away from Ciba in Summit. In a process that began in 1930, company leadership emphasized aesthetics in their facility planning. Designed by Voorhees, Walker, Foley & Smith, the research and development structure was one of the earliest examples of a corporate structure created deliberately to encourage collaboration and idea sharing. At about the same time, General Motors became a pioneer in the suburban campus when it commissioned Eero Saarinen to design a Technical Center outside of Detroit in 1945. This was the first of many corporate commissions for Saarinen and manifested GM's interest in promoting automobile travel. It also marked the beginning of a corporate Modernism featuring well-designed landscapes and amenities for employees, and often for the public.

Another Swiss company, Geigy Chemical Corporation moved their headquarters to Ardsley, New York in 1956 and created a unique art program for the benefit of employees and the community. The company hired Georgine Oeri as a consultant and undertook exhibition programming including a publication *Man and His Images: A Way of Seeing* that published in 1968 and distributed widely internally and externally. As the flyleaf describes, the book was one attempt to bridge the worlds of art and industry, "The human elements that create enduring art are also those which make industry strong and give it meaning: A devotion to an inner desire to create" (Oeri, 1968). Ciba merged with Geigy in 1970 and the new entity, Ciba-Geigy supported local cultural nonprofits and maintained a corporate art collection distributed among their facilities in Ardsley, New York, Greensboro, North Carolina and Summit, New Jersey. The art collection was begun in 1959 and featured works from the New York School as well as a collection of twentieth-century Swiss posters (Howarth, 1990). Ciba-Geigy subsequently became Novartis in 1996 after a merger with Sandoz.

Recognizing that green space was as important as the architecture, firms hired prominent landscape designers to produce park settings for administrative and research facilities. Most notably General Foods moved to White Plains, New York, in 1954, and Bell Labs commissioned Saarinen to build a research facility in Holmdel, New Jersey, in 1957–1962 (now Bell Works) (Figures 3.1 and 3.2). A grander conception of corporate campus design took root in the 1960s and became more explicit in the following decade. For example, in 1963, the Deere Company hired Saarinen to design a new headquarters in Moline, Illinois, and subsequently began to assemble an art collection. The most progressive corporate complexes resembled university campuses and provided green spaces open to the public. This new corporate version of Modernism often included innovative interiors with the latest systems furniture and experimental workstations.

In 1970, PepsiCo raised the bar when it moved to Purchase, New York, and established a public sculpture garden on its park-like corporate campus. In making its facilities accessible to the community, the company created a cultural resource that added value to the local context as well as the business. PepsiCo also commissioned Edward Durrell Stone Jr. to design a complementary landscape on 144-acre site, later hiring landscape architect Russell Page to redesign the grounds, in 1981. In

Figures 3.1 and 3.2 Eero Saarinen, Bell Labs, 1954, Holmdel, New Jersey. Photos courtesy of Eric Petschek

a similar fashion, General Mills established a sculpture park on its 85-acre Minneapolis campus in 1982 (Jacobson, 1993). Many of these projects received tax incentives from local and state governments. Yet in the wake of mergers, acquisitions, and business downturns, some sites have been abandoned and have become a burden on the local tax rolls. Many suburban corporate campuses have become, in the words of Carol Willis, "giant white elephants" (Willis, 1995).

There are plenty of examples of companies choosing to stay in urban centers out of a sense of social and cultural responsibility to their communities. Alcoa Aluminum, for example, remained in Pittsburgh and commissioned a new headquarters building, designed by Harrison & Abramowitz and completed in 1953. The innovative use of aluminum panels for the exterior skin and aluminum details in the interior distinguished the structure from other midcentury buildings (Leslie, 2011). The unique texture created by the aluminum panels was captured by artist and critic Harry Schwalb in an ink drawing from 1961 entitled *Corporate Image* (Book Cover). The headquarters interior featured a consistent design aesthetic courtesy of Knoll, along with a mobile by Alexander Calder and an aluminum sculpture in the lobby by Mary Callery, commissioned in 1953. As Victoria Newhouse suggests, this experimental use of an industrial product throughout the facility is reminiscent of early Modernists such as Bruno Taut (Newhouse, 1989). Alcoa also engaged in arts sponsorship when it acquired a collection of modern works from the collection of George David Thompson, an American investment banker and industrialist based in Pittsburgh.

In a similar vein, Reynolds Metals Company launched a campaign to promote aluminum to the building trade. In 1956, the company published the book *Aluminum in Modern Architecture*, exploring potential uses for the material in modern architecture. The company commissioned Minoru Yamasaki to design a regional sales headquarters in Southfield, a suburb of Detroit, Michigan. Completed in 1959, the building featured a dramatic gold aluminum screen that enveloped a three-story glass rectangular box (Ong Yan, 2017). For its corporate headquarters in suburban Richmond, Virginia, Reynolds hired architect Gordon Bunshaft and landscape designer Charles Gillette. In 1957, the company organized an aluminum sculpture competition, in collaboration with the American Federation of the Arts (AFA), followed by exhibitions featuring the winners.

Prudential Insurance Company of America, founded in 1875 in Newark, New Jersey, has consistently demonstrated a substantial commitment to art and culture in terms of both funding and employee engagement. Prudential has played a prominent role in the urban redevelopment of Newark, notably through its leadership and support—in excess of $12 million—to the New Jersey Performing Arts Center (NJPAC), which has been a catalyst in urban recovery (Americans for the Arts, 2020). Similarly, Johnson & Johnson, founded in 1886 in New Brunswick, New Jersey, has provided unwavering support for art and culture, playing a strategic part in the city's revitalization efforts. A new headquarters complex, designed by Pei Cobb Freed & Partners, was completed in 1983 and featured a park setting realized by landscape

architects Hanna/Olin. Both companies have developed art collections for the benefit of their employees and have supported living artists through their acquisition practices, gaining recognition for cultural responsibility by the BCA 10 award.

Urban-renewal efforts in the 1960s prompted some companies to consider locating their headquarters in city centers. In 1964, the Rohm and Haas Company built its new headquarters in downtown Philadelphia, becoming the "first private-investor urban renewal project in Philadelphia" (Ong Yan, 2020). Like Corning Glass, Alcoa and Reynolds, Rohm and Haas was eager to showcase one of its own products, Plexiglas, in the new facility, designed by Pietro Belluschi in collaboration with local architects George Ewing & Company. Although the company enjoyed robust sales during World War II, its leadership was challenged to open new markets for its innovative alternative to glass, so the company sought the consultation of industrial designers and architects including Henry Dreyfus and Walter Gropius (Ong Yan, 2020). The new headquarters afforded Rohm and Haas the opportunity to showcase its innovative product internally and externally. As part of its agreement with the Philadelphia Redevelopment Authority, the company was required to include art in the headquarters design. Among the many commissions was a series of Plexiglas chandeliers designed by György Kepes. Plexiglas murals were created by Sheryl Tattersfield and Freda Koblick, who deserves more attention as a pioneer in using plastic as a primary material (American Craft Council, 1968). Rohm and Haas was not alone in its efforts to collaborate in urban redevelopment efforts by commissioning innovative facilities design. In 1968, the Armstrong Rubber Company made a bold move when it hired Marcel Breuer to design a headquarters building in New Haven, Connecticut. The building was later occupied by Pirelli and is now slated to become a hotel.

International Business Machines (IBM)

Thomas Watson Jr., chairman of IBM's executive committee, famously confessed to an almost mystical experience on encountering the Olivetti retail store on Fifth Avenue, in New York (Schutte, 1975). Later, he recounted a visit with Adriano Olivetti in Italy that inspired him even more. An IBM colleague in Holland also pointed out Olivetti's progressive and integrative approach to design, suggesting that IBM was lagging. According to Watson, these events inspired a whole movement within the company to commission major Modernist architects to design "about 150 plants, laboratories, and office buildings" between 1956 and 1971 (Schutte, 1975). Whether IBM was feeling pressure from Olivetti's success or simply emulating the company, its leadership embraced a similar program of integrated design. The following, from a 1957 piece in *Architectural Forum*, illustrates the company's self-conscious approach:

> Like other big US corporations, International Business Machines is careful how it acts in public. During the past year it has become more

conscious of how it looks, too. Evidence is beginning to appear in many different ways: in a growing number of smart new IBM factories, training schools, laboratories and showrooms, in brightly colored electric typewriters coming off the assembly line, in boldly lettered packaging, trademark and displays—all part of a gradual, unpublicized program to make the company's appearance as advanced as the nature of its electronic machines and its ideas of business and cultural leadership.

It is interesting to see the phrase "how it acts in public" and the use of design and culture to portray a company. Also of note is the phrase "cultural leadership." Watson clearly saw design as a competitive advantage, embracing a holistic vision that went beyond the bottom line as part of a philosophy that integrated all elements of the corporate identity. He was also known for redesigning IBM's management from a pyramidal hierarchy to a more horizontal structure. This integration through all areas of the corporation evolved into what is now known as "design thinking." Eliot Noyes, an architect, industrial designer, and "curator of corporate character," was a key contributor to IBM's efforts to define a style that reflected its innovations in information technology (Harwood, *The White Room: Eliot Noyes and the Logic of the Information Age Interior*, 2003). As a consultant he helped Watson reinvigorate the corporate brand and identity: "IBM was not simply a maker of business machines, Noyes reasoned in an interview in 1966; rather, it was in the business of controlling, organizing, and redistributing information in space" (Harwood, 2011). Information technology was an emerging sector in global business, and Noyes saw an opportunity to define IBM's role in this new territory. For both Watson and Noyes, communication was design and design was communication:

> Viewed as a technique of communication, design was to be one of what Watson called "parallel communication paths." It was to be integrated into the dynamics of management so thoroughly that it could literally be considered a defining characteristic: management, as a process of communication, was to be inseparable from its environment.
>
> (Harwood, *The White Room: Eliot Noyes and the Logic of the Information Age Interior*, 2003)

There is no question that IBM was masterful in crafting its identity as a successful business in a new sector. What is at issue is the sustainability around the company's commitment to good design and creating goodwill. There is evidence that in the early 1960s IBM shifted its approach to commissioning new buildings and working directly with architects. In 1966, John Morris Dixon wrote, "The lesson of the IBM story to date seems to be this: IBM turned to the architects not so much for quality or efficiency but for an *image*. Image-making is a seductive job for the architect" (Dixon, 1966).

This was not IBM's first foray into the art and design world. Thomas Watson Sr. had commissioned a series of paintings from artists in all of the countries where

IBM did business. These works were exhibited in 1939 as part of IBM's presence at the New York World's Fair and the Golden Gate International Exposition, in San Francisco. However, the catalog for the San Francisco pavilion reveals a collection of unremarkable works by mostly middle-aged males, presenting the image of a multinational business with a conservative view of art. What was laudable, as Michele Bogart pointed out, was the fact that the works of art in the IBM collection were not to be used for advertising (Bogart, 1995).

The company established its Gallery of Science and Art in 1983, but closed it in 1994, two years after it reported a loss of $5 billion. The gallery was a pioneering effort that inspired a reexamination of the whole concept of what a museum is or should be. The company had celebrated "50 Years of Collecting Art: Art at IBM" with an exhibition and modest brochure stating that the continued acquisition of art for its new facilities was an ongoing practice underscoring its commitment to art and architecture (IBM Corporation, 1989). The IBM art collection was sold at auction in 1995.

IBM is an example of a case where a company's commitment to art and culture is not embedded in its core values and is subject to the whims of leadership and changing business climates. The company's interest in progressive architecture, art, and design appears to be grounded more in corporate brand building than in developing a sustainable relationship with the arts. The lack of humanism contrasts IBM's vision with that of Olivetti. It is difficult to determine the impact of IBM's approach to design on global businesses, employees, and local communities. It is also not clear how much good design contributed to good will for the corporation. Although both IBM and Olivetti have left a legacy of world-class buildings, they have left the fate of many of these monuments to the preservation community. For example, an iconic Vladimir Ossipoff building commissioned for IBM in 1962 recently faced demolition in Honolulu until the community organized opposition. Although altered, the building survived.

Noyes went on to develop design practices and projects for other major corporations, including a couple of projects for Cummins Engine. Most notably, he designed Southside Elementary School (formerly Southside Junior High) as part of J. Irwin Miller's engagement with Columbus, Indiana. While Adriano Olivetti was deeply involved with architects and designers, Watson entrusted Noyes to engage with some of the leading architects and designers in the world. As an outside consultant Noyes was able to provide objective and bold recommendations. Much like Herbert Bayer, he appears to have been among a small group of design experts who influenced many corporations in their embrace of Modernism and design thinking in the mid-twentieth century. Noyes was also involved with Westinghouse and accompanied Donald Burnham, who served as CEO from 1963 to 1968, on a visit to Olivetti in Italy. The trip convinced Burnham that a better-designed Westinghouse would be a more successful business (Heidekat, 2015). The company later appointed Richard Huppertz as an in-house executive to implement Burnham's vision, working with Paul Rand and establishing a design center at the headquarters.

As design consultant to Cummins Engine for 35 years, Rand was a key figure in the evolution of corporate design and brand building, notably his redesign of the IBM logo and corporate identity program for Westinghouse. In 1960, Rand and his wife, Ann, published an essay in a special edition of *Daedalus* that provided an interesting glimpse into the tension inherent in artists serving corporations:

> It is unfortunately rare that the commercial artist and his employer, be it industry or advertising agency, work together in an atmosphere of mutual understanding and cooperation. Against the outstanding achievements in design made possible by such companies as Olivetti, Container Corporation, IBM, CBS, El Producto Cigar Company, CIBA, and a comparatively few others, there stands the great dismal mountain of average work.
>
> <div align="right">(Rand and Rand, 1960)</div>

Corporate Identity

By the 1950s, the emerging field of corporate-identity management was reaching maturity, as exemplified in William Golden's design of the CBS eye. Golden worked under Mehemed Fehmy Agha at Condé Nast, where he was exposed to elements of European Modernism. The work of pioneers such as Lester Beall and Chermayeff & Geismar Associates (founded in 1957) became synonymous with progressive corporate-identity design. Alan Parkin and F.H.K Henrion were among the first to systematically explore the connection between design coordination within a company and its relationship to corporate image. Their 1967 publication, *Design Coordination and Corporate Image*, featured more than 20 examples of companies around the globe where design was integrated and managed at a senior level as a priority. Not surprisingly, IBM and Olivetti were among the companies singled out for good design practice. This was a critical time when design was taking on a more prominent role in the public-facing corporation. Beyond product design, the overall image and identity of a company became a boardroom topic. The intangible quality of the corporate image took on even greater importance as companies increasingly opened international offices. It was clearly on the minds of the organizers of the first International Design Conference in Aspen, reflecting the evolution of industrial design as a new discipline.

Wally Olins spent his career examining corporate identity, and his 1978 book *Corporate Personality: An Inquiry into the Nature of Corporate Identity* was one of the first to explore this facet of commerce, followed by *Corporate Identity: Making Strategy Visible through Design* in 1989 (J. M. Balmer, 2015). Companies were exploring new ways to enhance and protect their institutional images and brands. Corporate brand identity emerged as a subject of great interest while scholars continued to define product brand management as distinct from corporate brand management.

According to John Balmer and Edmund Gray, "A corporate brand can provide a sustainable competitive advantage to a company if it is characterized by value, rarity, durability, inappropriability, imperfect imitability, and imperfect substitutability" (Balmer and Gray, 2003). In other words, "Branding is a strategy aiming beyond the product. It aims at corporate transcendence" (Pelzer, 2006).

For some companies, a commitment to thoughtful design and cultural responsibility provided a means to differentiate the corporation among a diverse group of stakeholders. Already known as a socially responsible company, Pirelli took the major step of commissioning Gio Ponti to design Milan's first skyscraper, competed in 1958. The Pirelli Tower became an iconic Modernist symbol of the company's progressive approach. Recognizing the virtues of good design was one avenue to demonstrating cultural responsibility; promoting art and culture through museums and theaters could also enhance the corporate brand. Overall, business leaders were looking to align their identities with stakeholder expectations by staying relevant and creating value while creating a unique identity.

Corporate Art Collections

It is difficult it identify when the first corporate art collection was formed, although the Banca Monte dei Paschi, in Siena, Italy, started in the fifteenth century, is often cited. In the United States, in 1903, the Atchison, Topeka & Santa Fe Railway Company began collecting art to use in advertising and the promotion of rail travel. Artists would produce works in exchange for free travel. Although more opportunistic than culturally responsible, this patronage program supported the growth of the art colony in Taos, New Mexico, for more than 75 years. As Keith Bryant surmised, "Not a partnership, perhaps, but a cooperation which supported the needs of both the corporation and the residents of the colonies. As a result, the railway has acquired one of the nation's finest collections of western American art" (Bryant, 1978).

Early efforts such as IBM's art showcase exemplified the experimental relationship between art and commerce preceding World War II. It was argued that multiple stakeholders could benefit from these collections, including artists, employees, and community members. Additionally, an art collection connoted good taste and sophistication. As early as 1942, Downtown Gallery director Edith Halpert saw the potential of cultivating corporations as collectors of art. In 1950 and 1953, she organized exhibitions targeted to business leaders. The exhibition *Art in the Office* featured works by Georgia O'Keeffe, Jacob Lawrence, and Stuart Davis (Shaykin, 2019). In a collaboration with Dunbar Furniture Company, Halpert created installations that reflected business interiors. Dunbar was a popular contributor to the "Good Design" exhibition series, in partnership with Chicago's Merchandise Mart, from 1950 to 1955. Dunbar designer William Wormley was part of the selection team for the "Good Design" installation in January 1954. In a short review in the *New York Times*, Aline B. Louchheim noted that corporations rationalized collecting

art as a business decision since the cost could be amortized over a ten-year period or, if used in marketing or advertising, deducted as a business expense (Louchheim, 1953). Since the artists associated with the Downtown Gallery were seen as avant-garde, the companies acquiring their works could be perceived as progressive.

In 1948, Blanchette Rockefeller and the Junior Council of the Museum of Modern Art began to develop an art-lending library that would allow the public to rent works selected from the museum collection. It became the Art Lending Service (ALS) in 1951 (Museum of Modern Art Archives, 2020). To professionalize the growing practice of corporate art collecting, the MoMA, with David Rockefeller as chairman of the board, established the Art Advisory Service (AAS) in 1964. Keeping pace with the growth in corporate collecting, the AAS advised a number of companies on collecting art in the 1970s and 1980s. While art lending was common practice for major museums, MoMA went further in helping companies and developers with complex programming and commissions. Sandra Lang spent a good part of her career at the AAS and has shared the tensions of working for a commercial venture within the walls of a major museum in an oral history interview (Lang, 1999). Lang recounts the details of advising companies such as Johnson & Johnson, American Electric Power, and CIGNA Corporation while cultivating financial support and patrons for MoMA. Amy Baker Sandback, an art professional with ties to the publishing industry, joined Lang in the late 1970s. The lending service shut down in 1982, and the AAS was discontinued in 1996.

Corporate art collecting gained momentum in the 1960s, becoming a common practice by the 1980s, and by 1990 there were at least 1,170 companies with some sort of collection (Howarth, 1990). Some collections were displayed to the public; a few corporations incorporated museum-quality spaces into their headquarters and hosted changing exhibitions. This trend coincided with increased attention to corporate identity and the moving of headquarters to suburban sites, in cases such as AT&T Bell, General Foods, and PepsiCo. Many companies collected the work of living artists, which promoted the perception that they were supporting the community. Initiated in 1983, the *International Directory of Corporate Art Collections* is one of the only efforts to document company holdings. According to the 1990 edition, approximately 80% of corporate collections were found in the United States. In 1986, *ARTnews* debuted a monthly chronicle of corporate art acquisitions and related news (United States Patent and Trademark Office, 1986). As corporate collections grew, the ranks of art advisors also increased throughout the 1980s and 1990s. The need for professional standardization led to the establishment of the Association of Professional Art Advisors in 1980; it joined forces with the National Association of Corporate Art Management in 2002.

There was no significant scholarship on corporate collecting until 1990, with the publication of *Corporate Art*, by Rosanne Martorella (Martorella, 1990). The author, a sociologist, analyzed 234 US art collections published in the *ARTnews International Directory of Corporate Art Collections* and interviewed corporate leaders, curators, artists, and consultants about rationales for collecting art and how it reflects a

company's identity. Martorella's research determined that corporations collected art for three reasons: "public relations and image-making; as a benefit for employees; and as a capital asset with a real potential for increased value" (Martorella, 1990). While these findings may be accurate, they fail to take into consideration broader efforts by companies to engage with stakeholders, build a design identity, support living artists, and enrich communities. Martorella also attempted to determine the impact of corporate collecting on the art market and regional art production but came to no significant conclusions. She presented a limited view of corporate collecting that left little room for the unique motivations behind each corporate collection. In essence, Martorella failed to interpret this practice as part an overall trend for companies to engage with multiple stakeholders as a means of demonstrating cultural responsibility.

Throughout history, banks and financial services companies have led the way in building corporate collections and practicing arts patronage. As high-profile symbols of safety and security, banks are a ubiquitous presence in communities large and small. Along with Banca Monte dei Paschi, an early example is the Banco de España, which began its collection in the late fifteenth century and continues to collect today. Some of the Art Deco banks in New York City's financial district featured lavish lobbies and public spaces with sculpture and murals. Hildreth Meiere and Kimon Nicolaides created the monumental mural *The Pursuit of Wealth*, depicting an allegory of wealth in the service of beauty, in the lobby of the Irving Trust Company, at One Wall Street (1929–1931). The frieze (now lost) is an admonition to bankers that "their workday pursuit of money bears meaning only if transfigured into beauty" (Abramson, 2001). The work was reminiscent of the south facade of the Grand Central Terminal, where a monumental limestone sculptural group entitled *The Glory of Commerce* celebrated both travel and commerce. Dedicated in 1914 and created by Jules-Felix Coutan, the artwork celebrates the intellectual and physical nature of business in the context of a public building.

Banks and Corporate Collecting

As stakeholder capitalism emerged, financial institutions focused their CSR practices increasingly on communities to appear more in synch with modern society. Banks aspired to be more customer-friendly, transparent, and current. For example, in 1953, the Manufacturers Trust Company commissioned Gordon Bunshaft, of Skidmore, Owings & Merrill, to design a new branch in Midtown Manhattan. The International Style design comprised a bank vault that was visible to the public and gained notoriety. A monumental metal screen dominated the interior, along with a cloud sculpture suspended above the escalators, designed by Harry Bertoia (*The New York Times*, 2012).

One of the high-water marks of corporate art collecting was the formation of the Chase Manhattan collection in 1959, under the leadership of David Rockefeller

Jr. While many banks commissioned well-known architects to design buildings throughout the twentieth century, Chase was one of the first to integrate museum-quality art into its headquarters, a Modernist skyscraper by Skidmore, Owings & Merrill that triggered an economic revival of Lower Manhattan (Bzdak, 2007). Rockefeller led the way in making it acceptable for companies to showcase art collections at corporate campuses. The Museum of Modern Art supported the bank's efforts through curator Dorothy Miller, who played a leadership role in amassing the collection. As architect for the project, Bunshaft had advocated for the art collection and the major sculptural commissions in the public plaza (Adams, 2019). In 1999, the bank celebrated the 40th anniversary of the collection, comprised of more than 20,000 objects housed in more than 350 locations worldwide, by publishing a coffee-table book (Harrison, 1999). Through its selection of an architect and creation of a world-class art collection, Chase was a corporate pioneer in the effort to be culturally responsible.

A recent monograph by Nicholas Adams shines light on Bunshaft's role in developing a distinctive style of corporate Modernism where all aspects of the building were considered. In commissions such as Lever House, Chase Manhattan, and the Connecticut General Headquarters, Bunshaft and SOM helped to define a new architectural vocabulary that reflected an interest in good design, efficiency, and art and culture. Bunshaft played a critical role in proposing dramatic public art by leading artists such as Isamu Noguchi and Jean Dubuffet to complement his designs. Today One Chase Manhattan Plaza, now known as 28 Liberty, remains an aesthetic asset to the residents of Lower Manhattan with a publicly accessible park and a Dubuffet sculpture.

There are really two categories of corporate art acquisitions—those meant to be enjoyed by employees and those meant for public display. As Amanda Douberly explains,

> While art inside the office helped shape a total environment that became a backdrop for everyday business activities, lobby sculptures were focal points freighted with meaning about the patron company. They became an overt symbol of the corporation, much like a logo or trademark.
> (Douberley, 2015)

Public sculpture, as well as landscapes, developed by companies often became community or neighborhood assets. In cases where corporate facilities have been sold or absorbed as part of a merger or acquisition, the fate of the art is uncertain. As bank mergers became more common, new questions arose in terms of how companies could affect real estate values, the art market, or the careers of individual artists. Maintaining these buildings and collections could prove problematic for companies facing business challenges, including mergers and acquisitions. Along with the rise of consolidations and alternative workplaces, the impetus to form formal corporate art collections has waned in the last three decades.

Other notable art-savvy financial institutions included Chemical Bank and Citigroup. Formed in 1981, Chemical Bank's art collection comprised more than 1,700 works by contemporary American artists. The bank also established an education program and a public gallery as part of its art program. Its collection was absorbed by Chase Manhattan as a result of a merger in 1995. Publications issued by Chemical Bank characterized its art program as grounded in community and corporate responsibility (Alphi, 1985). Citigroup forged its own identity in the marriage of art, commerce, and banking. As early as 1945, the bank engaged 20 artists and illustrators to create more than 130 works of art to be used in promotional campaigns. The series, including works by Charles Sheeler and Thomas Hart Benton, highlighted the geographies where the bank was present, and accompanying texts connected the subjects to some aspect of the economy. These works formed the nucleus of a collection that grew to more than 15,000 pieces housed in offices throughout the world. The bank also explored more business-related ventures that integrated art with commerce: Jeffrey Deitch spent nine years at Citibank, from 1979 to 1988, creating an art-advisory consultancy as well as an art-lending service. Since then he has become one of the most successful art dealers in the world (Sussman, 2017).

Less known are the buildings commissioned by Howard Ahmanson, president of the California-based Home Savings and Loan. From 1953 to 1991, the bank commissioned Millard Sheets to design a series of buildings that were distinctive for the integration of mosaics, murals, stained glass, and figurative sculpture meant for public consumption. The design of these banks proved a competitive advantage since, according to Adam Arenson, the aesthetic appeal became a driver of business (Arenson, 2019). Sheets and his patron, Ahmanson, were strong advocates for artists engaging with business. It is no surprise that Millard Sheets was a participant in the Corning Conference in 1951.

The First Bank System, headquartered in Minneapolis, represents one of the low points for corporate patronage and collecting. The bank began assembling its collection in 1981 with the self-conscious mission of disrupting traditional notions of corporate art collections, acquiring art that was provocative and sometimes confrontational, under the direction of its CEO. According to Martorella, the collection "is one of the most provocative assemblages of international art among corporate collectors" (Martorella, 1990). First Bank embraced the controversy surrounding many of its acquisitions by allowing employees to banish their most despised works to what was called "Controversy Corridor." In many ways, the First Bank example underscores some of the dangers in the marriage of art and commerce. The corporation treated art as a commodity and image-building tactic with little regard for customers or employees. After losing $300 million in the bond market in 1988, the bank sold off work from the collection (Robinson, 1990). In 2008, a similar low point was experienced when the Lehman Brothers bankruptcy led to the auctioning off of its art collection.

Deutsche Bank is another top-tier corporate collector and supporter of the arts. The company's efforts extend to organizing major exhibitions of works from its

collection as well as sponsorship and publication of an art magazine (Deutsche Bank, 2020). A recent study suggests "that the art collection is 'currently underutilized as a marketing platform,' has received worldwide critical acclaim, is an excellent 'soft tool' to complement mainstream marketing activities, and constitutes 'a powerful differentiator' that needs to be fully leveraged" (R. B.-C. Kottasz, 2007). Although it was conducted with a small sample size of internal stakeholders, this study is one of few attempts to measure the value of a corporate art collection. However, Deutsche Bank is also feeling the effects of the economic crisis and, although still one of the largest in the world, the collection has decreased from 59,000 to 55,000 works (Hickley, 2020). Between 2006 and 2010 Drambuie Liqueur Company, Deloitte, and Lehman Brothers all liquidated their collections through auctions (Chong, 2010).

Toronto-Dominion Bank, now TD Bank, was created in 1955 when the Bank of Toronto and the Dominion Bank merged, and it formally began an art collection in 1965. Today, the collection holds 6,000 artworks with a focus on Indigenous art and living artists. The institution's approach, although not unusual, is to align its collection with broader CSR efforts and focus on "sharing artists' stories widely and connecting communities through artworks" (Selvin, 2020). Starting its collection late in the game, TD Bank has been able to carve a socially responsible niche with a singular focus on Indigenous culture and heritage. Bank of America has distinguished itself similarly by lending artworks to nonprofit organizations. Through the program Art in Our Communities, the bank has loaned works for more than 100 exhibitions to not-for-profit institutions (Tarmy, 2020). Wells Fargo boasts a collection of 10,000 artworks as a result of its acquisition of Wachovia in 2008. The bank long had a policy of loaning art and established a formal program in 1991.

Arguably corporations like Chase and CitiGroup sustained their reputations as revered art patrons by successfully integrating their art collections into broader community responsibility efforts and within their own company cultures. FirstBank and Lehman Brothers, on the other hand, neglected to engage successfully with key stakeholders and failed to build their cultural practices into their company cultures. The 2008 banking crisis greatly eroded trust in the financial sector and provided an opportunity for banks to reaffirm their commitment to cultural responsibility, making it a logical time to deemphasize ownership of art and refocus on supporting arts organizations and artists.

In the 1960s, two major collections were initiated by banks in Chicago, home to more than 30 corporate collections by the 1980s. The LaSalle Bank Photography Collection was established in the company headquarters building in 1967. Beaumont and Nancy Newhall were early advisors to the collection, which focused on photographs of Chicago and photographers born or living in the city. The bank published three elegant books that featured works from the collection. The First National Bank of Chicago began collecting in 1968, and Katherine Kuh served as curator until the early 1970s. The eclectic collection included paintings, drawings, prints, sculpture, tapestries, and photographs from prehistory to the present:

pre-Columbian clay sculptures to Roman marble busts, New Guinea
and African masks, 17th-century still lifes, 19th-century trompe l'oeil
paintings and landscapes, rare portraits by Gilbert Stuart and Thomas
Lawrence, and works both by modern masters such as Calder, Noguchi,
Miró, Arp, and Picasso and less celebrated 20th-century artists.

(Robertson, 1977)

A third Chicago collection, that of Refco, also made headlines when the firm faced
bankruptcy and sold off the collection. The Refco Collection of contemporary art
was established in 1975 and redesigned in1998 to focus solely on photography.
The adventurous collection was documented in a lavish 2003 catalog with essays by
prominent critics, curators, writers, and academics (Refco, 2003).

Many major banks have dedicated the practice of managing art specifically as
part of their wealth-management client offerings. This service gives banks the incen-
tive to interact with the cultural elite in their markets. Citi Private Bank, for exam-
ple, founded its art advisory group in 1979 to counsel clients in buying and selling
art as well as managing a collection (Citi, 2020). These advisory roles seem perfectly
natural for institutions catering to the wealthy and culturally literate, and their col-
lections created a favorable image to potential clients seeking advice on buying or
selling art.

Outside of the United States, there is increasing scholarly interest in the his-
tory of corporate collections. A 2010 study of Belgian banks reveals a deep interest
in collecting for many decades. Morgane Lindenberg and Kim Oosterlinck looked
at ten bank collections and identified five motivations for collecting: well-being,
education, brand image, corporate philanthropy, and investment (Lindenberg and
Oosterlinck, 2010). In further analysis, the researchers looked at three drivers of
corporate collections: the passion of an individual leader; cultural responsibility to
support national art production; and social responsibility to support the work of
living artists. This type of study is invaluable, especially in the case of Belgium, a
country with a very rich history in banking and commerce. Less known are collec-
tions initiated by banks outside of Europe and the United States, such as Fukuoka
Sogo Bank, which commissioned Arata Isozaki to design a headquarters building in
1972 incorporating an art collection. The Standard Bank, in Johannesburg, owns
one of the oldest corporate art collections in South Africa. Begun in 1938, the col-
lection includes more than 1,000 works by mostly South African artists. The bank
is also known as a leader in preserving national cultural heritage and art through
public-private partnerships.

For some companies, art collecting became a part of an overall corporate identity.
Following a framework created for corporate-identity management, scholars from
London Metropolitan University surveyed 181 companies to determine if their col-
lections reflected the identity, culture, and values of the company. They looked at the
component elements of behavior, communication, and symbolism (Kottasz et al.,
2008). Their findings reveal deeper motivations for the surge in collecting at a time

when image and identity were being discussed in regard to corporate reputation. For companies, especially banks, the arts provided an opportunity to build brand identity and credibility through collecting, sponsoring, and advising. In 1996, NYU professor Charles Fombrun published the book *Reputation: Realizing Value from the Corporate Image* and later cofounded the Reputation Institute, where a company can gain insights on stakeholder perceptions and sentiments (Fombrun, 1996). In 1999, the organization developed the Reputation Quotient (RQ), which evaluated organizations in six dimensions: emotional appeal, products and services, financial performance, vision and leadership, workplace environment, and social and environmental responsibility (Sever, 2020). For some, collecting art and/or sponsoring cultural events could contribute to a company's emotional appeal, promote well-being and social responsibility in the workplace, and drive positive sentiment among key stakeholders.

Corporate Collections as Public Assets

Major museums, especially those with corporate patrons, began to recognize the growing number of corporate art collections. In 1960, the Whitney Museum of American Art organized the exhibition *Business Buys Art*, followed by the show *Business and the Arts* organized by the San Francisco Museum of Modern Art in 1961. The Montgomery Museum of Fine Arts, in Montgomery, Alabama, organized an ambitious exhibition in 1979 entitled *Art Inc.: American Paintings from Corporate Collections*. The show was accompanied by a lavish catalog that included a brief history of corporate collecting and cited leaders such as Gideon Chagy and J. Irwin Miller. Thirty corporate collections were represented with three works from each. There are no real surprises among the works selected, ranging from the Hudson River School to pop art, with very few female artists represented. The focus on American art is puzzling since more progressive companies promoted international Modernism in the interest of developing a more global brand identity. The catalog presents a conservative group of paintings, conveying the impression that companies were assembling museum-quality collections to compete with regional museums such as the Montgomery Museum of Fine Arts. Not surprisingly, the corporate director behind this project was Winton Blount, president of Blount Inc., an Alabama development company. He was also one of the key leaders behind the Business Committee for the Arts, which later established an affiliate in Alabama. This effort by a relatively small museum in the southern United States was spearheaded by a division of the institution known as Art Inc., aspiring to "play a significant role in encouraging the continued growth and quality of the interaction between business and the visual arts." Here again, a public museum is validating the corporate practice of acquiring art.

In the post-pandemic world, the concept of the workplace has changed. While the practice of corporate art collecting continues to diminish, there is the question

of the disposition of existing collections. Since there is no official requirement for reporting cultural resources, companies are not likely to communicate the status of their art collections. However, it is possible to monitor auction activity to identify sellers. When UBS sold pieces from its collection at Sotheby's in 2011, some of the works had been shown in the MoMA exhibition *Contemporary Voices: Works from the UBS Art Collection* (2005) (Rosenbaum, 2011). Although the thrust of the exhibition was a gift of 44 works of contemporary art to the museum, it included an additional 30 works from the bank's corporate art collection (Temkin, 2005). This is an example of how museums can play a role in validating and, in some cases, enhancing the value of art that ultimately ends up on the market. It also exemplifies the questionable nature of corporate involvement in the museum world since Donald Marron, former CEO of UBS, served as a trustee of MoMA from 1975 to 2005. Similarly, Leonard Lauder was a trustee of the Whitney Museum of American Art for more than three decades, from 1977 to 2011. UBS continues to be a leader in corporate art world with an actively growing collection of 30,000 works to date.

In one of the more complicated transactions involving a private collection and a museum, the Metropolitan Museum of Art's acquisition of the Gilman Paper Company collection of photographs in 2005 is a notable example of a corporation dramatically enhancing the holdings of one of the world's largest museums. The collection of 8,500 photographs had an estimated value of $100 million, and the acquisition was an undisclosed combination of purchase and donation. The most remarkable aspects of the transaction were the long time frame involved in resolving the gift and the fact that the Met's curatorial staff was instrumental in assembling the collection in the first place:

> During the 1990s, Howard Gilman and his curator Pierre Apraxine had worked in unison with Maria Morris Hambourg, then curator in charge of the Metropolitan's Department of Photographs, to shape the Gilman Paper Company Collection as a perfect complement to that of the Museum.
>
> (PhotoCentral, 2005)

Making collections and exhibitions available to the public is another way companies have acted in a culturally responsive way. The S.C. Johnson Company assembled art from its collection as part of two traveling exhibitions: *Art: USA: Now* (1962) and *OBJECTS: USA* (1969). S.C. Johnson was known for its Frank Lloyd Wright headquarters building, in Racine, Wisconsin, and a commitment to community and cultural responsibility. In 2017, the company organized the exhibition *At Home with Frank Lloyd Wright* to mark the 150th anniversary of the architect's birth. Some companies have also shared their collections with university art galleries.

There are examples of culturally responsible companies that have used their collections to serve the greater public. In 1984, McCrory Corporation gave 249 works of abstract art to the Museum of Modern Art, along with a $1.75 million gift to the

museum's capital campaign (Tully, 2020). In 1998, Neutrogena and its former CEO Lloyd Cotsen donated more than 3,000 textiles and objects to the International Museum of Folk Art, in Santa Fe, New Mexico, housed in a wing named after the company (Collector's Guide, 2020). The same year, Sara Lee Corporation donated its corporate art collection to "twenty-five major art institutions in the United States of America and to fifteen art galleries abroad" (The National Gallery of Australia, 2020). This grand gesture is far better than having works from a corporate art collection auctioned off. In 2003, the Seagram Company photography collection, initiated by Phyllis Lambert in 1972, was auctioned after France's Vivendi bought the company from the Bronfman family. In 1975, Anheuser-Busch commissioned a series of 30 works by 23 African-American artists entitled "The Great Kings and Queens of Africa." Valued at more than $1 million, the collection was donated to the United Negro College Fund (UNCF) in 2012 and distributed to six of its member colleges and universities (Businesswire, 2021). In 2009, Deere & Company formed a partnership with the Figge Art Museum, in Davenport, Iowa, to exhibit art from its collection, an act of cultural responsibility that could serve as a model for other companies to share their assets with the public (Figge Art Museum, 2010).

In the case of Gencor Limited, a South African mining corporation, the creation of an art collection was handled as an act of social responsibility. With senior leader support, Gencor assembled a team of curators and advisors to develop a collection that reflected the dramatic social and political changes occurring in the 1990s in South Africa. Officially initiated in 1994, Gencor has assembled a museum-quality collection of contemporary South African art. The company did not shy away from art that provoked and challenged. According to Kendell Geers, the works in the collection, "are not didactic illustrations of the period in question, but rather represent the spirit and energy, a mind-scape of the times as seen through the eyes and imaginations of our artists, a document of a passing historical moment" (Geers, 1997). The company was culturally responsible in collecting works by living artists and also making the works available to public.

In 2018, a fascinating study of Italian financial institutions and their involvement in cultural responsibility demonstrated the power of bankers' investments in collections and sponsorships throughout history (Martino and Scarcella Prandstraller, 2018). The authors suggested that embracing the arts is most effective in times of crisis. Although this study attempts to include a weak "shared value" perspective, it primarily examines the cultural philanthropy and sponsorship of Italian financial institutions, focusing on the Intesa Sanpaolo and Mediolanum Banks. Intesa Sanpaolo actually included the value of its art collection on its 2017 balance sheet. As reported in the *Financial Times*, "3,500 pieces of fine art, out of 30,000, have a fair market value of €271m" (Gerlis, 2018). Another Italian Bank, UniCredit, made the decision in 2019 to sell off 60,000 pieces of its collection to "fund social initiatives" (Shaw, 2019).

Banca Intesa Sanpaolo is practicing cultural responsibility in an innovative way through its Advanced Training Course in the Management of Artistic and Cultural

Heritage and Corporate Collections. Offered through its Gallerie d'Italia Academy, "The training approach is multidisciplinary, oriented to the development of knowledge, specific skills and managerial skills and addresses the issue of protection, management and enhancement of private cultural heritage from an innovative and current perspective" (Intesa Sanpaolo, 2020). The program targets early-career arts professionals in the area of cultural heritage and includes a component on corporate art collections. Given the magnitude of the COVID-19 epidemic in Italy, it will be interesting to see if there will be a resurgence in business support of the arts along with more concerted efforts to communicate the banking industry's commitment to culture.

Cultural and Creative Industries

In the 1980s, art and culture figured in the larger conversation around growing corporate influence over the lives of private citizens and the general public. As capitalism advanced, there was increasing concern that the humanity at the heart of creativity would be diminished. In looking at the sociological and economic effects of the arts, attempts were made to differentiate mass-produced genres from more traditional arts with the term "cultural industries." The cultural industries were the subject of a 1982 UNESCO study including film, theater, television, advertising, and the software and IT industries; a second tier included museums, art galleries, and amusement parks (UNESCO, 1982). Andy Pratt has characterized the tension inherent in this large field of cultural practices:

> One reason for the ambivalent position that the cultural industries occupy is that they are commercially orientated and that they are commonly regarded as mass or low culture. Yet, they are situated under the umbrella of cultural policy, a perspective that has traditionally championed elite cultural forms funded from the public purse.
>
> (Pratt, 2005)

In 1998, the United Kingdom's Department for Culture, Media, and Sport set out to map the "creative industries" and their value to society. The project was complex and controversial, sparking great debate among policymakers and academics around the definitions of contributing sectors as well as the measurement of the economic and social value created by the creative industries. In essence, UK leaders dissolved the distinction between mass-produced and traditional arts. In 2006, the Centre for British Studies at Humboldt University convened "Cultural Industries: The British Experience in International Perspective" to examine the global phenomenon of the culture industries (Eisenberg, Gerlach and Handke, 2006). In 2008, the United Nations issued a special report on the global creative economy that outlined the "interface between creativity, culture, economics, and technology" against the broader framework of economics and development. These developments

underscore the unique roles that art, culture, and creativity play in society and how they contribute to our shared humanity.

Today, what is generally termed the "creative economy" generates "annual revenues of US$2,250 billion and global exports of over US$250 billion" (Ernst & Young Global Management, 2015) and is projected to "represent around 10% of global GDP in the years to come" (UNESCO, 2017). According to a 2015 study by Ernst & Young, Cultural and Creative Industries (CCI)

> revenues worldwide exceed those of telecom services (US$1,570b globally) and surpass India's GDP (US$1,900b). Within the total, the top three earners are television (US$477b), visual arts (US$391b), and newspapers and magazines (US$354b). With 29.5 million jobs, CCI employ 1% of the world's active population. The top three employers are visual arts (6.73m), books (3.67m), and music (3.98m).
>
> (Ernst & Young Global Management, 2015)

Upstart Co-Lab groups these industries into five categories: Ethical Fashion, Sustainable Food, Social Impact Media, Other Creative Industries and Creative Places (Callanan, 2021).

Bibliography

Abramson, Daniel M. 2001. *Skyscraper Rivals: The AIG Building and Architecture of Wall Street.* New York: Princeton Architectural Press.

Abruzzo, James. 2009. "The Leadership Crisis in Art Management." *JamesAbruzzo.net.* https://www.jamesabruzzo.net/wp-content/uploads/2014/07/LeadershipCrisis.pdf (Retrieved September 22, 2020).

Adams, Nicholas. 2019. *Gordon Bunshaft and SOM: Building Corporate Modernism.* New Haven: Yale University Press.

ADMICAL. 2020. *ADMICAL Our History.* November 29. https://admical.org/node/367.

Alexander, Victoria D. 1996. "From Philanthropy to Funding: The Effects of Corporate and Public Support on American Art Museums." *Poetics* 87–129.

Alphi, Karen, ed. 1985. *Chemical Bank: An Art Collection in Perspeective.* New York: Chemical Bank.

American Architect and Architecture. 1937. "Ciba Pharmaceutical Products Building, Summit, N.J." *American Architect and Architecture* 51–56. https://usmodernist.org/AMAR/AMAR-1937-10.pdf (Retrieved February 21, 2021).

American Craft Council. 1968. "Plastic Forms by Freda Koblick." *American Craft Council.* https://digital.craftcouncil.org/digital/collection/p15785coll6/id/6392 (Retrieved February 28, 2021).

Americans for the Arts. 2020. *Award for Arts Achievement.* September 8. https://www.americansforthearts.org/by-program/promotion-and-recognition/awards-for-arts-achievement/bca10/prudential-financial-inc.

Anderson, Robert O. 1971. "The Businessman and the Artist." In *The State of the Arts and Corporate Support,* by Gideon Chagy, ed., 3–7. New York: Paul S. Eriksson, Inc.

Arenson, Adam. 2019. "Banking with Family in Postwar California: Howard Ahmanson, the Millard Sheets Studio, and the Home Savings and Loan Commissions, 1953–91." In *Corporate Patronage of Art & Architecture in the United States, Late 19th Century to the Present*, by Monica E. Jovanovich and Melissa Renn, eds., 190–205. New York: Bloomsbury.

Balmer, John M. T., 2015. "Corporate Identity, Corporate Identity Scholarship and Wally Olins (1930–2014)." *Corporate Communications*, 20(1), 4–10. http://dx.doi.org.proxy.libraries.rutgers.edu/10.1108/CCIJ-08-2014-0052 (Retrieved July 31, 2020).

Balmer, John M. T., and Edmund R. Gray. 2003. "Corporate Brands: What Are They? What of Them?" *European Journal of Marketing*, 37(7/8), 972–997. https://www.researchgate.net/publication/235294085_Corporate_Brands_What_are_They_What_of_Them_CORPORATE_BRAND_CORPORATE_BRAND_MANAGEMENT_EUROPEAN_JOURNAL_OF_MARKETING (Retrieved August 1, 2020).

Baumol, William J., and William G. Bowen. 1966. *Performing Arts-The Economic Dilemma*. New York: The Twentieth Century Fund.

Blount, Winton M. 1984. *Business Support to the Arts Is Just Good Sense*. New York: Business Committe for the Arts.

Bogart, Michele. 1995. *Artists, Advertising, and the Borders of Art*. Chicago: University of Chicago Press.

Bryant, Keith L. Jr. 1978. "The Atchison, Topeka and Santa Fe Railway and the Development of the Taos and Santa." *Western Historical Quarterly*, 9(4), 437–453. https://www.jstor.org/stable/967446 (Retrieved April 5, 2021).

Business/Arts Canada. 2021. *Business/Arts Canada*. April 14. http://www.businessandarts.org/our-story/.

Businesswire. 2021. *Anheuser-Busch Donates 'Great Kings and Queens of Africa' Art Collection to UNCF to Educate and Inspire Generations to Come*. April 1. https://www.businesswire.com/news/home/20121030005140/en/Anheuser-Busch-Donates-%E2%80%98Great-Kings-and-Queens-of-Africa%E2%80%99-Art-Collection-to-UNCF-to-Educate-and-Inspire-Generations-to-Come.

Bzdak, Michael. 2007. "Money in the Bank? Corporate Support of the Arts." In *Money and Culture*, by Fiona Cox and Hans-Walter Schmidt-Hannisa, eds., 319–332. Frankfurt am Main: Peter Lang.

Callanan, Laura. 2021. *Impact Investing in the Creative Economy Today*. March 28. https://www.creativityculturecapital.org/impact-investing-in-the-creative-economy-today/#r+365+2+12.

Chagy, Gideon. 1973. *The New Patrons of the Arts*. New York: Harry N. Abram.

———. 1971. *The State of the Arts and Corporate Support*. New York: Pauls S. Eriksson, Inc.

Chong, Derrick. 2010. *Arts Management*. London: Routledge. https://doi.org/10.4324/9780203865347.

Citi. 2020. *Citi Private Bank Art Advisory & Finance*. July 22. https://www.privatebank.citibank.com/home/art-advisory-and-finance.html.

Collector's Guide. 2020. "Collector's Guide." *The Neutrogena Textile Collection*. October 2. https://www.collectorsguide.com/fa/fa069.shtml (Retrieved October 2, 2020).

Deutsche Bank. 2020. *Deutche Bank Society*. July 22. https://www.db.com/cr/en/society/art-culture-sports.htm.

Dixon, John Morris. 1966. "IBM Thinks Twice." *Architectural Forum*, 124, 32–39.

Douberley, Amanda Ann. 2015. *The Corporate Model: Sculpture, Architecture, and the American City, 1946–1975*. Austin: The University of Texas at Austin; Ann ArborProQuest.

Eells, Richard. 1967. *The Corporation and the Arts*. New York: The Macmillan Company.

Eisenberg, Christiane, Rita Gerlach, and Christian Handke, eds. 2006. *The Cultural Industries: The British Experience in International Perspective. 2006. Online. Humboldt University Berlin, Edoc-Server and ISBN 978-3-86004-203-8. 234 S.* Berlin: Humboldt University. https://edoc.hu-berlin.de/handle/18452/18524 (Retrieved July 15, 2020).

EY. 2021. "Cultural Times: The First Global Map of Cultural and Creative Industries." *UNESCO.org.* March 28. https://en.unesco.org/creativity/sites/creativity/files/cultural_times._the_first_global_map_of_cultural_and_creative_industries.pdf.

Figge Art Museum. 2010. *The John Deere Art Collection.* November. https://figgeartmuseum.org/art/exhibitions/view/the-john-deere-art-collection/154 (Retrieved August 23, 2020).

Fombrun, Charles J. 1996. *Reputation: Realizing Value from the Corporate Image.* Boston: Harvard Business School Press.

Fox, Daniel M. 2017. *Engines of Culute: Philanthropy and Art Museums.* Oxon: Routledge.

Friedman, Milton. 1970. "The Social Responsibility of Business Is to Increase Its Profits." *New York Times Magazine,* September 1970: 122–126.

Geers, Kendell. 1997. "Past, Present Future: Meeting the Challenge of the Corporate Collector." In *Contemporary South African Art: The Gencor Collection,* by Kendell Geers, ed., 9–22. Johannesburg: Jonathan Ball Publishers.

Gerlis, Melanie. 2018. "Results as Clear as Day." *Financial Times Weekend,* November 25: 19.

Gingrich, Arnold. 1969. *Business & the Arts: An Answer to Tomorrow.* New York: aul S. Eriksson, Inc.

Guback, Thomas H. 1970. "Review of "Business and the Arts by Arnold Gingrich"." *The Journal of Aesthetic Education,* 4(3),131–137.

Hanks, Nancy. 1975. "Design for America's Third Century." In *The Art of Deisgn Management,* by T. Schutte, 91–105. New York: Tiffany & Co.

Harrison, William B. Jr. 1999. *Art at Work: Forty Years of the J.P. Morgan Chase Collection.* New York: J.P. Morgan Chase & Co.

Harwood, John. 2003. "The White Room: Eliot Noyes and the Logic of the Information Age Interior." *Grey Room* 7–31. www.jstor.org/stable/1262641 (Retrieved May 23, 2020).

———. 2011. *The Interface: IBM and the Transformation of Corporate Design, 1945–1976.* Minneapolis: University of Minnesota Press.

Heidekat, George. 2015. "How Westinghouse Brought 'Midcentury Modern' to the Pittsburgher on the Street." *Storyboard.* November 16. https://storyboard.cmoa.org/2015/11/how-westinghouse-brought-midcentury-modern-to-the-pittsburgher-on-the-street/ (Retrieved February 14, 2021).

Heilbrun, James, and Charles M. Gray. 2001. *The Economics of Art and Cultue.* New York: Cambridge University Press.

Hickley, Catherine. 2020. "Goodbye Gerhard: Deutsche Bank Shrinks Art Collection." *https://www.theartnewspaper.com/.* February 4. https://www.theartnewspaper.com/news/deutsche-bank-shrinks-collection.

Howarth, Shirley R. 1990. *ARTnews International Directory of Corporate Art Collections.* Largo Fl: International Art Alliance.

IBM Corporation. 1989. *50 Years of Collecting Art: Art at IBM.* New York: IBM.

Intesa Sanpaolo. 2020. *Intesa Sanpaolo Formazione.* December 1. https://www.intesa-sanpaoloformazione.it/progetti/corso-di-alta-formazione-in-gestione-dei-patrimoni/.

Jacobson, Marjory. 1993. *Art for Work: The New Renaissnace in Corporate Collecting.* Boston: Harvard Business School Press.

Koch, Frank. 1979. *The New Corporate Philanthropy.* New York: Plenum Press.

Kottasz, Rita., Roger Bennett, Sharmila Savani, W. Mousley, and Rehuma Ali-Choudhury. 2007. "The Role of the Corporate Art Collection in Corporate Identity Management:

The Case of Deutsche Bank." *International Journal of Arts Management* 10(1),19–31 (Retrieved June 27, 2020, from www.jstor.org/stable/41064905).

Kottasz, Rita, Roger Bennett, Sharmila Savani, and Rehnuma Ali-Choudhury. 2008. "The Role of Corporate Art in the Management of Corporate Identity." *Corporate Communications: An International Journal,* 13(3), 235–254.

Lang, Sandra, interview by Sharon Zane. 1999. *The Museum of Modern Art Oral History Program* (January 20 https://assets.moma.org/momaorg/shared/pdfs/docs/learn/archives/ transcript_lang.pdf (Retrieved September 22, 2020)).

Leslie, Stuart W. 2011. "The Strategy of Structure: Architectural and Managerial Style at Alcoa and Owens-Corning." *Enterprise & Society,* 12(4), 863–902. 10.1017/ S1467222700010703 (Retrieved December 29, 2020).

Lindenberg, Morgane, and Kim Oosterlinck. 2010. "Art Collections as a Strategy Tool: a Typology Based on the Belgian Financial Sector." *Working Papers CEB 10–011.RS, ULB—Universite Libre de Bruxelles.* https://www.academia.edu/24050040/Art_ Collections_as_a_Strategy_Tool_a_Typology_based_on_the_Belgian_Financial_Sector (Retrieved September 25, 2020).

Louchheim, Aline B. 1953. "Art Show Is Set Up for Business Men." *New York Times.* November 17. https://timesmachine.nytimes.com/timesmachine/1953/11/17/83740945. pdf?pdf_redirect=true&ip=0 (Retrieved March 21, 2021).

Martino, Valentina, and S. Scarcella Prandstraller. 2018. "Corporate Cultural Responsibility and Shared Value in the Banking Sector. An Explorative Study in Italy." *Communication Management Review* 58–79.

Martorella, Roseanne. 1990. *Corporate Art.* New Brunswick: Rutgers University Press.

Miller, J. Irwin. 1972. *Business, Society and the Arts.* New York: Business Committee for the Arts.

———. 1977. *Business in the Arts… A New Challenge.* New York: Business Committee for the Arts.

Mozingo, Louise A. 2011. *Pastpral Capitalism: A History of Suburban Corporate Landscapes.* Cambridge: The MIT Press.

Museum of Modern Art Archives. 2020. *Museum of Modern Art Archives.* September 22. https://www.moma.org/research-and-learning/archives/finding-aids/ArtLendingb. html.

New York Public Library. 2020. *NYPL Homepage.* November 26. http://archives.nypl.org/ mss/18811#overview.

Newhouse, Victoria. 1989. *Wallace K. Harrison, Architect.* New York: Rizzoli.

Oeri, Georgine. 1968. *Man and His Images: A Way of Seeing.* New York: The Viking Press.

Ong Yan, Grace. 2017. "Soft-Selling Aluminum: Minoru Yamasaki's Reynolds Metals Sales Headquarters." *Docomomo US News.* September 28. https://www.docomomo-us.org/ news/soft-selling-aluminum-minoru-yamasaki-s-reynolds-metals-sales-headquarters (Retrieved February 14, 2021).

———. 2020. *Building Brands: Corporations and Modern Architecture.* London: Lund Humphries.

Pelzer, Peter. 2006. "Art for Management's Sake? A Doubt." *Culture & Organization,* 12(1), 65–77. https://web-a-ebscohost-com.proxy.libraries.rutgers.edu/ehost/detail/detail?vid=0&sid=- f89ee3f8-bfe1-4df5-9035-5c04e34316ef%40sdc-v-sessmgr03&bdata=JnNpdGU9ZWh- vc3QtbGl2ZQ%3d%3d#AN=19701839&db=aph (Retrieved August 2, 2020).

PhotoCentral. 2005. *NY Met Acquires Gilman Paper Collection of 8,500 Photographs Worth Perhaps Over $100 Million.* March 19. https://www.iphotocentral.com/news/article- view.php/92/86/455 (Retrieved January 9, 2021).

Pratt, Andy. 2005. "Cultural Industries and Public Policy." *International Journal of Cultural Policy* 31–44. http://eprints.lse.ac.uk/16020/1/Cultural_industries_and_public_policy_(LSERO).pdf (Retrieved July 25, 2020).

Rand, Paul, and Ann Rand. 1960. "Advertisement: Ad Vivum or Ad Hominem?" *Daedalus* 127–135.

Refco. 2003. *Subjective Realities, Works from the Refco Collection of Contemporary Photography.* Chicago: Refco.

Robinson, Walter. 1990. "Minnesota Bank Loses Interest in Provocative Art." *Art in America*, March: 35–37, 239.

Rockefeller Brothers Fund, Inc. 1965. *The Performing Arts: Rockefeller Panel Report on the Future of Theatre, Dance, Music in America.* New York: McGraw-Hill Book Company.

Rockefeller, David. 1966. BCA. October 14, 1997.

———. 1997. *Reflections and Visions: Business-Arts Alliances.* David Rockefeller Lecture. New York: Business Committe for the Arts, October 14.

Rosenbaum, L. 2011. *Museum Imprimatur: UBS to Sell MoMA-Showcased Works at Sotheby's UPDATED.* November 7. https://www.artsjournal.com/culturegrrl/2011/11/ubs_sells_moma-showcased_works.html (Retrieved August 23, 2020).

Sanders, Shauna. 2005. "The Case for the National Endowment for the Arts: Federal Funding for the Arts in America in the 1960s and 1970s." *History of Political Economy,* 37(3), 593–616. https://doi-org.proxy.libraries.rutgers.edu/10.1215/00182702-37-3-593 (Retreived July 12, 2020).

Schutte, T., ed. 1975. *The Art of Design Management: Design in American Business.* New York: Tiffany & Co.

Selvin, Claire. 2020. "Banking on Art: TD Bank Has Expanded Its Art Collecting—and Has the Stickers to Prove It." *ARTNews,* July 23. https://www.artnews.com/art-news/news/td-bank-art-collection-1202695037/ (Retrieved November 15, 2020).

Sever, Joy Marie. 2020. *The Reputation Quotient | Corporate Reputation Measurement.* May 17. https://www.beyondthebio.com/the-reputation-quotient.

Shaw, Anny. 2019. *UniCredit to Sell Off One of World's Largest Corporate Art Collections.* May 10. https://www.theartnewspaper.com/news/unicredit-to-sell-one-of-world-s-largest-corporate-holdings-of-art (Retrieved November 21, 2020).

Shaykin, Rebecca. 2019. *Edith Halpert: The Downtown Gallery and the Rise of American Art.* New Haven: Yale University Press.

Shils, E. A. 1960. "Mass Society and Its Culture." *Daedalus,* 99, 288–314. www.jstor.org/stable/20026572Copy (Retrieved July 3, 2020).

———. 1964. "The High Culture of the Age." In *The Arts in Society,* by R.N. Wilson, ed., 315–362. Englewood Cliffs: Prentice-Hall, Inc.

Strom, Elizabeth. 2002. "Converting Pork Into Porcelain: Cultural Institutions and Downtown Development." *Urban Affairs Review,* 38(1), 3–21. https://journals-sagepub-com.proxy.libraries.rutgers.edu/doi/pdf/10.1177/107808702401097763 (Retrieved August 7, 2020).

Sussman, Anna Louie. 2017. *How Jeffrey Deitch, Citibank, and Christo Created the Art Market as We Know It.* July 30. https://www.artsy.net/article/artsy-editorial-jeffrey-deitch-citibank-christo-created-art-market (Retrieved March 22, 2021).

Tarmy, James. 2020. *Banks Are the 'New Medici' When It Comes to Art Collecting.* November 19. https://www.bloomberg.com/news/features/2020-11-19/big-banks-have-massive-corporate-art-collections-here-s-why (Retrieved November 21, 2020).

Temkin, Ann. 2005. *Contemproary Voices: Works form the UBS Art Collection.* New York: The Museum of Modern Art.

The National Gallery of Australia. 2020. *SARA LEE CORPORATION'S GIFT.* September 10. https://nga.gov.au/monet/gift.htm.

The New York Times. 2012. *Behind the Low-Priced Clothing, a Priceless Midcentury Sculpture.* May 31. https://cityroom.blogs.nytimes.com/2012/05/31/behind-the-low-priced-clothing-a-priceless-midcentury-sculpture/ (Retrieved January 14, 2021).

Tully, Judd. 2020. "Collectors' Reversals of Fortune can Mean a Payday for Auction Houses—or Spell Disaster." *ARTnews.* October 20. https://www.artnews.com/art-news/market/fallen-art-collectors-1234574412/ (Retrieved April 9, 2020).

UNESCO. 1982. *Cultural Industries: A Challenge for the Future of Culture.* Paris: UNESCO.

———. 2017. "Re|shaping Cultural Policies: Advancing Creativity for Development." *Unesco.org.* December 14. https://en.unesco.org/creativity/sites/creativity/files/global_report_fact_sheet_en.pdf (Retrieved August 15, 2020).

United States Patent and Trademark Office. 1986. "Official Gazette of the United States Patent and Trademark Office." *https://babel.hathitrust.org/.* November 4. https://babel.hathitrust.org/cgi/pt?id=wu.89050369347&view=1up&seq=11.

Vilar, Alberto. 2002. *Business Success as a Platform for Generating Private Philanthropy for the Arts.* David Rockefeller Lecture. New York: Business Committe for teh Arts, Inc.

Vogel, David. 2005. "Is There a Market for Virtue?: The Business Case for Corporate Social Responsibility." *California Management Review,* 47(4), 19–45.

Walton, Clarence C. 1967. *Corporate Social Responsibilities.* Belmont: Wadsworth Publishing Company, Inc.

Wetherwell, Sam. 2020. *Foundations: How the Built Environment Made Twentieth-Century Britain.* Princeton: Princeton University Press.

Willis, Carol. 1995. *Form Follows Finance: Skyscrapers and Skylines in New York and Chicago.* New York: Princeton Architectural Press.

Wilson, R. N., ed. 1964. *The Arts in Society.* Englewood Cliffs: Prentice-Hall, Inc.

Chapter 4

The Tensions of Patronage

Sponsorship, Brands, and Philanthropy

> Manufacturing products may require drills, furnaces, hammers, and the like, but creating a brand calls for a completely different set of tools and materials. It requires an endless parade of brand extensions, continuously renewed imagery for marketing and, most of all, fresh new spaces to disseminate the brand's idea of itself.
>
> Naomi Klein

A 1968 editorial in the *Academy of Management Journal* signaled a change in attitude in business supporting the arts and culture:

> The corporate new look at opera and at other art forms is most welcome. It supports the thesis that material goods and materialism, per se, are not the ultimate goals of our enterprise system. Yet, without an abundance of goods, and good things and good managers, the Good Life is but a Utopian dream.
>
> (Vance, 1968)

Given that consumption was equated with the "good life," companies and brands were increasingly interested in communicating "emotions, messages, and values through collaboration with 'symbolic creators'" in the art world (Dell'Era, 2010). This dynamic is exemplified by Mobil Oil's sponsorship of the PBS series "Masterpiece Theatre," from 1971 to 2004. This high-profile sponsorship included the design

DOI: 10.4324/9781003099222-5

and publication of posters to publicize each of the 121 programs underwritten by the corporation. Leaders at Mobil used the term "affinity-of-purpose marketing" to describe this alignment of "the company with some worthy endeavor that most of our target audience would happily endorse" (Schmertz, 1987).

The growth of arts patronage was accompanied by an increase in the corporate sponsorship of blockbuster exhibitions, raising questions around the benefits of these high-level marriages of business and culture. Not everyone was convinced that the marriage of art and commerce was appropriate, and prominent artists have pointed out the problematic networks of corporate power behind many cultural institutions. In the late 1960s, Hans Haacke, a founder of the Art Worker's Coalition, critiqued the corporate influence on art museums, taking aim at the unethical behavior of the Guggenheim Museum's board of directors through his artistic practice. As an artist, critic, and writer Haacke exposed the explicit and implicit social and cultural power that museums and their donors hold over the general public. The late 1960s and early 1970s witnessed a growing identity crisis for museums over questions of relevance from artists and radical student movements. Duncan Cameron, director of the Brooklyn Museum, called for reforms and a return to the roots of public museums as "part of social responsibility in cultural programming" and as "necessary to the democratization of culture, or ... to the creation of an *equality of cultural opportunity*" (Cameron, 1971).

In 1979, the Twentieth Century Fund issued the book *The Art Museum: Power, Money, Ethics,* by Karl E. Meyer (Meyer, 1979). Following Baumol and Bowen's book on the performing arts, Meyer's critique took on a more journalistic approach in chronicling the unique Americanness of art museums and the growing financial deficits of the 1970s. The book is an entertaining collection of narratives around major museums and their governance, yet it avoids almost entirely the issue of business support of the arts. Meyer does explore the lack of diversity in the boards of trustees of major museums, identifying the common challenge in "their governance by private boards composed of the established rich who have been operating with limited accountability and who have on occasion demonstrated minimal sophistication about the arts" (Meyer, 1979). He also exposes the questionable influence of museums on the art economy in terms of acquisitions, donations, and the practice of deaccessioning works from collections.

According to Chin-tao Wu, the free enterprise and privatization promoted by Margaret Thatcher and Ronald Reagan profoundly accelerated the comingling of art and business (Wu, 2002). The "marketization" of art institutions took hold, and museums began to behave more like corporations, basing decisions on attendance numbers and seeking to diversify their funding streams (Ekstrom, 2020). Although this was primarily a trend in the United States and Britain, other countries developed new models of corporate support for the arts. A recent study, for example, documents the transition from sports sponsorships to cultural patronage in Sweden (Gianneschi and Broberg, 2020). The attraction of corporate funding has also led many museums to engage in a form of self-censorship and/or compromise, making

curatorial decisions that were more benign than challenging. The advent of "Superstar Museums" challenged commonly held views on the role of these institutions in society (Frey, 1998). Museums faced new challenges in retaining intellectual independence, maintaining permanent collections, and procuring new funding streams (Museum Management and Curatorship, 1996).

Corporate leaders started to embrace the arts on many levels, ranging from cause-related sponsorships to serving on the boards of museums, operas, and symphony orchestras. Pierre Bourdieu and others have described the various forms of cultural capital that can be garnered by individuals and companies. As Domini van Aaken, Violetta Splitter, and David Seidl explained,

> Pro-social practices can be understood as attempts to transform an individual actor's economic capital into other forms of capital. From this perspective, pro-social behaviour can be understood not as a sacrifice of economic capital for the social good, but as a transformation of the amount and structure of an individual actor's capital into other forms of capital.
>
> (van Aaken, Splitter and Seidl, 2013)

This accumulation of social influence and capital, in particular, caused growing unease as corporate leaders increasingly viewed the art world as a place to exercise power and build or enhance brands. This transformation of capital can be abused, especially in an era when museums (and all arts organizations) are seeking new sources of funding. An illustrative example is Dennis Kozlowski, CEO of Tyco, who joined the Whitney Museum of American Art's board of directors and then had the company sponsor a series of traveling exhibitions at a cost of $4.5 million. Beyond the questionable use of company funds for philanthropy, Kozlowski's conviction on tax evasion related to his personal acquisition of art raises questions around his motivations for engaging with the arts and his relationship with the Whitney.

Philip Morris exemplified how a company could leverage support of the arts to burnish its reputation while being scrutinized for its business ethics and questionable influence on society. Beginning in the 1960s, the company embraced support and sponsorship of the arts as a means to building its identity as a good citizen and fortifying its brand. According to former executive Stephanie French,

> As marketers, we needed new ideas; we needed to become more creative, and more in touch with our consumers' changing needs. And since all phases of our marketing operations dealt with line, movement, color, shape, sound, theme, and texture, a forward-thinking focus on the arts would serve as an example of the kind of creativity and communication we needed.
>
> (French, 1991)

In a sense, French was reinforcing one of the early motivations for business involvement in culture: identifying a company with the innovative nature of the arts as an image-building strategy. According to George Weismann, the company's CEO and chairman of the board:

> Within our structure, we have shaped an environment to retain, attract, and build a special kind of staff—a closely knit corps of people who channel their creative energies and enthusiasm into corporate strategy, long-range planning, and day-to-day operations. … In fulfilling our core philosophy of manufacturing and selling quality products, we have become sensitive— during Philip Morris's more than two decades of sustained growth—to the subtle ways in which art and architecture have influenced our way of looking at things and going about our business.
>
> <div align="right">(The University of Alabama, 2021)</div>

In 1983, the New York headquarters lobby of Philip Morris was transformed into a branch of the Whitney Museum of American Art as part of an ongoing philanthropic relationship between the two institutions. In 1990, Philip Morris contributed about $15 million to arts organizations in the United States. Meanwhile, the company's support of Senator Jesse Helms's election campaign caused controversy due to the conservative politician's combative position on national funding for the arts. The issue became the subject of one of Haacke's critical works, *Helmsboro Country*. Yet the company was revered throughout the 1980s and 1990s as an exemplary supporter of the arts, and Philip Morris/Altria was honored in 1992 with a Business Committee for the Arts (BCA) 10 Hall of Fame Award for directing "approximately 25% of its annual philanthropic budget to the arts, which amounts to millions of dollars each year" (Awards for Arts Achievement, 1992).

Philip Morris unabashedly positioned its role as arts patron to cultivate new markets. As Mark Rectanus has shown, the company did not shy away from pursuing its diverse market agenda through sponsoring shows such as *Latin American Women Artists: 1915–1995*, at the Milwaukee Art Museum (M. R. Rectanus, 2002). Philip Morris also embraced opportunities to support the US government's ambitions to communicate American freedom of expression through the arts globally. As Daniele Fox surmised,

> Although Philip Morris was ostensibly motivated by philanthropic concerns, it should be evident that by promoting the 11 Pop Artists prints as symbols of US freedom and democracy in Europe and Latin America, the company was also trying to develop and maintain foreign markets for its products.
>
> <div align="right">(Fox, 2001)</div>

This came at a time when the health effects of smoking were becoming more public in the United States, putting the pressure on Philip Morris to expand its international consumer base.

Philip Morris was not the only tobacco company to embrace the practice of corporate arts patronage. In 1960, Dutch company Peter Stuyvesant initiated what became a formal art program and collection by hanging a series of large abstract canvases on the production floor of the Turmac Tobacco Factory, in Zevenaar, Netherlands (Witte, 2020). This was considered the first corporate art collection in the country and was held up as a model. As in the case of Philip Morris, a major museum helped to validate the company's efforts: an exhibition of the nascent collection was held at the Stedelijk Museum, in Amsterdam, in 1962. This case study is particularly interesting because many actors were involved in the creation of the collection, which until recently was attributed to the managing director of the tobacco company, Alexander Orlow. It turns out that the Dutch Ministry of Arts, Education, and Sciences and the European Cultural Foundation, founded in 1954 in Geneva and relocated to Amsterdam in 1960, and possibly the Nederlandse Kunststichting, were all involved in the Peter Stuyvesant project (Witte, 2020). The reality in this case suggests that national agendas may have more connection to corporate collecting than once assumed. The collection grew and survived multiple mergers and acquisitions, finally meeting its fate in 2008, when the artworks were auctioned off at Sotheby's. This example illustrates that there is still a great deal to be discovered in the marriage of art and commerce outside of the US and UK.

Daniele Fox highlighted the role of public-affairs agency Ruder-Finn in brokering many of the early corporate sponsorships of museum projects. Founded in 1948 by David Finn and Bill Ruder, it grew to become one the largest global PR firms and was at the forefront of the growing arts and commerce movement, including early engagement with the Business Committee for the Arts. Finn, who spent his career deeply involved in all aspects of the arts, defended corporate sponsorship of museum exhibitions in the 1984 article "Is There a Legitimate Role for Public Relations in the Arts?" (Finn, 1984). He also recognized the growing corporate push toward reputation management and brand building as well as the need for arts organizations to diversify their funding sources. Not surprisingly, Ruder-Finn was involved in many of the early high-profile sponsorship projects and established a special practice focused on companies seeking to unite art and commerce. Peter Finn, David's son, carries on the legacy of art sponsorship with his own agency, Finn Partners.

The relationship of art to advertising took a turn in the 1980s when Sweden's Absolut Vodka broke new ground by "fusing arts patronage, advertising, and lifestyle promotion" to strengthen its brand appeal and sales (M. R. Rectanus, 2002). One of the most important outcomes of this campaign, other than increased sales, was the opportunity afforded to lesser-known artists to build their own careers and market recognition. According to Mark Rectanus, the shift exemplified by Philip Morris and Absolut

> positions the corporate sponsor within the cultural marketplace as (1) an artist (entrepreneurship becomes synonymous with creativity), (2) a patron (a venture capitalist in cultural investments), (3) an art dealer (a broker or mediator of cultural programs), (4) a collector (consumer or

investor), and (5) an audience/consumer (the corporation claims to be part of local communities and promotes its interests as being consonant with the community's own).

(M. R. Rectanus, 2002)

The fact that this new positioning was spearheaded by the alcohol and tobacco industries was just one reason that critics and the arts community raised questions about the corporation's role as artist and audience, in addition to patron, dealer, and promoter.

The museum world was challenged increasingly in the late 1980s and early 1990s by questions regarding purpose and relevance. Under the heading "The New Museology," the conversation moved from a focus on traditional museum methods to the role of the museum in society. One group of scholars framed the museum as an information resource with the potential to generate wisdom for the museumgoer in "intellectual, aesthetic, sensory, spiritual, or emotional" spheres (Stam, 1993 (1990)). The MoMA continued to be a pioneer in framing and reframing Modernism's role in defining and shaping culture. The 1991 exhibition *High & Low*, for example, explored how comics, graffiti, and advertising influenced modern and contemporary art. In his essay on Cubism and the appropriation of newspaper fragments in collage, Kirk Varnedoe revealed that Georges Braque, Pablo Picasso, and Kurt Schwitters used popular culture as a key element in their avant-garde experiments.

While fashion and art have enjoyed a fascinating coexistence over the past 60 years, Debora Silverman's critique of the fashion industry's ties to the Metropolitan Museum of Art broke new ground (Silverman, 1986). Elsa Schiaparelli's relationship with Surrealism is well documented, while Hermès designer Lola Prusac and French designer Yves Saint Laurent found inspiration in Piet Mondrian and Andy Warhol got his start in the fashion business. Yet Silverman focused on a series of exhibitions at the Met that, according to the author, compromised principles of scholarship in favor of blatant marketing efforts by the sponsors. The 1984 exhibition *Man and the Horse* provided Ralph Lauren, its sponsor, marketing and promotional benefits, calling into question the boundaries between art and commerce. As in the case of Absolut, this is a great example of the fusion of patronage, advertising, and lifestyle promotion. The Guggenheim ventured into this murky space with *The Art of the Motorcycle*, sponsored by BMW in 1998, and an exhibition on Giorgio Armani in 2000, blurring the lines between art and advertising and curatorial independence and consumption.

In 2005, Michael Kimmelman sounded the alarm around donor influence over museums, citing examples such as *Sensation*, an exhibition of the Charles Saatchi collection at the Brooklyn Museum in 1999–2000, as well as the Guggenheim's controversial *Armani* show (Kimmelman, 2005). The Saatchi Gallery, established in London in 1985, exhibits works from the private collection of Charles Saatchi, who subsidized the traveling show *Sensation* and in 1998 reportedly offered his collection to the Tate and the UK Arts Council in 2010. In 2019, Saatchi Gallery registered

with the British government's Charity Commission and has since operated as a non-profit. The gallery's attendance was 1.8 million in 2017, declining to 1.2 million visitors the following year (Artforum, 2019). The issue is not simply corporations funding cultural institutions: it extends to board members of nonprofit institutions with connections to corporations. The case of Advanta, a financial-services company in Philadelphia, highlights the tensions and complexities of corporate sponsorship. Amy Ninetto's detailed look at Advanta's sponsorship of the Cézanne exhibition at the Philadelphia Museum of Art reveals the complexity of a corporation attempting to link its identity with art and artists (Ninetto, 1998). This example also underscores how decisions to sponsor the arts by senior leaders might be made without a business strategy in place.

In many cases, museum trustees have considerable investments in controversial companies, a concern raised by Haacke. Often, the sources of a trustee's wealth are under question, as in the case of the Sackler family, one of the most dramatic examples in recent years (Frances, 2018). Ruth Millington has summarized the situation succinctly:

> The Sackler story teaches museums a moral lesson. By accepting arts philanthropy, institutions also accept philanthropists' power, which can transform cultural institutions (for better or for worse). Museums must ensure that any financial gift serves the museum, rather than the donor's desire to build their brand.
>
> (Millington, 2019)

Power, influence, and branding are often the motivation for philanthropy, whether the donor is an individual, a family, or a corporation.

Haacke was also a pioneer in exposing Exxon's use of the arts as a "social lubricant" in 1975 (Schiller, 1989). Companies in the extractive industries, such as Exxon and Mobil, were among the most generous patrons of the arts and became easy targets for activists. Coalitions such as Art Not Oil have taken aim at the oil industry's dubious support of culture and museums. The website *Platform* was initiated in 1983 as a forum for artists and activists to discuss and take action on social and environmental issues. According to the site, its members "have experimented with new methods and tactics and engaged in artistic and political movements over the many years, to deepen the expression of our core values" (Platform, 2021). One potential solution "is to open the hood of museums and rewire their internal structure so that board members have less power and other community stakeholders have more" (Halperin, 2019). This call for "full disclosure" is a positive move but will be effective only if the arts community demands more involvement in the workings of cultural institutions (M. R. Rectanus, 2002).

Concern over the relationship of capitalism to modern culture has been raised since the 1920s, starting with the writings of Antonio Gramsci and the Frankfurt Institute for Social Research. Discontent with big business had been growing since

the Cold War and became more visible with the anti-war demonstrations, campus unrest, and growth of public-interest advocacy groups. Corporations faced a legitimacy gap as public trust waned throughout the 1960s and 1970s. Fearing more regulation from government, companies sought to demonstrate how they provided value to society. The response took many forms, including increased advocacy, communications, and social responsibility. Citizens and students formed coalitions such as Common Cause and Nader's Raiders. Richard Prince, among other artists, responded by exploring advertising and appropriation while "subverting the dominance of the market and the economy" by taking images back from advertising in a critical stance on capitalism (The Broad, 2021).

The National Affiliation of Concerned Business Students (NACBS) was founded by graduate students from ten US business schools and supported by 34 corporations (including Cummins Engine Company) in 1971. One of its major contributions was the symposium "Corporate Social Policy in a Dynamic Society," held in 1972 at the University of California, Berkeley. As a result of the conference a comprehensive publication, edited by Berkeley professor S. Prakash Sethi, provides a glimpse into the tensions, issues, and dialogue around the role of business in society. As Sethi states prophetically, "It is a fallacy that business can prosper—or, indeed, even exist—without regard to broader social concerns. Nor will the dominant social concerns always be economic ones" (Sethi, 1974). The symposium and its published proceedings, entitled *The Unstable Ground: Corporate Social Policy in a Dynamic Society*, were a call to action. The volume included essays by business and government leaders, academics, and public-interest advocates. John D. Rockefeller set the tone in the foreword:

> I have come to believe in recent years that we are in the midst of a revolution in our society second in importance only to the first American Revolution two hundred years ago. It is a humanistic revolution. A gradual revolution, and it is the dynamics of this revolution that demands a new social awareness on the part of all of us, including American business.
>
> (Sethi, 1974)

The influence of anti-corporate social-media campaigns and coalitions has grown over the past few decades. The growing resistance to and resentment of multinational corporations has been well documented by authors such as Naomi Klein, who writes,

> The astronomical growth in the wealth and cultural influence of multinational corporations over the last 15 years can arguably be traced back to a single, seemingly innocuous idea developed by management theorists in the mid-1980s: that successful corporations must primarily produce brands as opposed to products.
>
> (Klein, 2000)

The marriage of art and commerce had clearly favored business while diminishing the power of art. Not surprisingly, culture continues to be one of the many means of brand building. Moving beyond museum sponsorships, the strategies of Prada and Armani illustrate the value of connecting brand to the arts.

In the last ten years, luxury brands have emerged as major patrons of the arts. Louis Vuitton and Cartier have opened art museums. Beyond its identity as a global fashion brand, Prada operates a contemporary art foundation and plays a high-profile role as a patron of art, design, and architecture. Prada commissioned Rem Koolhaas for the design of an entire art complex, appropriating architecture to shape its brand. As Nicky Ryan has demonstrated, Prada has seemingly embraced the avant-garde as a brand differentiator through its ongoing association with Koolhaas as well as their patronage of contemporary art (Ryan, 2007). The Prada complex in Milan has the profile of a major public institution, so the company does not need the validation of a prestigious museum to enhance its brand identity. Yet its model of Corporate Cultural Responsibility raises many questions. While the business value of its brand of identity building is clear, the social value is more difficult to discern. Not surprisingly, Armani also built a museum in Milan, further blurring the lines between public and private cultural production and between product promotion and education.

Transparency regarding a company's motivations for sponsorship of the arts is a prerequisite for successful collaborations. The partnership between the Guggenheim Museum and UBS provides an example where each party was deliberate and forthcoming about the value they expected to gain from the relationship (Lund and Greyser, 2015). UBS had a legacy of engagement with the arts and was seeking to develop new markets; the Guggenheim needed to fill gaps in its collection from particular regions and countries. UBS chose a path where the business could achieve positive outcomes while supporting the arts in a sustainable and culturally responsive way. The effort was supported by the bank's corporate leaders and clearly offered benefits to both society and the business (Lund and Greyser, 2020). The move from sponsorship to partnership is a promising trend that facilitates the needs of both businesses and the arts to enable more authentic collaborations. Scholars have only just begun to validate this model. As Kamila Lewandowska has concluded,

> The successful relations with the arts should be based on partnership collaboration, which indicates that both partners are involved in the project design and implementation, and that employees in different departments are involved in this co-creation process. In addition, both partners should look for new ideas and concepts which would derive from the synergy of both partners' objectives.
>
> (Lewandowska, 2015)

With a rich history as a longstanding patron of the arts and design, the Swiss pharmaceutical company Roche exemplifies an enlightened patronage model. The key figure was Maja Sacher, an aspiring architect who apprenticed under sculptor

Emile-Antoine Bourdelle in Paris. She married Emanuel Hoffmann, the eldest son of company founder Fritz Hoffmann-La Roche, in 1921. The couple began to build a collection of modern art while living in Belgium. In 1930, Hoffmann lost his life in a traffic accident, and in memory of her husband, Maja established the Emanuel Hoffmann Foundation to support contemporary art (Roche Historical Archive, 2016). The company (and family) became a key foundation of art and culture in Basel and upped the ante in Corporate Cultural Responsibility by donating the Museum Tinguely to the city in honor of the company's centenary, in 1996. Designed by Mario Botta and subsidized by Roche, the museum was an unprecedented corporate bequest. According to the company website,

> Roche built the museum, contributed works from its own holdings, and provided funding for additions to the museum's collections. The museum's operating costs and the costs of maintaining the adjacent Solitude Park have been funded entirely and exclusively by Roche since 1996.
> (roche.com/sustainaibility/philanthropy/arts, 2020)

Another form of sponsorship that has played a role in the dynamic between art and commerce is the revival of the concept of prizes and competitions. Two examples illustrate the possibilities: the Compasso d'Oro (Golden Compass), sponsored by Italian department store La Rinascente, and the Hugo Boss Prize, developed in partnership with the Guggenheim Museum. Based in Milan, La Rinascente instituted its award in 1954 to highlight outstanding designers and manufacturers developing innovative products for public consumption. The company's commitment to good design can be traced back to 1927, when it opened a separate department dedicated to Italian design (Arvidsson, 2003). The Compasso d'Oro highlighted design innovation in everyday objects, featuring products by Olivetti, Fiat, and Alessi and designers such as Gae Aulenti, Marco Nizzoli, Gio Ponti, and Ettore Sottsass. In 1955, the jury awarded both national and international grand prizes to Adriano Olivetti and Marcel Breuer, respectively. In most countries—such as the United Kingdom, France, Germany, and Belgium—the government has organized design excellence prizes. The only national design prize created and funded by a company, the Compasso d'Oro inspired the creation of other award programs outside of Italy.

Established in 1996, the Hugo Boss Prize honors contemporary artists with an award of $100,000, administered by the Solomon R. Guggenheim Foundation. The work of the winning artist is also featured in an exhibition at the Guggenheim Museum. The Guggenheim's fundraising efforts have long blurred the lines between art and commerce, design and consumerism, as exemplified in its exhibitions *Armani* and *The Art of the Motorcycle*. Through schemes like the Hugo Boss Prize, artists have realized the potential of building their own brands. This is most apparent in the fashion world, where there are numerous examples of successful collaborations, ranging from Tracey Emin and Selfridges to Takashi Murakami and Louis Vuitton. With this new trend came entrepreneurial opportunities for intermediaries such as Cary Leitzes,

whose roster of artist-fashion projects is impressive (Chong, 2010). La Rinascente clearly aimed to elevate national design standards through the Compasso d'Oro, with very little benefit to the company in terms of business, whereas the Hugo Boss Prize was intended to support individual artists while accruing prestige for both the host and the sponsor. La Rinascente, through their advocacy for good design, sustained a tradition of department stores playing leadership roles in offering the public products with design integrity. While these two disparate examples stand at the crossroads of art and commerce, they embody distinctive forms of value for different stakeholders.

Bibliography

Americans for the Arts. 1992. *Awards for Arts Achievement.* https://www.americansforthearts.org/by-program/promotion-and-recognition/awards-for-arts-achievement/bca10/altria-group-incphilip-morris-companies-inc.

Artforum. 2019. "London's Saatchi Gallery Becomes a Nonprofit." *Artforum.* April 8. https://www.artforum.com/news/london-s-saatchi-gallery-becomes-a-nonprofit-79265 (Retrieved November 30, 2020).

Arvidsson, Adam. 2003. *Marketing Modernity: Italian Advertising from Fascism to Postmodernity.* London: Routledge.

Cameron, Duncan F. 1971. "The Museum, a Temple or the Forum." *Curator: The Museum Journal,* 14(1), 11–24 https://doi.org/10.1111/j.2151-6952.1971.tb00416.x (Retrieved November 29, 2020).

Chong, Derrick. 2010. *Arts Management.* London: Routledge. https://doi.org/10.4324/9780203865347.

Dell'Era, Claudio. 2010. "Art for Business: Creating Competitive Advantage Through Cultural Projects." *Industry and Innovation,* 17(1), 71–89. 10.1080/13662710903573844 (Retrieved July 18, 2020).

Ekstrom, Karin M., ed. 2020. *Museum Marketization: Cultural Instituions in the Neoliberal Era.* London: Routledge.

Finn, David. 1984. "Is There a Legitimate Role for Public Relations in the Arts?" *The Annals of the American Academy of Political and Social Science,* 471(1), 57–66 (Retrieved June 27, 2020 www.jstor.org/stable/1044135Copy).

Fox, Danielle. 2001. "Art." In *Culture Works: The Political Economy of Culture,* by R. Maxwell, ed., 22–59. Minneapolis: Univeristy of Minnestoa Press (Retrieved June 26, 2020 www.jstor.org/stable/10.5749/j.cttts95w.4Copy).

Frances, Allen. 2018. "The Sackler Family's Drug Money Disgraces Museums Around the World." *The Guardian.* February 16.

French, Stephanie. 1991. "The Corporate Art of Helping the Arts." *Public Relations Quarterly,* 36, 25–27; cited June 15, 2020. https://search-ebscohost-com.proxy.libraries.rutgers.edu/login.aspx?direct=true&db=bsh&AN=9705306659&site=ehost-live.

Frey, Bruno S. 1998. "Superstar Museums: An Economic Analysis." *Journal of Cultural Economics,* 22, 113–125. https://doi-org.proxy.libraries.rutgers.edu/10.1023/A:1007501918099 (Retrieved December 6, 2020).

Gianneschi, Marcus, and Oskar Broberg. 2020. "A History of Cultural Sponsorship in Sweden." In *Museum Marketization: Cultural Institutions in the Neoliberal Era,* by Karin M. Ekstrom, 208–225. London: Routledge.

Halperin, Julie. 2019. *In an Age of Political Division and Dirty Money, Can Museum Boards Ever be Immaculate? Some Think They Have Found a Solution.* ArtNetNews.

Kimmelman, Michael. 2005. "Art, Money and Power." *New York Times.* May 11: E1 & E6.

Klein, Naomi. 2000. *No Logo: Taking Aim at the Brand Bullies.* Toronto: Knopf Canada.

Lewandowska, Kamila. 2015. "From Sponsorship to Partnership in Arts and Business Relations." *The Journal of Arts Management, Law, and Society*, 45, 33–50. 10.1080/10632921.2014.964818 (Retrieved August 2, 2020).

Lund, Ragnar, and Stephen A. Greyser. 2015. "Corporate Sponsorship in Culture: A Case of Partnership in Relationship Building and Collaborative Marketing by a Global Financial Institution and a Major Art Museum." *Harvard Business School Working Paper Series.* https://www.hbs.edu/faculty/Publication%20Files/16-041_0a81dd11-2e2f-459c-8eca-008f24bb313e.pdf (Retrieved July 21, 2020).

———. 2020. "Integrated Partnerships in Cultural Sponsorship." In *Museum Marketization: Cultural Institutions in the Neoliberal Era*, by Karin Ekstrm, ed., 188–207. Milton Park: Routledge.

Meyer, Karl E. 1979. *The Art Musuem: Power, Money, Ethics.* New York: William Morrow & Company, Inc.

Millington, Ruth. 2019. *Arts Philanthropy: Should Museums Refuse Dirty Money?* September 10. https://www.riseart.com/article/2019-09-10-art-world-news-arts-philanthropy-should-museums-refuse-dirty-money.

Museum Management and Curatorship. 1996. "'He Who Pays the Piper Calls the Tune': Sponsorship, Patronage and the Intellectual Independence of Museums." *Museum Management and Curatorship*, 15(4), 345–350. https://doi.org/10.1016/S0260-4779(97)82033-X (Retrieved November 28, 2020).

Ninetto, Amy. 1998. "Culture Sells: Cézanne and Corporate Identity." *Cultural Anthropology* http://www.jstor.org/stable/656552 (Retrieved November 15, 2020).

Platform. 2021. *History.* May 4. https://platformlondon.org/about-us/history/.

Rectanus, Mark R. 2002. *Cuture Incorporated: Museums, Artists and Corporate Sponsorships.* Minneapolis: Univeristy of Minnesota Press.

Roche Historical Archive. 2016. "Traditionally Ahead of Our Time." *Roche.com.* https://www.roche.com/dam/jcr:34e01314-7411-411e-83e1-2fbc83cc3272/en/histb2016_e.pdf (Retreived November 15, 2020).

roche.com/sustainaibility/philanthropy/arts. 2020. *roche.com/sustainaibility/philanthropy/arts.* November 15. https://www.roche.com/sustainability/philanthropy/arts_culture.htm.

Ryan, Nicky. 2007. "Prada and the Art of Patronage." *Fashion Theory: The Journal of Dress, Body & Culture*, 11(1), 7–24. https://doi-org.proxy.libraries.rutgers.edu/10.2752/136270407779934588 (Retrieved July 28, 2020).

Schiller, Herbert. 1989. *Culture Inc.: The Corporate Takeover of Public Expression.* New York: Oxford University Press.

Schmertz, Herbert. 1987. *Patronage That Pays.* New York: Business Committee for the Arts.

Sethi, S. Prakash, ed. 1974. *The Unstable Ground: Corporate Social Policy in a Dynamic Society.* Los Angeles: Melville Publishing Company.

Silverman, Debora. 1986. *Selling Culture.* New York: Pantheon.

Stam, Deirdre C. 1993 (1990). "The Informed Muse: The Implications of "the New Museology" for Museum Practice." *Museum Management and Curatorship*, 12(3), 267–283. https://doi.org/10.1016/0964-7775(93)90071-P (Retrieved November 29, 2020).

The Broad. 2021. *Richard Prince: Artist Bio.* April 2. https://www.thebroad.org/art/richard-prince (Retrieved April 2, 2021).

The University of Alabama. 2021. *Philip Morris and the Arts*. February 21. https://csts.ua.edu/museum/pm-arts/.

van Aaken, Dominic, Violetta Splitter, and David Seidl. 2013. "Why Do Corporate Actors Engage in Pro-social Behaviour? A Bourdieusian Perspective on Corporate Social Responsibility." *Organization,* 20(3), 349–371. https://doi.org/10.1177/1350508413478312 (Retrieved December 8, 2020).

Vance, Stanley. 1968. "Editorial Comments: Corporations and Culture." *The Academy of Management Journal,* 11(4), 364–366 www.jstor.org/stable/254884Copy (Retrieved June 27, 2020).

Witte, Arnold. 2020. "The Myth of Corporate Art: The Start of the Peter Stuyvesant Collection and Its Alignment with Public Arts Policy in the Netherlands, 1950–1960." *International Journal of Cultural Policy,* 27(3), 344–357. 10.1080/10286632.2020.1746291 (Retrieved November 27, 2020).

Wu, Chin-tao. 2002. *Privatising Culture: Corporate Art Intervention since the 1980s.* London: Verso.

Chapter 5

Cultural Responsibility and the Public Good

The creative economy is not yet recognized as a distinct segment of impact investing, and targeted financial products, standards, and metrics all need to be developed. But if we figure out how to bring the capital, creative people will find the solutions. When creative people pursue businesses that have a social purpose, they can have a catalytic impact on job creation, the economy, and social well-being. And that benefits everybody.

Laura Callanan

The 1980s witnessed a deep recession in the United States and the collapse of commercial building construction as well as the restructuring and downsizing of many companies. The publication in 1982 of the bestseller *In Search of Excellence*, by Tom Peters and Robert Waterman Jr., marked a new era in the corporate focus on quality, reputation, and transparency (Peters and Waterman, 1984). The book became popular because it was both practical and conceptual and stressed the importance of values and culture. New beliefs about the role of business in society since then have increased the pressure on businesses to transparently target goals beyond financial gain for the benefit of multiple stakeholders.

The tension between business versus social value has led to multiple approaches, theories, and practices. In 1984, Ed Freeman introduced "stakeholder theory" into the CSR dialogue to explain a corporation's multiple responsibilities beyond shareholders inside and outside of the organization (Freeman, 1984). In an attempt to achieve both social and business goals, many companies turned to strategic philanthropy to achieve business goals, bolster their reputation, and prove to stakeholders the value of corporate citizenship. As early as 1999, Michael Porter and Mark

DOI: 10.4324/9781003099222-6

Kramer were addressing the inability of corporate philanthropy to deliver measurable value to a company. The practice of corporate philanthropy was under siege, with some business writers calling for a redirection of funds on the grounds that charity does not help a brand, nor is it the most effective way to make social change. The Committee Encouraging Corporate Philanthropy (CECP) was created, in part, as a response to the issue in 1999, when the conversation around business responsibility to society was advancing (CECP, n.d.). Porter and Kramer followed up in 2006 with a specific proposal for developing the role of philanthropy in creating a competitive context. In 2011, they published a seminal article on "creating shared value," leading to a movement that sought to legitimate a bigger role for business in society (Porter and Kramer, 2011). Building on Porter and Kramer's earlier work, this shared-value approach advises companies to develop a competitive advantage by seeking points of profitability at the intersection of business opportunities and social challenges.

In 2002, Charles Handy suggested a greater purpose for business beyond generating profit and wealth (Handy, 2002). Many scholars followed in his footsteps to refine the business and social ramifications of balancing corporate stakeholder expectations. In 2007, Michael Barnett introduced the "construct of stakeholder influence capacity (SIC): the ability of a firm to identify, act on, and profit from opportunities to improve stakeholder relationships through CSR" (Barnett, 2007). The following year CB Bhattacharya, Daniel Korschun, and Sankar Sen published research demonstrating the ability of CSR to build deep relationships with key stakeholders such as employees and customers (Bhattacharya, Korschun and Sen, 2008). In this vein, Corporate Cultural Responsibility provides an opportunity for many consumer-facing companies to engage with like-minded stakeholders within and outside of the company.

At the same time, the role of the nonprofit organization (NPO) in the arts was also undergoing transformation. Museums, as previously discussed, were evolving to produce more earned income and developing more commercial models. Beginning in 1989, the Johns Hopkins Comparative Nonprofit Sector Project (CNP) sought to answer fundamental questions about the role of NPOs in society and developed a framework to describe their associated value in terms of five categories: service, innovation, advocacy, leadership development, and community building (Salamon, Hems and Chinnock, 2000). Subsequent scholarship by CNP discussed the role of NPOs in the arts and their value proposition for society (Toepler, 2001). Grantmakers in the Arts was formally incorporated in 1989, and one of its first major contributions was *Arts Funding: A Report on Foundation and Corporate Grantmaking Trends*, published in 1993. The professionalization of the field led to advocacy for more arts funding. In turn, funders looked for creative ways to measure the impact of their giving, and arts organizations were challenged to develop impact data. Economic-impact studies were a popular means of measuring the value of the arts, especially in community settings. The Business Committee for the Arts (BCA) continued to monitor corporate support and "estimated that arts and culture funding by businesses with at least $1 million in annual revenues grew by 59 percent after

inflation between 1991 and 2000" (Lawrence, 2018). Evidence of renewed interest in creativity was highlighted by Howard Gardner's research around innovation and multiple intelligences (Gardner, 1994), as well as Mihaly Csikszentmihalyi's examination of the psychological basis for discovery (Csikszentmihalyi, 1997). This focus was reminiscent of the 1950s, when business leaders began to embrace creativity as both a business imperative and an opportunity to celebrate individualism and freedom.

Raj Sisodia, and later John Mackey, offered a new model of capitalism built on responsibility to multiple stakeholders that became known as "conscious capitalism" (Rajendra Sisodia, 2007). The movement was exemplified in companies such as Patagonia, Whole Foods, and Southwest Airlines. Although it has not revolutionized traditional capitalism, the trend has inspired new conversations in academia and among business leaders (Vogel and O'Toole, 2011). Jeremy Rifkin has predicted the end of capitalism as we know it, followed by a new age of collaboration where "quality of life, accessibility of resources, sustainability" will replace our traditional notions of market forces (Aspden, 2015).

Lynn E. Stern's 2015 study reflecting the changing nature of Corporate Social Responsibility (CSR) identified the main objectives of corporate engagement in the arts as follows: (1) to enhance corporate investments in community and economic development, education, health, and other priority areas; (2) to promote and reinforce company mission, core values, and brand; and (3) to achieve internal CSR/Corporate Community Involvement (CCI) goals such as employee engagement, volunteerism, and workforce diversity (Stern, 2015). Based on interviews with key corporate leaders in the United States, these findings reflect a greater alignment with multiple stakeholder expectations along with a clearer business rationale for arts support. These drivers represent a shift away from the BCA model, which was the domain of the CEO and promoted arts philanthropy as the primary means of support. Sponsorship, however, has retained its allure for some sectors and companies seeking to enhance their brands: in 2018, support of performing and visual arts organizations, primarily by banks, was estimated to reach $1.03 billion in North America (IEG, 2018).

There is still a great deal of potential in realizing greater alignment with stakeholders through cultural engagement. In the wake of social unrest in 2020, for example, some companies turned to their art collections to produce dialogues around race, discrimination, and social injustice. There are plenty of opportunities for health-care companies to explore collaborations with artists and arts organizations in the area of healing and resilience, particularly in mental health. Companies may also deploy their employees to build capacity in arts organization through pro bono work. Corporate art collections could be shared more broadly with the community and support local education efforts in schools that have incorporated STEAM (Science, Technology, Engineering, Arts, and Mathematics) programs into their core curricula. Finally, companies could leverage their internal design departments to support CSR, community development, diversity, and inclusion goals. Picking up

on earlier efforts, such as the Tiffany-sponsored series at the Wharton School, companies and universities could collaborate to educate the next generation of leaders on the fundamentals of art, culture, and design (Schutte, 1975). As a pioneer in thought leadership around art, design, and commerce, the Aspen Institute could direct the conversation toward MBA curriculum change.

Vitra and Novartis

An innovative example of corporate stakeholder engagement can be found in the German town of Weil am Rhein, where furniture manufacturer Vitra's community-friendly campus has become a showcase for cutting-edge architecture. Founded in 1934, Vitra began to manufacture furniture designed by Charles and Ray Eames and Alvar Aalto for the mass market as early as 1957. The corporate campus was partially destroyed by a fire in 1981, inspiring an innovative architectural reconstruction. Echoing the approach of Adriano Olivetti, company chairman Rolf Fehlbaum engaged leading architects to create factory buildings and public spaces as well as a design museum. Yet whereas Olivetti favored Italian architects and designers, Fehlbaum cast a wide net to seek architects from around the world.

Vitra has become a cultural destination, bringing tourism to the region and fostering international design leadership and education while burnishing its reputation for quality and social responsibility. With more than 300,000 visitors annually, the Vitra campus rivals many major museums in terms of attendance. Most important, the company has redefined the role of the corporation as a design leader. By privileging the design of all facets of its campus, Vitra has created a new model distinct from the traditional corporate campus, museum or collection. As Mark Rectanus has noted, "Vitra explores both the corporation's relations to those who produce design and design's function within the workplace" (Rectanus, 2002). In essence, everything on the campus is grounded in the idea of good design.

Vitra's embrace of collaboration is evidenced in its partnership with the Corning Museum of Glass at Domaine de Boisbuchet, a design retreat that is a cooperative effort by the Vitra Design Museum, the Centre Georges Pompidou, and C.I.R.E.C.A. (Centre International de Recherche et d'Education Culturelle et Agricole), in the Charente region of France (Glass On Line, 2010). Vitra and Corning also collaborated on the Corning Museum's portable hot-glass program known as GlassLab, staging it on the Vitra campus in 2010. It is not surprising that two companies so committed to design would find a meaningful way to collaborate.

Vitra has become a public asset with the ability to educate and inspire. Beyond the corporate campus, Fehlbaum used his influence to organize a design workshop for the surrounding community to reimagine Weil am Rhein (Dixon, 1993). Like Prada, Vitra aligned with leading architects to design its campus. Yet the company commissioned a variety of architects—including Tadao Ando, Frank Gehry, Zaha Hadid, and Herzog & de Meuron—to design radically different buildings, not as a

retail experience but as a public campus. Unlike the Italian fashion company, Vitra is not attempting to merge arts patronage and luxury brand building; it has the broader mission of becoming a global educational resource for the public and an advocate for good design.

Nearby, Swiss pharmaceutical company Novartis embarked on a high-profile investment in architecture and design for its headquarters in Basel after a merger with Sandoz and Ciba-Geigy in 1996. Harking back to earlier efforts by Bell Labs and innovative headquarters designs in Silicon Valley, Novartis leadership assembled an impressive group of architects, including Frank Gehry, Herzog & de Meuron, and SANAA, to create a campus conducive to collaboration and innovation. The Novartis complex carries great "symbolic significance" for the company image yet is not open to the public, whereas Vitra's campus manifests its authentic commitment to design advocacy and cultural responsibility (Todtling, Reine and Dorhofer, 2014). Novartis applied the same level of design rigor to a 230-acre site in East Hanover, New Jersey, continuing what the company terms "design patronage for people's benefit" (Novartis Pharmaceuticals, Corporation 2014). This high-profile project reflects the evolution of corporate campus design to involve a massive re-envisioning of company properties. The Novartis example is distinctive for the company's engagement of outside consultants such as Vittorio Magnago Lampugnani, who advised on both the Basel and East Hanover projects. The long-term vision for the Basel site is part of a 30-year master plan to "alter the company culture by creating a flexible, exciting workplace—most visible through its architecture—to foster employee communication, well-being, and pride of place" (Lentz, 2011). The company also published lavishly illustrated books on each project.

The Art Market

The art market is subject to the same pressures and volatility as any other segment of the global economy. As early as 1999, a new type of investment in the arts, influenced by Wall Street, was evolving in the United States. There were already at least two historical precedents for investing in fine arts. The first private art investment club, Peau d'Ours, was founded by a group of Parisian collectors in 1904, and between 1974 and 1980, the British Rail Pension Fund invested £40 million in art (Frye, 2018). Both were early efforts to tap into the opaque economy of the art world, where value is often calculated with a high degree of subjectivity. Since that time a number of investment initiatives have been launched with varying degrees of success, and a handful of scholars have attempted to create indices to track the value of art as a commodity. Principles of economics and sociology have been called upon to shed light on the important question of value in the arts and return on investment (ROI).

In 1967, the *Times of London* and Sotheby's met the need for data on sales of artworks with the publication of indices to track art market activity in the UK newspaper and in the *New York Times*. According to Erica Coslor, these indices could

"change the perception of art as a potential investment, one that could be easily understood by the layperson" (Coslor, 2011). One of the key moments in the history of art economics was the Sotheby's auction of the Robert Scull collection in 1973. The owner of a fleet of taxis in New York City, Scull became synonymous with the irrationality of the contemporary art market. The infamous sale marked a turning point for art as a commodity because the collector had purchased the works from artists who were struggling financially early in their careers; years later, these artworks sold at dramatically higher prices. Among the economists tackling the mechanisms of the art market early on was Robert C. Anderson, a professor at Tufts University who looked at the value of paintings from 1780 to 1970 with his article *Paintings as an Investment* (Anderson, 1974). The 1970s marked the transition from industrial capitalism to an economy based more on knowledge and information, leading in turn to an increasing awareness of the symbolic value of art. Pierre Bourdieu described symbolic value as that which goes beyond economic quantification (Bourdieu, 1984). However, as Chin-tao Wu pointed out,

> As companies had never entered into the cultural sphere as social agents in such a collectively dominant way as they did in the 1980s, they have yet to be seen as on object of inquiry in terms of their economic positions, social relations and cultural practices, except for a few case studies in which attempts have been made to explore exceptionally notorious instances.
>
> (Wu, 2002)

According to sociologist Olav Velthuis, "the value of an artwork does not reside in the work itself, but is produced and constantly reproduced by the artist, intermediaries, and the audience" (Velthuis, 2003). Among the many influences on the art market are intangibles related to taste, timing, and geography, further complicating efforts to define and quantify value. Through his analysis of art markets in New York and the Netherlands, Velthuis attempted to unpeel the complex layers related to the pricing and selling of art. While his research focused on the art market in general, Velthuis made an illuminating analysis of the art dealer, characterized as operating in two worlds: (1) the capitalist context of supply and demand and buying and selling, and (2) the cultural context of imbuing meaning to works of art much like a museum or a critic (Velthuis, *Talking Prices: Symbolic Meanings of Prices on the Market for Contemporary Art*, 2005). The art dealer is on the frontline of both manipulating and navigating the tension between the economic and symbolic values of art.

Thomas Fillitz, a professor of social and cultural anthropology, examined three sectors of the art market—auctions, galleries, and art fairs—to develop some fascinating distinctions in the context of globalization (Fillitz, 2014). His analysis was organized in terms of "three logics": "The auction market and the logic of gambling," "The gallery market and the logic of a moral economy," and "Art fairs and the logic of glamour." While Fillitz describes the type of value derived from each element of

the art market, his focus on art fairs is perhaps the most instructive. Developed in the 1970s, starting with Art Basel, fairs became a market norm after 2000, and by 2010, there were "156 art fairs that deal exclusively with modern and contemporary art" (Ehrmann, 2010). Among the giants, Art Basel Miami was launched in 2002 and Frieze London in 2003, followed by Frieze New York in 2012. These fairs attract corporate sponsors such as UBS, Deutsche Bank, and BMW.

The profile of contemporary art rose dramatically after the Scull auction, and investors began to view the art market as an exciting new commodity to buy, sell, and trade. The advent of art stardom, epitomized by Andreas Gursky and Julian Schnabel, made becoming an art collector an enticing path for successful Wall Street traders. A 2011 magazine article listing "Wall Street's 25 Most Serious Art Collectors" included Steven Cohen, Henry Kravis, Donald Marron, and Wilbur Ross (Wachtel, 2011). Two striking facts about this lineup: they are (or were) all ultra-wealthy men and most of them have served as board members or advisors to prominent museums and arts organizations. Many of these individuals were certainly attracted to the art world as a way to acquire or enhance cultural capital. As Laurie Hanquinet explains,

> As has been long established by now, cultural capital combined with economic and social capital positions individuals in the social space and shapes their cultural consumption by providing symbolic access to some cultural genres and items and limiting it to others.
>
> (Hanquinet, 2017)

William Goetzmann has been investigating the relationships between wealth, luxury consumption, and the value of art since the early 1990s. An article he wrote in collaboration with Luc Renneboog and Christophe Spaenjers in 2010 concludes that "it is indeed the money of the wealthy that drives art prices. This implies that we can expect art booms whenever income inequality rises quickly" (Goetzmann, Renneboog and Spaenjers, 2010). In 2000, Richard Caves applied economic contract theory to explain the inner workings of the art world (Caves, 2000). In 2002, Jianping Mei and Michael Moses, professors at New York University, developed an index to track the value of American, nineteenth-century, Old Master, Impressionist, and Modern paintings from publicly available auction records (Mei and Moses, 2005). The Mei Moses Indices, acquired by Sotheby's in 2016, generated some interesting conclusions, such as the underperformance of masterpieces and the potential of art investment as part of a broader investment strategy.

It is no surprise that the tech boom triggered disruption in the art market. After spending the early part of her career in the digital industry, Jen Bekman established her own traditional art gallery on the Lower East Side of Manhattan in 2003. She followed in the 2007 with 20 × 200, an online gallery selling art editions at affordable prices—an ideal marriage of accessible art and instant gratification. According to *Fast Company*, "Since its launch, 20 × 200 has sold more than 65,000 prints by

both emerging and established artists, and in 2009, 20 × 200 received $885,000 in funding in a Series A round led by True Ventures" (Walker, 2010).

In the art auction arena, Paddle8 has played the role of disruptor, most recently engaging in online sales of curated street art and providing the art market's first blockchain authentication service. Sotheby's has been experimenting with artificial intelligence through its acquisition of Thread Genius, a startup providing the ability to predict buyers' behavior in the future. Emerging in 2017, Masterworks allows investors to purchase blue-chip art using a proprietary data base that tracks its value (Masterworks, 2020). Snark.Art, also founded in 2017, "uses blockchain to connect disruptive artists to consumers in a more effective and far-reaching way." In the wake of the COVID-19 pandemic, it announced a selling platform with a unique revenue model that shares profit with artists (Snark.Art, n.d.). This new breed of entrepreneurial tech incorporating cultural responsibility presents a promising model for the future.

Much of the disruption in the art market has been engendered by the perception that buying and selling art is the domain of the privileged and powerful. It is no wonder that the perception of elitism has led to alternative voices and practices. As one of the pioneering digital leaders, Yehudit Mam, co-founder of DADA.nyc, states in a blog advocating the use of blockchain and cryptocurrency:

> The people who champion artists, collect them, anoint them or ignore them, inflate their prices, and market them are certainly essential to this particular ecosystem, but only artists can be art leaders. We have reached a stage in which art business has successfully made art an intimidating fortress of wealth and connections that alienates the vast majority of people and of artists. How can this possibly be good for art?
>
> (Mam, 2018)

Creativity and Capital

Although arts and culture have been part of community-development efforts for many decades, today there are limited products and funds available to investors interested in directing their capital to these creative efforts, especially for low-income communities. According to Cora Mirikatani,

> This new breed of creative philanthropic investor might be characterized as having a generally high tolerance for risk and uncertainty, an interest in learning, and the flexibility to find and act on the best talent, ideas, and programmatic opportunities available in the field.
>
> (Mirikatani, 1999)

The Creative Capital Foundation was cited as an early effort to think differently about supporting the arts and creators. Not surprisingly, there are funds where

investors pool resources to buy and sell art. The Fine Art Fund was established in 2004, and Meridian Art Partners created an emerging art markets fund in 2008. A different model is V22, where investors buy shares of an arts organization, for example, a collection, a gallery, and even artist studios (Chong, 2010).

Although art and cultural organizations have seemingly missed out on the boom in venture philanthropy, there are some promising models in the United States, such as Creative Capital and the Working Capital Fund at the Ford Foundation. There are early examples of impact investment in many areas of global development, but the field has remained challenging in terms of opportunities to create social impact in the context of art and culture. There have also been efforts that embrace financial technology (fintech) to bring more speed and efficiency to informing art investors. For the last two decades, Deloitte has been an active voice in advising on art as an emerging asset class. A 2010 Deloitte report predicted "a new era for the art markets and for the benefit of society as a whole by fostering culture, knowledge, and creativity" (Picinati di Torcello, 2010).

The World Economic Forum has collaborated with the Schwab Foundation for Social Entrepreneurship to develop a Cultural Leaders network that focuses on best practices to demonstrate the cultural dimensions inherent in all major societal issues (Peterhans and Raja, 2020). Germany, Italy, and Spain are leading a European effort to create a fund supporting culture in the wake of the pandemic. The rationale for Pirelli, one of the many companies backing this fund, is as follows:

> Culture also needs air, because its thousands of institutions—large and small, central and peripheral, public and private—are the lung of a country. And it would be a great thing—and indeed, a necessary step— if the Italian people, who are proving so prodigious with their donations in these tragic days, were to take a central role within a fund that serves to keep that lung alive.
>
> (Fondazione Pirelli, 2020)

A promising example of a pioneer in facilitating creative investment is Upstart Co-Lab, founded in 2015 as a "bridge between artists, creative entrepreneurs, and the impact investors whose funding will enable them to grow and scale their work." Led by Laura Callanan, the organization is poised to apply the expertise and rigor of social investment tempered by lessons learned from philanthropy and government funding of the arts. In 2019, Upstart Co-Lab partnered with the Local Initiative Support Corporation in New York City to create the Inclusive Creative Economy Fund, which makes facility-related loans to arts organizations. The following year Upstart announced a collaborative funding coalition with other art-related funders, including the Souls Grown Deep, BRIC, and Bonfils-Stanton Foundations (Schultz, 2020). By recognizing the role of the global creative economy, Upstart has the potential to disrupt social-impact space and provide opportunities for investors to fund cultural projects and mobilize money. Reporting evidence of impact will be a key factor in determining the future scale of this effort.

The B Corporation movement has also seen culturally related businesses evolve. It is encouraging that 10% of certified B Corps in the United States are situated in the creative industries. There are now more than 3,000 B Corporations in 71 countries, mostly small businesses. For example, 2b design started when two entrepreneurs became concerned about the disappearing architectural heritage of Lebanon. The business takes artifacts such as "discarded old wrought iron balustrades, railings, window frames, and other pieces of architectural salvage which at best would have ended up melted down into car parts" and transforms them into functional design objects (2b design, 2020). The company also hires and trains marginalized individuals in new skills and trades.

Business and Society: A Relationship at a Turning Point

In August 2019, the Business Roundtable (BRT) issued a statement that may shift the conversation around the role of business in society for the next few decades (Roundtable, 2019). In essence, it pointed to a more engaged role for the private sector in all aspects of society. In other words, business has the potential to add much greater value to stakeholders well beyond the direct shareholder. Momentum is building to re-envision capitalism, with some calling for its elimination and rebirth (Petriglieri, 2020). There is clearly a real push toward a more human-centered approach to profit and purpose.

What this turning point means for Corporate Cultural Responsibility remains to be seen. A socially responsible approach to supporting, advancing, and preserving culture is among the most obvious ways that business can create value for society. This affirmation of the importance of culture is a clear path to regaining the social acceptance that the private sector has lost in the past few decades. There is a great deal of potential for the business sector to collaborate with the arts to drive social innovation. In other fields, some promising partnerships have appeared in the last few decades among the most unlikely collaborators, for example:

> NIKE, Inc., NASA, the U.S. Agency for International Development and the U.S. Department of State convened 150 materials specialists, designers, academics, manufacturers, entrepreneurs, and NGOs this week to catalyze action around one of the world's biggest challenges— the sustainability of materials and how they are made.
>
> (Nike, 2013)

It is natural to assume that similar collaborations would be fruitful in solving cultural issues important to governments, society, and business. Social innovation has become a common practice in all sectors and is increasingly applied to CSR efforts. Many collaborations adopt "open-source methods of innovation, innovations with a social purpose, social entrepreneurship, or innovation in public policies and governance" (Sanzo, Álvarez and Rey, 2015). In Europe, creative culture partnerships are

referenced in the "Work Plan for Culture 2011–2014," adopted by the Council of the European Union to "help transfer creative skills from culture into other sectors" (Council of the European Union, 2010). As an example, Lisa Russell, art activist and filmmaker, has called for more engagement of artists in global development efforts. Clearly, the rationale and need for increased collaboration between business and the creative sector is abundantly evident.

Bibliography

2b design. 2020. *2b Design.* July 12. https://www.2bdesign.biz/about-us.

Anderson, Robert C. 1974. "Paintings as an Investment." *Economic Inquiry,* 12(1), 13–26. https://onlinelibrary-wiley-com.proxy.libraries.rutgers.edu/doi/pdfdirect/10.1111/j. 1465-7295.1974.tb00223.x (Retrieved November 6, 2020).

Aspden, Peter. 2015. "Art and the End of Capitalism.*" Financial Times,* March 6. https://www. ft.com/content/c705e7a8-c259-11e4-ad89-00144feab7de (Retrieved April 2, 2021).

Barnett, Michael L. 2007. "Stakeholder Influence Capacity and the Variability of Financial Returns to Corporate Social Responsibility." *The Academy of Management Review,* 32(3), 794–816. http://www.jstor.com/stable/20159336 (Retrieved August 9, 2020).

Bhattacharya, C. B., Daniel Korschun, and Sankar Sen. 2008. "Strengthening Stakeholder– Company Relationships Through Mutually Beneficial Corporate Social Responsibility Initiatives." *Journal of Business Ethics,* 85(S2), 257–272. https://www. researchgate.net/publication/227105764_Strengthening_Stakeholder-Company_ Relationships_Through_Mutually_Beneficial_Corporate_Social_Responsibility_ Initiatives (Retrieved August 10, 2020).

Bourdieu, Pierre (trans. Richard Nice). 1984. *Distinction: A Social Critique of the Judgement of Taste.* London: Routledge and Kegan Paul.

Business Roundtable. 2019. *Statement on the Purpose of a Corporation.* August 19. https:// opportunity.businessroundtable.org/ourcommitment/.

Caves, Richard E. 2000. *Creative Industries: Contracts between Art and Commerce.* Cambridge: Harvard University Press.

CECP. n.d. *About Us.* https://cecp.co/about/ (Retrieved May 18, 2021).

Chong, Derrick. 2010. *Arts Management.* London: Routledge. https://doi. org/10.4324/9780203865347.

Coslor, Erica. 2011. *Wall Streeting Art: The Construction of Artwork as an Alternative Investment and the Strange Rules of the Art Market Diss.* Chicago: University of Chicago. https://search-proquest-com.proxy.libraries.rutgers.edu/docview/894260326?pq-origsite=summon (Retrieved August 5, 2020).

Council of the European Union. 2010. *Work Plan for Culture 2011–2014.* Brussels: Council of the European Union. https://www.consilium.europa.eu/uedocs/cms_data/docs/ pressdata/en/educ/117795.pdf (Retrieved August 2, 2020).

Csikszentmihalyi, Mihaly. 1997. *Creativity: Flow and the Psychology of Discovery and Invention.* New York: Perennial.

Dixon, J. M. 1993. "The Vitra Campus: A Furniture Company Enlists Star Architects in Its Efforts to Create a Harmonious Factory Complex." *Progressive Architecture* 60–63.

Fillitz, Thomas. 2014. "The Booming Global Market of Contemporary Art." *Focaal* 84–96. http://dx.doi.org.proxy.libraries.rutgers.edu/10.3167/fcl.2014.690106 (Retrieved December 6, 2020).

Fondazione Pirelli. 2020. *A Fund to Save Cultural Enterprises, Too: They Are the Cornerstones of Community and Economic Development*. April 6. https://www.fondazionepirelli.org/en/corporate-culture/blog/a-fund-to-save-cultural-enterprises-too-they-are-the-cornerstones-of-community-and-economic-development/ (Retrieved January 30, 2021).

Freeman, R. Edward. 1984. *Strategic Management: A Stakeholder Approach*. Boston: Pitman.

Frye, Brian L. 2018. "New Art for the People: Art Funds & Financial Technology." *Law Faculty Scholarly Articles*. https://uknowledge.uky.edu/cgi/viewcontent.cgi?article=1620&context=law_facpub (Retrieved July 18, 2020).

Gardner, Howard. 1994. *Creating Minds: An Anatomy of Creativity Seen Through the Lives of Freud, Einstein, Picasso, Stravinsky, Eliot, Graham, and Gandhi*. New York: Basic Books.

Glass On Line. 2010. "Corning Museum of Glass Brings GlassLab to the Vitra Design Museum." *Glass On Line*. May 6. https://www.glassonline.com/corning-museum-of-glass-brings-glasslab-to-the-vitra-design-museum/ (Retrieved August 29, 2020).

Goetzmann, William N., Luc Renneboog, and Christophe Spaenjers. 2010. " Art and Money (April 28, 2010)." *Yale ICF Working Paper No. 09–26*. TILEC Discussion Paper No. 2010–002, CentER Discussion Paper Series No. 2010–08, Available at SSRN. https://ssrn.com/abst (Retrieved November 6, 2020).

Handy, Charles. 2002. "What Is a Business for?" *Harvard Business Review* 65–82. SSRN: https://ssrn.com/abstract=932676

Hanquinet, Laurie. 2016. "Place and Cultural Capital: Art Museum Visitors Across Space." *Museum and Society*, 14, 65–81. https://journals.le.ac.uk/ojs1/index.php/mas/article/view/677/630 (Retrieved August 10, 2020).

IEG. 2018. "Sponsorship Spending on the Arts to Total $1.03 Billion in 2018." *IEG Sponsorship Report*. March 12. http://www.sponsorship.com/Report/2018/03/12/Sponsorship-Spending-On-The-Arts-To-Total-$1-03-bi.aspx (Retrieved August 14, 2020).

Lawrence, Steven. 2018. *Arts Funding at Twenty-Five*. New York: Grantmakers in the Arts. https://www.giarts.org/sites/default/files/29-1-arts-funding-at-twenty-five.pdf (Retrieved July 30, 2020).

Lentz, Linda C. 2011. "Illuminating Novartis." *Architectural Record*. August 16. https://www.architecturalrecord.com/articles/7662-illuminating-novartis (Retrieved March 20, 2021).

Mam, Yehudit. 2018. "What the Art World Needs Now…" *DADA.art*. January 31. https://powerdada.medium.com/what-the-art-world-needs-now-95bb30d802fc (Retrieved May, 5, 2021).

Masterworks. 2020. *Masterworks About Us*. September 6. https://www.masterworks.io/about/about-masterworks.

Mei, Jianping, and Michael Moses. 2005. "Beautiful Asset: Art as Investment." *The Journal of Investment Consulting*, 7(2), 1–7. https://www.researchgate.net/publication/228317792_Beautiful_Asset_Art_as_Investment (Retrieved July 18, 2020).

Mirikatani, Cora. 1999. "The Role of Philanthropy in the Intersection between Culture and Commerce." *The Journal of Arts Management, Law, and Society*, 29(2), 128–131.

Nike. 2013. "Nike, NASA, StateDepartment and USAID Aim to Revolutionize Sustainable Materials." *Nike News*. April 25. https://news.nike.com/news/nike-nasa-u-s-state-department-and-usaid-seek-innovations-to-revolutionize-sustainable-materials.

Novartis Pharmaceuticals Corporation. 2014. *Interaction Leads to Innovation: Transforming a Campus*. San Francisco: ORO Editions.

Peterhans, Linda, and Pavitra Raja. 2020. *Agenda: How Arts and Culture can Serve as a Force for Social Change*. October 29. https://www.weforum.org/agenda/2020/10/how-arts-and-culture-can-serve-as-a-force-for-social-change/ (Retrieved January 17, 2021).

Peters, Thomas J., and Robert H. Waterman. 1984. *In Search of Excellence: Lessons from America's Best-Run Companies.* New York: Harper & Row, Publishers.

Petriglieri, Gianpiero. 2020. "Are Our Management Theories Outdated?" *Harvard Business Review.* June 21. https://hbr.org/2020/06/are-our-management-theories-outdated.

Picinati di Torcello, Adriano. 2010. *Why Should Art be Considered an Asset Class.* na: Deloitte.

Porter, Michael E., and Mark R. Kramer. 2011. "The Big Idea: Creating Shared Value." *Harvard Business Review* 2–17.

Rectanus, Mark R. 2002. *Cuture Incorporated: Museums, Artists and Corporate Sponsorships.* Minneapolis: Univeristy of Minnesota Press.

Salamon, Lester M., Leslie C. Hems, and Kathryn Chinnock. 2000. "The Nonprofit Sector: For What and for Whom?" *Working Papers of the Johns Hopkins Comparative Non-profit Sector Project.* na. http://ccss.jhu.edu/wp-content/uploads/downloads/2011/09/CNP_WP37_2000.pdf (Retrieved July 26, 2020).

Sanzo, Maria Jose, Luis Ignacio Álvarez-Gonzalez, and Marta Rey-Garcia. 2015. "Business–Nonprofit Partnerships: A New Form of Collaboration in a Corporate Responsibility and Social Innovation Context." *Service Business,* 9, 611–636.

Schultz, Abby. 2020. *Invest.* June 25. https://www.barrons.com/articles/upstart-co-lab-creates-member-coalition-to-spur-creative-economy-01593025276 (Retrieved July 17, 2020).

Schutte, Thomas F., ed. 1975. *The Art of Design Management: Design in American Business.* New York: Tiffany & Co.

Sisodia, Rajendra, David Wolfe, and Jagdish Sheth. 2007. *Firms of Endearment: How World-Class Companies Profit from Passion and Purpose.* Philadelphia: Wharton School Publishing.

Snark.Art. n.d. *Snark.Art.* https://snark.art/ (Retrieved May 18, 2021).

Stern, Lynn E. 2015. *Corporate Social Responsibility and the Arts.* New York: Americans for the Arts.

Todtling, Franz, Prud'homme Van Reine, and Steffen Dorhofer. 2014. "Open Innovation and Regional Culture-Findings from Different Industrial and Regional Settings." In *Companies, Cultures, and the Region,* by Nick Clifton, Stefan Gartner, and Dieter Rehfeld, eds., 31–53. London: Routledge.

Toepler, Stefan. 2001. "Culture, Commerce, and Civil Society. Administration & Society." *Administration & Society,* 33(5), 508–522. https://www.researchgate.net/publication/249625222_Culture_Commerce_and_Civil_Society (Retrieved July 26, 2020).

Velthuis, Olav. 2003. "Symbolic Meanings of Prices: Constructing the Value of Contemporary Art in Amsterdam and New York Galleries." *Theory and Society,* 32(2), 181–215. https://doi-org.proxy.libraries.rutgers.edu/10.1023/A:1023995520369 (Retrieved August 2, 2020).

———. 2005. *Talking Prices: Symbolic Meanings of Prices on the Market for Contemporary Art.* Princeton: Princeton Univeristy Press.

Vogel, David, and James O'Toole. 2011. "Two and a Half Cheers for Conscious Capitalism." 53(3), *California Management Review* 60–76.

Wachtel, Katya. 2011. "Meet Wall Street's 25 Most Serious Art Collectors." *Business Insider.* February 7. https://www.businessinsider.com/wall-street-art-collectors (Retrieved August 7, 2020).

Walker, Alissa. 2010. *Fast Company.* April 12. Accessed May 26, 2021. https://www.fastcompany.com/1600932/1600932.

Wu, Chin-tao. 2002. *Privatising Culture: Corporate Art Intervention since the 1980s.* London: Verso.

Chapter 6

Building a Better Case for Support of Culture and the Arts

Five Recommendations

> We need a truly human management, one that makes room for our bodies and spirits alongside our intellect and skills. That cares for what work does and feels and means to us, not just for what we can do at work and how. A management that abjures the relentless pursuit of efficiency and alignment—and celebrates, or even just acknowledges the inconsistencies that make us human.
>
> Gianpiero Petriglieri

As the cases presented in the preceding chapters illustrate, companies that engage stakeholders through the arts, design, and culture are rewarded in both tangible and intangible ways. As José María Herranz de la Casa, Juan Luis Manfredi-Sánchez, and Francisco Cabezuelo-Lorenzo have concluded, "Thus, arts and culture not only work as a tool of corporate branding beyond company products and services, but they help to cultivate a social capital of long-term quality relationships with different categories of stakeholders" (Herranz de la Casa, Manfredi Sánchez and Cabezuelo-Lorenzo, 2015). In this age of transparency, accountability, and digital immediacy, companies are being scrutinized increasingly to determine the authenticity of their cultural responsibility and to assure that their actions measure up to their rhetoric. Stakeholders have an ever-increasing ability to analyze and evaluate company actions.

DOI: 10.4324/9781003099222-7

Building on the lessons learned over the past few decades, there are a number of opportunities to strengthen the connection between art and commerce. The following recommendations combine rethinking older models with responses to changes in society, the workplace, the economy, and our common humanity.

Develop Sustainable Connections between the Arts and Business

There is a rich history of companies inviting artists into the workplace to inspire innovation and creativity. A handful of corporations addressed the tensions between the private and social sectors in the 1960s and 1970s through extended experimental artist residencies. As industrialization gave way to the information economy, companies were seeking to "identify and internalize new approaches in order to adapt their culture, structure, and management systems to external changes" (Schnugg and Song, 2020). Striving to discover new ways to innovate, they looked to the arts community as a natural source of inspiration. In the mid-1960s, Barbara Steveni and John Latham launched the Artist Placement Group (APG), engaging artists such as Joseph Beuys and Yoko Ono. One of its purposes was to organize residencies for artists at industrial and government institutions, such as the British Steel company. Focused on the process of negotiating placements, the forum was more suited to conceptual than traditional art. In other words, the experiential took precedence over the production of traditional art.

In the 1960s, Robert Rauschenberg and Robert Whitman cofounded E.A.T. (Experiments in Art and Technology) with Billy Klüver and Fred Waldhauer, engineers at Bell Labs, to facilitate experimental collaborations at the company (Cizek, Uricchio and Rafsky, 2020). One of the outcomes of the E.A.T. collaboration were a series of multimedia, performance art productions in 1966. In a similar vein, Mel Bochner's residency at Singer Laboratories has been seen as a pivotal experience in his artistic evolution (Domus, 2017). The Los Angeles County Art Museum initiative Art and Technology (A&T) placed artists in businesses from 1967 to 1971. The program provided four potential sponsorship levels to the corporation ranging from full sponsorship which included hosting an artist and receiving a work of art to simple contributing sponsors who would offer services and or modest philanthropic support (Los Angeles County Musuem of Art, 1971). The two most notable examples from the program are Richard Serra's project with the workers of the Kaiser Steel Corporation and Robert Irwin and James Turrell's collaboration with Dr. Edward Wortz, a psychologist at Garrett Aerospace Corporation who was investigating perceptual elements of space travel. Serra's work in the steel mill is discussed more than Turrell's and Irwin's with Garrett. Outside of California, not surprisingly, Cummins was one of the companies to sign on for the program, although the resulting sculpture by Jean Dupuy, in collaboration with company engineers, has been little discussed (De Fay, 2005). In an effort to sustain and normalize these types of collaboration, Stephen Wilson went so far as advocating in 1984 for a new career path: the "industrial research artist" (Wilson, 1984).

In the United Kingdom, Arts & Business (formerly known as the Association for Business Sponsorship of the Arts) has experimented with placing artists in the workplace. The project was created

> soon after the merger of Elida Fabergé and Lever Brothers in 2000, when the Chairmen of the respective companies, James Hill at Lever and Keith Weed at Elida Fabergé, identified the need to provoke a change in culture to encourage creativity and risk taking inside the business.
>
> (Arts & Business, 2004)

The well-documented experiment served as evidence that the arts add value to business in the form of education and development as well as humanizing the workplace. More interesting was a scheme known as the Skills Bank Programme, which placed business-people in arts organizations to nurture capacity building. In a survey, participants said they not only learned more about the arts but also continued to support the sector in some way and were willing to work with other arts organizations in the future. In 2004, the NyX Forum for Art and Business developed a collaborative program in Denmark where "20 artists were paired with 20 companies for 20 days" (Darsø, 2005).

One of the most ambitious artist-in-residence programs was created by Xerox on its Palo Alto Research Campus (PARC) in 1994. Similar to the E.A.T. initiative, it paired fine artists and scientists to explore technologies collaboratively. The project was documented in a book published by MIT press in 1999, although the program ended abruptly the following year (Art and Innovation: The Xerox Parc Artist-in-Residence Program, 1999). Intel initiated a similar collaboration with college and university faculty in 1993 (Plautz, 2005). Google has perpetuated the tradition through Artists + Machine Intelligence (AMI), a program "that invites artists to work with engineers and researchers together in the design of intelligent systems" (Kozanecka and McDowell, 2020). In fact, a whole new genre of art incorporating artificial intelligence has been produced in the past few years (Agüera and Arcas, 2017). Examples of this new hybrid were showcased in the 2020 show *DeepDream: The art of neural networks*:

> The art works in this exhibition are made using artificial neural networks (NN). NNs are a biologically inspired form of computing which, unlike classical computer algorithms, aren't programmed directly by human operators but instead learn from large amount of example data. The networks used in this work are trained with natural images from the environment and learn to distinguish objects and parse them into high level features. ... Once trained, these networks can then also be used to generate new imagery, essentially 'imagining' images based on the learned rules and associations.
>
> (Gray Area, 2020)

On a smaller scale, the Kohler Arts/Industry residency program—founded by Kohler Co. in Sheboygan, Wisconsin, in 1974—has hosted more than 400 artists

in 40 years. The program represents a true collaboration between art and industry, with artists spending three months in residence at the Kohler manufacturing facility. The long-standing partnership was commemorated by an elegantly illustrated book chronicling the rewarding relationships between the company and the artists it has hosted (John Michael Kohler Arts Center, 2014). Corning Glass has also experimented with residencies and still maintains a program where artists come on-site for a month to experiment with glass. The Studio of the Corning Museum of Glass partners with the John Michael Kohler Arts Center in a joint artist-in-residence program where artists spend one month at Corning and two to six months at Kohler.

Other companies hosting artists on their premises include Facebook and Autodesk (Segran, 2015). Outside of the United States and launched in 2015, STARTS (Science, Technology, and the Arts) is an initiative of the European Commission intended to encourage collaboration among all sectors of society around the three disciplines. Although not targeted specifically to business and the arts, the program aspires to have more artists engage with industry to encourage "competitiveness, sustainability, and social inclusion" (European Commission, 2020). This innovative practice of residency programs and targeted collaborations has never reached its full potential and remains an intriguing area for mutual benefit and value creation.

Interest in arts-based learning gained momentum with the publication of two special issues of *The Journal of Business Strategy*, in 2005 and 2010 (Seifter and Buswick, Arts-based learning for business, 2005; Seifter and Buswick, Editor's Note, 2010). In essence, it was argued that creative thinking and arts-related knowledge should be part of traditional leadership and management development as well as MBA programs. Arts-based learning is defined formally as

> a wide range of approaches by which management educators and leadership/organization development practitioners are instrumentally using the arts as a pedagogical means to contribute to the learning and development of individual organization managers and leaders, as well as contributing to organizational learning and development.
>
> (Nissley, 2010)

Both issues highlighted examples of companies that have embraced creativity as part of business practice, including IBM, Samsung, Target, and Unilever. The year 2004 was significant for the attention Daniel Pink received for his assertion that the MFA was the new MBA. The phrase—first used in a commencement speech entitled "Art, Heart, and the Future" at the Ringling School of Art and Design, in Sarasota, Florida—was widely cited (The New MBA, 2020).

Product & Vision, a 2005 collaborative project in Berlin, sought to bridge the divide between art and business with a rigorous set of interventions. In the early stages of designing the collaboration, the organizers sought to answer three questions:

> (a) Is a cooperation between arts and business possible that meets the needs, requirements, and expectations of the artistic as well as the

business sphere?; (b) To what extent can this kind of cooperation contribute to identifying approaches to solve current societal issues?; and (c) How could those approaches possibly be integrated into societal, business, and cultural activities?

<div align="right">(Strauss, 2017)</div>

The results of this ambitious program are difficult to quantify and reveal the complexity of bridging two worlds.

One of the key findings of nascent research into these interdisciplinary collaborations is the lack of focus on results. The missing factor in determining the success of artists' interventions in the workplace is the ability to measure tangible outcomes. More value is placed on process and the experience of the artist in the workplace (Schnugg and Song, 2020). Yet, the rich history of artist-in-residence programs offers a great opportunity to measure the effectiveness of these programs on both the artist and the workplace. A 2013 study funded by the European Commission is a promising step in the right direction. Researchers examined 268 publications related to artist residencies in the business setting and found evidence of measurable effects (Berthoin Antal and Strauß, 2013). They grouped the results into the following eight categories: strategic and operational impacts, organizational development, personal development, relationships, collaborative ways of working, artful ways of working, seeing more and differently, and activation. Countries where these interventions were implemented include Belgium, Denmark, Germany, Sweden, and the United Kingdom.

The concept of residencies holds great promise in terms of Corporate Cultural Responsibility (CCR). Since corporations have become more and more sophisticated in measuring leadership skills as well as employee engagement, this model could easily be tested and applied in a more formal and large-scale approach. Recent research has shown that "partnerships between business and arts organizations have an impact on an organization's creativity and learning, as well as on building relations with communities and stakeholders" (Lewandowska, From Sponsorship to Partnership in Arts and Business Relations, 2015). In addition, a 2014 study commissioned by Adobe revealed a number of business benefits associated with creativity in the workplace (Forrester Research, Inc., 2014). Although the research was conducted mostly among software-development professionals, the findings clearly showed that creativity was a key element of the workplace and culture of successful companies.

In 2017, Nokia Bell Labs partnered with the New Museum to reinstate the E.A.T. program in the form of a year-long artist residency. According to Lindsay Howard,

> The artists are granted traditional Bell Labs privileges: access to the company's research, tools, resources, and fabrication studios as well as the freedom to explore countless avenues of research in order to identify relationships and areas of interest, open collaboration with researchers who are exploring everything from machine learning to multi-touch sensors, and a long-term scope to try, perhaps fail, learn, and try again.

<div align="right">(Howard, 2017)</div>

By revisiting its historical connection to art and artists, Nokia Bell Labs is reinventing a form of cultural responsibility once popular among companies in the tech industry. Similarly, LACMA has resurrected Art + Technology and in its new incarnation it

> performs matchmaking between tech players and contemporary artists to produce art on the cutting edge. Ferrying a lean four to six projects a year, it enlists the resources of companies from SpaceX to Snap to realize a vast array of works involving machine learning, 3D printing, robotics, extended realities, and more.
>
> (Chen, 2021)

In its revival of E.A.T., renamed E.A.T. Now, Nokia Bell Labs has a great opportunity to codify and measure the social and business impacts of the project. As technology advances more and more rapidly, the value of artists' interventions for IT and technology companies becomes even more critical. The arts have at their core the potential to amplify "humanistic values such as spirituality, ethics, purpose, and culture" (Schnugg and Song, 2020). These principles are particularly relevant in the advancement of cultural diversity and human development. The mission of E.A.T. Now

> is to break down barriers that exist between people/race/culture/religion by enabling higher order modes of communication beyond our basic spoken and written word. Our goal is to invent technology that will augment our senses and enable new forms of communication, interaction, and sharing between people.
>
> (Nokia Bell Labs, 2020)

Realizing (and measuring) these goals will build better bridges between art and commerce while elevating the quality of CCR.

One of the valuable insights gleaned from the PARC and other multidisciplinary collaborations is the potential of spatial design to encourage the free flow and exchange of information. The concept of open innovation was formally introduced by Henry Chesbrough in 2003, encouraging companies to explore internal and external sources of ideas in new ways (Chesbrough, 2003). Thought leaders such as John Seely Brown and John Hagel III continue to influence corporations in their quest for well-designed laboratories, factories, and headquarters. At the core of Novartis's vision for its new campus in Hanover, New Jersey, was the aspiration for a place where associates could "collide, connect, and cross-pollinate ideas" with the help of design, landscape, and artwork. Its reimagining was preceded by changes at the company's headquarters in Basel, Switzerland, called the "Site of Knowledge," with its New Jersey counterpart designated the "Campus of Innovation" (Novartis Pharmaceuticals Corporation, 2014).

Celebrate and Preserve Indigenous Art, Architecture, and Culture

In the context of "conscious capitalism," Raj Sisodia and Michael Gelb have chronicled the efforts of a number of companies to deliver value and "healing" to their stakeholders. In 2019, they highlighted Jaipur Rugs Company as an example of a business that is making the world a better place for its employees, customers, communities, and investors while producing a well-designed and executed product (Sisodia and Gelb, 2019). The Jaipur Rugs Foundation, founded in 2004 by company director Nand Kishore Chaudhary, provides a sustainable model for emerging economies that addresses the needs of multiple stakeholders. The approach was popularized by the late C.K. Prahalad, who changed the way we see the poor as consumers seeking value through his book *The Fortune at the Bottom of the Pyramid* (Prahalad, 2006). Prahalad's MBA students at the University of Michigan developed a case study on Jaipur Rugs as a progressive model of a business with a social conscience (Anderson et al., 2009). They framed the successful elements of the Jaipur model in four categories: paying competitive wages that enable employees to enjoy a better quality of life compared with workers in other villages; investing in skills training and leveraging government subsidizations of the cost of looms and learning; providing access to health care and education through partnerships with relevant NGOs that support the weavers; and providing opportunities for aspiring entrepreneurs through loans to make them feel invested in the production process. This rural community development model has empowered and supported individuals to make products valued for their aesthetic and technical excellence. The 40,000 Indian artisans employed by Jaipur Rugs are treated with dignity and respect and serve as the key to the company's success. The company's high-quality products are sold by upscale retailers and available globally through a network of distributors (Figure 6.1).

The Jaipur business model balances three major realities of twentieth-century commerce: globalization, sustainable business practices, and CSR. One of the keys to the company's success was its establishment of the nonprofit Jaipur Rugs Foundation to address the health and well-being of weavers and their families. As Ruchi Tyagi noted,

> They have mastered the arts of making productive use of their natural environment, managing their economic development, and structuring their social organization; protecting and maintaining the social diversity to which rural communities contribute; an integrated, all-inclusive approach in which, logically, efforts to identify economic opportunities, ecological constraints, and social expectations should all proceed hand in hand.
> (Tyagi, 2012)

This integrated model epitomizes CCR in its delivery of sustainable social and business value with an added high degree of artistic integrity and human development.

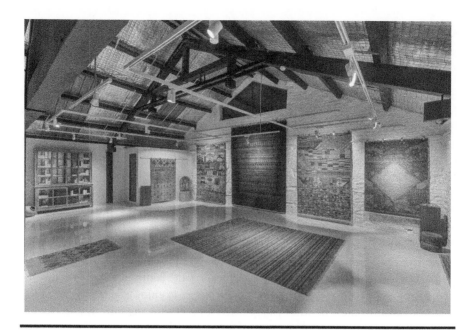

Figure 6.1 Jaipur Rugs, Mumbai Retail Store. Photo courtesy of Jaipur Rugs

As a model of social responsibility, Jaipur Rugs demonstrates that CCR can be an inherent element of business strategy for an enterprise of any size. At its core is a focus on the health and welfare of the artisan, creating value in turn for the community, the consumer, and the business. The model has proven sustainable in the long term and has been replicated in Ghana and Ethiopia by the TIE (Tradition, Innovation, Entrepreneurship) Initiative. The simple premise behind Jaipur Rugs and TIE is to open global markets to locally produced goods while privileging the artisan (Figure 6.2). By embodying the criteria of the CCR framework, these businesses demonstrate the benefits of preserving and celebrating indigenous traditions in markets and communities around the world.

A hybrid example that honors the artisan while delivering profit is Liya Kebede's Lemlem Foundation and its partnership with H&M. The African fashion brand produces clothing and objects created by female traditional artisans in Ethiopia, and its profits support health and education efforts (Feitelberg, 2021). Similarly, BlinkNow, part of a women's empowerment project, sells objects created by artisans in rural Nepal to support the community (BlinkNow, 2021). In 2012, the Aspen Institute created the Artisan Alliance in partnership with the US Department of State as a resource for consumers and entrepreneurs interested in supporting the sustainable growth of more than 240 artisan businesses around the world. For example, RefuSHE is a social enterprise in Kenya that produces clothing and fashion-related goods as a means of generating income to support young refugee girls.

Figure 6.2 Issahaku Taiba, TIE Global Artisans, Tamale, Ghana. Photo courtesy of Pyxera Global

Another area of potential growth in CCR is business support of cultural heritage sites. Beginning in the 1970s in Europe, architectural heritage became a sector of economic potential, especially in terms of tourism. The number of historic sites in the United States and Britain, for example, grew exponentially in the 1980s (Corsane, 2005). Although many companies have funded historic preservation and adaptive-reuse projects, there has been no concerted effort to link these efforts to the overall sustainability practices of the private sector. According to the *Directory of Corporate Art Collections*, companies in five countries—Italy, Japan, South Africa, South Korea, and Spain—are leading the way in support for cultural heritage projects (S. R. Howard, 2017). American Express has been a consistent champion of cultural heritage with the rationale that it is both good business and good for society. Ever since the company launched its famous campaign to help restore the Statue of Liberty in 1983, cause-related marketing (CRM) has become a common approach for companies seeking win-win promotional strategies. Although cultural heritage has rarely been the focus of CRM ventures, it could easily become the cause of choice for culturally responsible companies.

A study from 2001 made a compelling argument that cultural preservation directly supports sustainability (Starr, 2012). UNESCO has been advocating "the role of culture, creativity, and artistic innovation as both drivers and enablers of development" and is collecting documented evidence (UNESCO, 2017). A follow-up report was issued in 2018 with emphasis on the role of culture in development, focusing on areas such as the building of sustainable cities (UNESCO, 2018). Unfortunately, the UNESCO reports show little in the way of public-private partnerships; a section on its website lists a small number of "private sector" partnerships. However, there remains some tension among those involved in defining architecture's role in the creative economy. As Ashley Paine, Susan Holden and John Macarthur point out,

> ...architecture is known to be of monetary value in the cultural economy as well as in the property and construction economy, but quite why it has a 'cultural' value that represents money is obscure, lost between the arcane and exclusive language of the profession on the one hand, and the transcendent values that building have if they are considered heritage.
>
> (Paine, Holden and Macarthur, 2020)

Italy's experimentation in corporate sponsorship of major monument restoration has had mixed results. With more than 60% of world's cultural heritage, including a staggering number of UNESCO World Heritage Sites, the country is under great pressure to preserve its historic resources. In a forward-looking initiative, the Italian government asked Olivetti to sponsor an exhibition on endangered cultural heritage following the floods in Florence in 1968. The company provided financial support and lent its expertise for exhibition design, marketing, and graphic design of catalogs and posters (Kicherer, 1990). In 1982, the Minister for Cultural Heritage invited Olivetti to be the sole sponsor the restoration of Leonardo da Vinci's *The Last Supper*, at the Convent of Santa Maria delle Grazie, in Milan (Ventura, Cassalia and Della Spina, 2016). However, it is unclear what benefits the company accrued from the project beyond reputation and goodwill.

Tod's support of the Roman Colosseum is a recent example of an attempt to satisfy a commercial need (promotion) by fulfilling a societal need (cultural heritage preservation). The company has invested €25 million over five years, taking advantage of a tax incentive introduced in Italy to increase private support of public art and architecture (Gianecchini, 2020). It is curious that so few corporate leaders have embraced cultural heritage as an area of socially responsibility. Bulgari's CEO, Jean-Christophe Babin, explains the motivation behind the company's support of the restoration and exhibition of the Torlonia marbles, a collection of Greek and Roman classical sculpture: "Private companies constitute the economic and social structure of a country, and they must do their part for cultural growth, as much as possible" (Silver, 2020). With Olivetti's home base, Ivrea, and the company town Crespi d'Adda now designated as UNESCO sites, it seems that Italy's business sector may have an even greater role to play in historic preservation.

In the past 30 years, the arts have been called upon increasingly to help regenerate urban centers. Recent scholarship has sought to disentangle the elements of successful projects integrating culture as a development tool, for example:

> Culture-led regeneration is effective if culture is enabled to function as a 'translation device' among different spheres of the urban realm that deploys new problem-solving strategies to key planning problems. Consequently, no culture-led regeneration project may reasonably succeed at this scale without a real attempt at mobilizing and involving the local community in order to generate substantial and permanent changes as to how urban issues are perceived, tackled, and solved.
>
> (Ferilli et al., 2017)

One of the most prominent examples of a lost opportunity for cultural value in a regeneration project is the Pirelli development of Bicocca, where the marketing of tangible assets such as the buildings was overemphasized while community participation was ignored. As Pierluigi Sacco and Giorgio Tavano Blessi explain, "The emphasis on culture was officially motivated as a means to improve social cohesion, reinforce the identity of the place, and provide opportunities for the human development of the new and old local communities" (Sacco and Tavano Blessi, 2009). Even though the regeneration included the building of a new theater and museum, Bicocca lacks the cultural vibrancy and social cohesion that characterize a sustainable community. The challenge of reinvigorating post-industrial sites is highlighted in the case of Bethlehem, Pennsylvania, where city leaders have focused on using art, culture, heritage—and gambling—to spark growth after the demise of Bethlehem Steel. The company employed up to 30,000 workers and occupied a vast expanse of land on the south side of the city. Like other industrial cities, Bethlehem has been forced to transform an urban identity dominated by a former corporate presence (Kennedy, 2014).

Preserving modern architecture and design has become a growing concern in the last few decades as many corporate campuses have been abandoned or become obsolete. Through organizations such as Docomomo, companies and developers can be held more accountable for the way they handle corporate real estate. In the case of the Bell Labs complex in Holmdel, New Jersey, discussed in Chapter 3 and designed by Eero Saarinen, the Tri State chapter of Docomomo led a three-day design charette in collaboration with many other individuals and organizations to inspire and document the many ways the landmark could be reused while preserving the integrity of the building and landscape. Today, the site is a thriving hub of businesses and public resources that returns value to local residents as well as its tenants. The former corporate campus has become a cultural and civic space with a branch of the public library as well as acres of walking paths. What could have been a regrettable outcome for Modernism and the community became a transformative asset. This sort of process could be made part of an agreement when corporate projects are initiated to avoid the eventuality of an abandoned site.

Employ Art to Bridge Differences and Create Social Change

A final area of growing importance for the role of corporations in advancing humanity became clear in the wake of the racial strife triggered by the killing of George Floyd, in April 2020. Companies, as a result, have started playing more active roles in efforts to achieve greater diversity and equity inside and outside of corporations. There is also the opportunity to exercise a whole new level of CCR by supporting arts and humanities programs that educate and heal. For example, a number of corporate donors stepped forward to support the Smithsonian National Museum of African American History & Culture's initiative "Talking About Race," created "to help people, educators, communities, and families discuss racism, racial identity and how these concepts shape every aspect of our society from politics to the economy to the nation's culture" (Keyes, 2020). Corporate sponsorships can promote public dialogue and bring awareness to issues of racism and social injustice. Bank of America's sponsorship of the 2021 exhibition *Dawoud Bey: An American Project*, at the Whitney Museum of American Art and the San Francisco Museum of Modern Art, helped to reopen a chapter in American history through the artist's examination of the 1963 bombing of the 16th Street Baptist Church, in Birmingham, Alabama.

It is encouraging to see a shift in acquisition strategy for corporate art collecting too. One example is the

> TD Ready Commitment, a multiyear inclusivity- and diversity-focused program that directs its giving—$1 billion CAD by 2030—in four areas. Arts and culture falls under 'connected communities.' The other areas are environmental, health, and financial security. The bank is also actively acquiring works for its new media and time-based collection, which has been presented in Toronto, with plans to make landfall at public-facing sites in New York.
>
> (Selvin, 2020)

In the post-COVID-19 world, companies may be judged by how much they enhance or improve society or promote and preserve culture. As the next generation of CSR practice matures, the coming years will witness a notable shift in the pursuit of a higher purpose beyond financial gain. This will likely include more engagement in cultural initiatives and inclusive business models. Liz Claiborne demonstrated the possibilities in 1992 when the company collaborated directly with artists to launch the San Francisco Domestic Violence Campaign. Six women artists created powerful images and messages for traditional billboards and transit-stop ads to educate the public and spur activism against domestic violence. The evolving field of social practice, including performance art and community activism, will continue to change commonly held assumptions about the art world. It is unclear what role the private sector will play, but academia has firmly embraced social practice as new area of study within a growing number of university programs (Sholette, 2017).

As Hershey Friedman and William Adler have written, "If capitalism is going to have a future, it has to be concerned about truth, justice, compassion, and the environment" (Friedman and Adler, 2011). Successful brand and identity efforts will be aligned with the needs of stakeholders. As noted earlier, senior executives need to ensure that an "institution's key corporate identity traits are robust, meaningful, and mutually profitable" (J. M. Balmer, 2017). Design thinking may be part of the solution, given its emphasis on problem solving and innovation. It has been fully embraced as a strategy by leading companies, and its business benefits are readily apparent (Sheppard et al., 2018). Walter Paepcke was ahead of his time in organizing the International Design Conference in 1951 around the theme "Design as a Function of Management."

Since most major companies have embraced some version of design thinking, the next step may be to train the discipline on addressing social challenges. Some have compared design thinking to the Total Quality Management movement of the 1980s. As the business community employed this new methodology to improve quality, the practice became normalized and integrated into corporate structures, precluding the need for quality-assurance departments. The same is possible for design thinking as a path to sustainable innovation (Liedtka, Salzman and Azer, 2017). As a business tool, design thinking has the potential to ground us in our common humanity: "Because design is empathetic, it implicitly drives a more thoughtful, human approach to business" (Kolko, 2015).

As Jeanne Liedtka has stated,

> Recognizing organizations as collections of human beings who are motivated by varying perspectives and emotions, design thinking emphasizes engagement, dialogue, and learning. By involving customers and other stakeholders in the definition of the problem and the development of solutions, design thinking garners a broad commitment to change.
>
> (J. Liedtka, 2018)

Engagement, dialogue, and learning are at the core of collaboration; collaboration is often talked about, but strong examples of businesses collaborating with each other are glaringly sparse.

The UBS collaboration with the Guggenheim Museum may be a new paradigm for art and commerce in which business is a coparticipant rather than a leader. In this case, the focus on long-term goals and careful negotiation of social and business values led to a culturally responsible outcome. A new model of stakeholder engagement and business-arts partnerships should aspire to three important attributes: (1) a long-term relationship focused on issues of mutual importance; (2) a collaboration should include exposure to risk for both organizations; (3) an engagement with multiple stakeholder groups. Above all, the process should be transparent to all participants.

The massive amount of capital invested in cultural endowments could be more mission-driven and aligned with the needs of the cultural economy. "With more than $58 billion in their combined endowments, if America's cultural anchor

institutions align their money with their values and mission, the result will be meaningful for their communities and the creative sector as a whole" (Upstart Co-Lab, 2020). The Louvre Museum, for example, has reportedly allocated 5% of its €250 million endowment fund to socially responsible investments, including cultural tourism, heritage, and education. One of the Louvre's investments is in Mirabaud Patrimoine Vivant (Living Heritage), a private-equity fund focused on European artisan and traditional craft businesses (Upstart Co-Lab, 2020). Arts organizations supporting the creative industries create a virtuous circle through innovative finance. Souls Grown Deep was established with a 1,300-piece collection of works by 160 African-American artists based in the South. Through its Collection Transfer Program, the foundation sells pieces from its collection to major museums at a discount and reinvests the proceeds in programming and an impact investing strategy. It recently launched the Resale Royalty Award Program (RRAP), which bestows cash grants "to living artists who are part of the Foundation's collection and whose works have since been sold at auction, in galleries, and to museums through Souls Grown Deep's Collection Transfer Program" (Souls Grown Deep's Resale Royalty Award Program, 2021). In addition, the organization invests in a socially responsible fund that provides access to capital for women and BIPOC entrepreneurs.

New models of art and commerce should move beyond distinctions of high and low culture or the perspective that art is created by the few for the few. Recognizing that corporate sponsorships can range from the Container Corporation of America's Great Books project to the Armani exhibition at the Guggenheim, it is time for arts organizations and corporations to pursue collaborations that benefit all stakeholders and contribute something of measurable value to society. The world needs more leaders like Chaudhary to demonstrate how art and culture create value on many levels. His business has supported human and community development while opening new markets for his rugs.

Create New Ways to Measure Social Impact

As academics, consultants, and business leaders seek new and better ways to measure business impact on society, the measurement of social value remains an area in need of improvement. Since the early days of social audits and CSR reporting, companies have struggled to quantify the value they return to society. In terms of outcomes, impact, and reporting, CSR efforts have always been mostly measured from the perspective of the company. In this light, some scholars are calling for new and more rigorous measurement of CSR initiatives in terms of community enrichment (Barnett, Henriques and Husted, 2019). Scholars and practitioners have spent a great deal of energy developing the business case for CSR while largely ignoring the social perspective. As Christopher Marquis has noted, "If we are to build a more sustainable and resilient capitalism in the wake of COVID-19 and its

economic fallout, large public and multinational companies must adopt rigorous methods and processes to take all stakeholders seriously" (Marquis, 2020). The art, design, and creative sectors play critical roles in creating a common humanity and collectively represent a large group of crucial stakeholders. We need a new metrics approach on how the arts create value to communities and, as Nina Kressner Cobb suggested, a better understanding of the "broader social ramifications of strengthening the arts in a community" (Cobb, 2002).

The creative industries play a significant role in the global economy, and the 2020 pandemic has revealed the vulnerability of the sector. Based on a recent study in the United States, there have been estimated

> losses of 2.7 million jobs and more than $150 billion in sales of goods and services for creative industries nationwide, representing nearly a third of all jobs in those industries and 9% of annual sales. The fine and performing arts industries will be hit hardest, suffering estimated losses of almost 1.4 million jobs and $42.5 billion in sales. These estimated losses represent 50% of all jobs in those industries and more than a quarter of all lost sales nationwide.
>
> (Florida and Seman, 2020)

Not surprisingly, the cities hit hardest were New York and Los Angeles. The World Economic Forum's "Future of Jobs Report," published in October 2020, revealed a dramatic global retraction in arts, entertainment, and recreation employment. Yet, on a more positive note, many countries reported the skills needed for the emerging economy as the following: complex problem solving; creativity, originality, and initiative; resilience, stress tolerance, and flexibility; and emotional intelligence (World Economic Forum, 2020a).

While there have been a number of studies around the economic impact of the arts, there is no global standard to measure social value. Americans for the Arts has published economic-impact reports, most recently in 2015:

> Nationally, the nonprofit arts and culture industry generated $166.3 billion of economic activity during 2015—$63.8 billion in spending by arts and cultural organizations and an additional $102.5 billion in event-related expenditures by their audiences. This activity supported 4.6 million jobs and generated $27.5 billion in revenue to local, state, and federal governments.
>
> (Americans for the Arts, 2020)

There are methodologies that measure the quantitative value of the arts, as well as opportunities to measure qualitative impact. The complexity of measuring outcomes in the creative industries lies in the fact that they deliver value on three levels: economic, cultural, and social (Cunningham and Flew, 2019). Adding to this is the

tension between publicly supported culture and the commercial creative industries. According to the authors of the Warwick Commission report,

> A particular challenge for the publicly funded arts, culture, and heritage sector is how to determine metrics for evaluating the impact of their artistic, cultural, and social value creation in order to be more account-able to public investors and to attract private investors in particular.
>
> (Warwick Commission, 2015)

Improvements in measurement might also enable cultural responsibility to become part of Environmental, Social, and Governance (ESG) reporting more broadly. Since ESG reporting is broadly accepted as a CSR best practice, the integration of CCR metrics is a logical next step. Moreover, the improvements in measurement could lead to strategies for insulating the creative industries from disruptions like the recent pandemic.

A 2020 ranking of the world's most sustainably managed companies by the *Wall Street Journal* cited "social capital" as one of the key categories:

> Creating value for local communities while also generating value for stakeholders was a key theme among the companies that did the best in social capital—broadly defined as what a company contributes to society in return for a license to operate within it.

This is an interesting equation in that it implies that what companies contribute to society is both measurable and valued by society. The use of the phrase "value for stakeholders" also suggests that value can mean different things to different groups of stakeholders. The World Economic Forum (WEF) has been an advocate for improved measurement of the impact of business on society, proposing an expanded set of metrics including those quantifying the intangible value companies contribute to society and the economy (World Economic Forum, 2020b).

The WEF researchers identified seven categories of potential impact under the category of Total Social Investment (TSI), created in collaboration with Chief Executives for Corporate Purpose (CECP): communities, human rights, diversity equity and inclusion (internal and external), training, health and safety, and labor relations. "The two gaps in current knowledge are broader partnerships and social value categories, including efforts such as socially-driven internships, donations of digital material, impact investing, and shared-value work." According to the WEF report,

> The measurement of social investment is continuing to evolve as both the private and public sectors attempt to measure their contributions to the communities and societies where they live and work. Corporate social activities, which may have started by addressing challenges in local communities with community investments (e.g., cash contributions to

community partners), have expanded to include other types of social investment such as employee involvement, the use of company influence to raise funds from others, product development with social purpose and much more.

(World Economic Forum, 2020b)

Cultural heritage preservation sponsorship by companies like Tod's and Bulgari could be documented more formally as part of TSI reporting. Corporate support of local arts organizations is often connected to philanthropic community responsibility work in areas such as education and community livability. Currently, there is no mechanism to capture the social impact of such initiatives and improving the measurement of CCR would be a logical extension of CECP's work.

Revisit the Role of Museums in Mediating and Validating Culture

Museums have played a prominent role in the history of art and commerce, as "Engines of Culture" (D. M. Fox, 2017). First, museums have become venues for the display of works produced by companies, whether actual products or design related to advertising. Museums were key to introducing Modernism to the general public, especially in the United States. Second, museums have traditionally relied on patrons, often industrialists, to thrive and survive. This relationship became more troublesome in the 1980s, when cause-related marketing began to blur the lines between public and private, for-profit and nonprofit. Third, museums continue to affect the economics of the art market and validation of artists. As Rosalind Krauss cautioned in 1990, museum directors such as Thomas Krens treated their institutions as engines of capitalism, adopting the language and practice of corporations rather than serving the public (Krauss, 1990).

As the previous chapters have demonstrated, museums such as the MoMA, Tate, Guggenheim Museums, Metropolitan Museum of Art, Whitney Museum of American Art, and Art Institute of Chicago have played significant roles in bridging the gap between art and business. While the MoMA's 1952 Olivetti exhibition bolstered the company's entry into the US market, under John Cotton Dana, the Newark Museum became a model for the museum as a community resource. The Whitney branches on corporate sites, the advent of blockbuster exhibitions, the MoMA's Art Advisory Service, and the innovative partnerships initiated by the Guggenheim all contributed to promoting a new relationship between art and commerce while invigorating the role of the museum in society.

MoMA curator Paola Antonelli still honors the museum's advocacy for good design in her curatorial approach to design and social issues. In dealing with global issues such as risk, safety, and climate change, she leverages the weight of the institution to position design as a potential solution to global challenges. Antonelli's

exhibition *Broken Nature: Design Takes on Human Survival,* at the Triennale di Milano in 2019, explored

> the state of the threads that connect humans to their natural environments—some frayed, others altogether severed. In exploring architecture and design objects and concepts at all scales and in all materials, Broken Nature celebrates design's ability to offer powerful insight into the key issues of our age, moving beyond pious deference and inconclusive anxiety.
>
> (Broken Nature: XXII Triennale di Milano, Broken Nature, 2021)

The Cooper Hewitt's National Design Awards was founded in 2000 on the promise of "the power of design to change the world" (Cooper Hewitt, 2021). Sponsored by Target and Facebook, the prize recognizes socially responsible and innovative designs with proven impact and is complemented by education programming. The physical trophy was created in collaboration with the Corning Museum of Glass.

As donors, companies and corporate leaders have often accumulated social and cultural capital in the extreme, while museums have overstepped the bounds of their roles in providing a public good. Thomas Krens's expansion of the Guggenheim constellation and Abu Dhabi's efforts to develop Saadiyat Island have both raised questions around the museum as a public institution. The privatization of museums complicates the issue, for example, in the cases of the Fondation Louis Vuitton, financed by industrialist Bernard Arnault, and the Broad, a contemporary art museum in Los Angeles founded by Eli and Edythe Broad in 2015 (D. Chong, 2020). According to Georgina S. Walker, Broad's version of patronage "can be likened to a corporate takeover of the cultural sector in the city of Los Angeles" (Walker, 2019). Many critics have wondered where the boundaries between public and private should be and who is really monitoring the common good. Hans Haacke suggested that museums are "managers of consciousness" and therefore have a responsibility to provide content that is not influenced or constrained by the agendas of their funders.

Julie Halperin has argued that it might be the right time to "open the hood of museums and rewire their internal structure so that board members have less power" (Halperin, 2019). The enduring issue of board composition and accountability has been discussed for decades. The cases of Donald Marron and Leonard Lauder underscore the need for both term limits and broader representation on boards of directors. If museums are to be considered resources for the common good, they ought to be more accountable and relevant to the public. The call for transparency of governance should hold true for all donors, whether corporations, foundations, or individuals. As previously noted, the advent of corporate-owned museums raises additional questions in terms of how these institutions can serve as responsible "managers of consciousness."

The COVID-19 pandemic has put many museums in serious financial peril. In the United States alone, it is projected that museums may have lost as much as

$29.75 billion since the lockdown began (Cascone, 2020). Of the estimated 95,000 museums in the world, many will not be able to reopen or will struggle to return to normalcy. It is safe to predict that there will be increased pressure on funders to support these institutions and/or their programming. There is a role for scholarship in determining the parameters of the new normal. As Garry Gray and Victoria Bishop Kendzia suggest, "A close examination of power relationships existing in negotiations between funders and nonprofit organizations, and the subsequent acts of organizational self-censorship that stem from these relationships, needs to be further examined in academic research" (Gray and Kendzia, 2009). Scholarship can help in uncovering best practices in museums. Two categories of museums working toward positive social change were highlighted by Richard Sandell in 1998: museums working as agents of regeneration to deliver positive social outcomes to defined audiences, often through direct contact and ongoing project work with small groups of people considered to be disadvantaged, socially excluded, or living in poverty; and museums acting as vehicles for broad social change by exploiting their potential to communicate, educate, and influence public opinion (Sandell, 1998).

The global pandemic has exacerbated an identity crisis in the museum world, reflecting the one experienced in the 1960s and 1970s. Part of the solution may be the use of information technology to create wider access to the museum resources. As Lynn Teather suggested more than 20 years ago, "It also raises the question of how museums may in fact reconceptualize their relationships with people, groups, and communities using the technology of the Internet and in the spirit of the current discourse in museology" (Teather, 1998). In 2014, as one effort to innovate, the New Museum took a bold step in creating NEW INC, the first museum-led cultural incubator, described as

> a creative ecosystem that aims to foster cultural value, not just capital value. The program brings together boundary-pushing professionals who are inventing new forms and pursuing new models in fields as varied as music, interactive art, fashion, gaming, architecture, film, performing arts, product design, and web development, among others.
>
> (New Museum, 2021)

Not surprisingly, Nokia Bell Labs is one of the key funders of the new organization.

The widespread shift to learning from home prompted by COVID-19 opens the door for museum educators to explore innovative practices. Gamification is only one format being pursued across the creative industries, including art museums. The digital transformation of society presents a great opportunity for corporate cultural investment. Museums, with corporate support, can employ technology to improve all aspects of their operating models. The Modigliani Art Experience, pioneered by Milan's Mudec Museum of Cultures in 2018 is one example of a new breed of museum experience. Known as a "fully digital experiential exhibition," this immersive and multimedia format engages viewers in a novel and dramatic way (Caru, n.d.).

Bibliography

Agüera y Arcas, Blaise. 2017. "Art in the Age of Machine Intelligence." *Arts*. https://www.mdpi.com/2076-0752/6/4/18#cite (Retrieved June 24, 2020).

Americans for the Arts. 2020. "Arts and Economic Prosperity 5." *americansforthearts.org*. October 22. https://www.americansforthearts.org/by-program/reports-and-data/research-studies-publications/arts-economic-prosperity-5.

Anderson, Jennifer, Nina Henning, Marion Ntiru, and Shra Senior. 2009. "Jaipur Rugs: Connecting Rural India to Global Markets." *https://www.nkchaudhary.com/publications/page/6/*. https://d2x7u65ctlzo8.cloudfront.net/main/web-content/media/articles/the-fortune-at-the-bottom-of-pyramid-by-c.k.-prahalad-635675587071220353.pdf (Retrieved April 1, 2021).

Arts & Business. 2004. *Art Works: Why Business Need the Arts*. London: Arts & Business.

Balmer, John M. T. 2017. "The Corporate Identity, Total Corporate Communications, Stakeholders' Attributed Identities, Identifications and Behaviours Continuum." *European Journal of Marketing*, 51(9/10), 1472–1502.

Barnett, Michael, L. Irene. Henriques, and Bryan W. Husted. 2019. "Beyond Good Intentions: Designing CSR Initiatives for Greater Social Impact." *Journal of Management*. 46(1). https://papers.ssrn.com/sol3/papers.cfm?abstract_id=3506963 (Retrieved August 9, 2020).

Berthoin Antal, Ariane, and Anke Strauß. 2013. *Artistic Interventions in Organisations: Finding Evidence of Values-Added*. Berlin: Creative Clash Report. https://www.wzb.eu/system/files/docs/dst/wipo/effects_of_artistic_interventions_final_report.pdf (Retrieved September 29, 2020).

BlinkNow. 2021. *Our BlinkNow Goods*. April 9. https://blinknow-foundation.myshopify.com/collections/fall-2019.

Broken Nature: XXII Triennale di Milano, Broken Nature. 2021. *Broken Nature: XXII Triennale di Milano, Broken Nature*. April 9. http://www.brokennature.org/about/xxii-triennale/.

Caru, Antonella. n.d. The Impact of Techonolyg on Visitor Immersion in Art Exhibitions.

Cascone, Sarah. 2020. *Artnet News Art World*. November 17. https://news.artnet.com/art-world/museums-shuttering-aam-report-1924371 (Retrieved November 25, 2020).

Chen, Min. 2021. "The Many Ways LACMA's Art + Technology Lab Binds Creativity With Tech." *Jing Culture & Commerce*. February 8. https://jingculturecommerce.com/lacma-art-technology-lab/ (Retrieved June 2, 2021).

Chesbrough, Henry William. 2003. *Open Innovation: The New Imperative for Creating and Profiting from Technology*. Boston: Harvard Business School Press.

Chong, Derrick. 2020. "Art, Finance, Politics, and the Art Museum as a Public Institution." In *Museum Marketization*, by Karin Ekstrom, ed., 98–114. London: Routledge.

Cizek, Katerina, William Uricchio, and Sarah Rafsky. 2020. "Part 5: Estuaries: Media Co-Creation Across Disciplines. In Collective Wisdom (1st ed.)." *Collective Wisdom-Part-5*. June 11. https://wip.mitpress.mit.edu/pub/collective-wisdom-part-5.

Cobb, Nina Kressner. 2002. "The New Philanthropy: Its Impact on Funding Arts and Culture." *The Journal of Arts Management, Law, and Society*, 32(2), 125–143. 10.1080/10632920209596969 (Retrieved November 21, 2020).

Cooper Hewitt. 2021. *National Design Awards*. February 13. https://www.cooperhewitt.org/national-design-awards/.

Corsane, Gerard, ed. 2005. *Heritage, Museums and Galleries*. London: Routledge. https://doi.org/10.4324/9780203326350 (Retrieved November 29, 2020).

Cunningham, Stuart, and Terry Flew. 2019. "Introduction to a Research Agenda for Creative Industries." In *A Research Agenda for Creative Industries*, by S. Cunningham and T. Flew, eds., 1–20. Cheltenham: Edward Elgar Publishing.

Darsø, Lotte. 2005. "International Opportunities for Artful Learning." *Journal of Business Strategy*, 26(5), 58–61. https://doi-org.proxy.libraries.rutgers.edu/10.1108/02756660510620734 (Retrieved July 18, 2020).

De Fay, Christopher R. 2005. *Art, Enterprise, and Collaboration: Richard Serra, Robert Irwin, James Turrell, and Claes Oldenburg at the Art and Technology Program of the Los Angeles County Museum of Art, 1967–1971*. Ann Arbor: University of Michigan. ProQuest Dissertations and Thesis, 427. https://search-proquest-com.proxy.libraries.rutgers.edu/docview/305458789?accountid=13626.

Domus. 2017. "Singer Notes." *Domus.* August 29. https://www.domusweb.it/en/news/2017/08/29/singer_notes.html (Retrieved June 14, 2020).

European Commission. 2020. *European Commission.* July 20. https://ec.europa.eu/digital-single-market/en/ict-art-starts-platform.

Feitelberg, Rosemary. 2021. *H&M Reveals Upcoming Collaboration with Leading Model's Label*. April 8. https://wwd.com/fashion-news/fashion-scoops/hm-collaboration-liya-kebede-lemlem-1234796042/ (Retrieved April 9, 2021).

Ferilli, Guido, Pier Luigi Sacco, Giorgio Tavano Blessi, and Stefano Forbici. 2017. "Power to the People: When Culture Works as a Social Catalyst in Urban Regeneration Processes (and When It Does Not)." *European Planning Studies,* 25(2), 241–258. https://web-a-ebscohost-com.proxy.libraries.rutgers.edu/ehost/detail/detail?vid=0&sid=7c-1cc618-a755-4603-aa3c-30c06c8c0e01%40sessionmgr4007&bdata=JnNpdGU9ZWhvc3QtbGl2ZQ%3d%3d#db=aph&AN=120781740 (Retrieved January 24, 2021).

Florida, Richard, and Michael Seman. 2020. *Lost Art: Measuring COVID-19's Devastating Impact on America's Creative Economy.* Washington: Metropolitan Policy Program at Brookings. https://www.brookings.edu/wp-content/uploads/2020/08/20200810_Brookingsmetro_Covid19-and-creative-economy_Final.pdf (Retrieved October 4, 2020).

Forrester Research, Inc. 2014. *The Creative Dividend: How Creativity Impacts Business Results.* Cambridge: Forrester Research, Inc. https://landing.adobe.com/dam/downloads/whitepapers/55563.en.creative-dividends.pdf (Retrieved October 22, 2020).

Fox, Daniel M. 2017. *Engines of Culute: Philanthropy and Art Museums.* Oxon: Routledge.

Friedman, Hershey, and William Adler. 2011. "Moral Capitalism: A Biblical Perspective." *American Journal of Economics and Sociology,* 70(4), 1014–1028.

Gianecchini, Martina. 2020. "Strategies and Determinants of Corporate Support to the Arts: Insights from the Italian Context." *European Management Journal,* 38(2), 308–313. https://doi.org/10.1016/j.emj.2019.08.007 (Retrieved September 26, 2020).

Gray Area. 2020. "DeepDream: The Art of Neural Networks." *Gray Area.* June 24. https://grayarea.org/event/deepdream-the-art-of-neural-networks/.

Gray, Garry C., and Victoria Bishop Kendzia. 2009. "Organizational Self-Censorship: Corporate Sponsorship, Nonprofit Funding, and the Educational Experience." *Canadian Review of Sociology/Revue canadienne de sociologie,* 46(2), 161–177 https://doi-org.proxy.libraries (Retrieved November 28, 2020).

Halperin, Julie. 2019. *In an Age of Political Division and Dirty Money, can Museum Boards Ever be Immaculate? Some Think They Have Found a Solution.* July 17. https://news.artnet.com/art-world/boards-museums-money-2019-1600507 (Retrieved June 2, 2021).

Harris, Craig, ed. 1999. *Art and Innovation: The Xerox Parc Artist-in-Residence Program.* Cambridge: MIT Press.

Herranz-de-la-Casa, José Maria, Juan-Luis Manfredi-Sánchez and Francisco Cabezuelo-Lorenzo. 2015. "Latest Trends and Initiatives in Corporate Social Responsibility: A Communicational Analysis of Successful Cases of Arts and Culture in Spain." *Catalan Journal of Communication & Cultural Studies*, 7(2), 217–229.

Howard, Lindsay. 2017. "Inventing the Future: Art and Technology." *Art 21 Magazine*. October 27. http://magazine.art21.org/2017/10/26/inventing-the-future-art-and-technology/#.XuKSkEVKg2w.

Howard, Shirley Reiff. 2017. *International Directory of Corporate Art Collections*. Belleair Bluffs: The Interantional Art Alliance, Inc.

John Michael Kohler Arts Center. 2014. *Arts/Industry: Collaboration and Revelation*. Sheboygan: John Michael Kohler Arts Center.

Kennedy, Michael D. 2014. "Rewriting the Death and Afterlife of a Corporation: Bethlehem Steel." *Biography*. https://link.gale.com/apps/doc/A388052732/LitRC?u=new67449&sid=LitRC&xid= (Retrieved May 23, 2021).

Keyes, Allison. 2020. "How to Have That Tough Conversation About Race, Racism and Racial Identity." *Smithsonian Magazine*, June 4. https://www.smithsonianmag.com/smithsonian-institution/how-have-tough-conversation-about-race-racism-and-racial-identity-180975034/.

Kicherer, Sibylle. 1990. *Olivetti: A Study of the Corporate Management of Design*. New York: Rizzoli.

Kolko, Jon. 2015. "Design Thinking Comes of Age." *Harvard Business Review*. https://hbr.org/2015/09/design-thinking-comes-of-age (Retrieved July 14, 2020).

Kozanecka, Eva, and Kenric Allado-McDowell. 2020. "Announcing the Artists + Machine Intelligence Grant Recipients." *The Medium*. February 6. https://medium.com/artists-and-machine-intelligence/announcing-the-artists-machine-intelligence-grant-recipients-c3cba9addca8 (Retrieved June 24, 2020).

Krauss, Rosalind. 1990. "The Cultural Logic of the Late Capitalist Museum." *October*, 3–17. 10.2307/778666 (Retrieved May 23, 2021).

Lewandowska, Kamila. 2015. "From Sponsorship to Partnership in Arts and Business Relations." *The Journal of Arts Management, Law, and Society* 33–50. 10.1080/10632921.2014.964818 (Retrieved August 2, 2020).

Liedtka, Jeanne, Randy Salzman, and Daisy Azer. 2017. *Design Thinking for the Greater Good: Innovation in the Social Sector*. New York: Columbia University Press.

Liedtka, Jeanne. 2018. "Why Design Thinking Works." *Harvard Business Review*. September–October. https://hbr.org/2018/09/why-design-thinking-works (Retrieved July 11, 2020).

Los Angeles County Musuem of Art. 1971. "A Report on the Art and Technology Program of the Los Angeles County Museum of Art, 1967-1971." *Internet Archive*. https://archive.org/details/reportonarttechn00losa_/page/10/mode/1up (Retrieved June 2, 2021).

Marquis, Christopher. 2020. "The B Corp Movement Goes Big." *Stanford Social Innovation Review* https://ssir.org/articles/entry/the_b_corp_movement_goes_big# (Retrieved August 14, 2020).

New Museum. 2021. *NEW INC*. March 27. https://www.newmuseum.org/pages/view/new-inc-1.

Nissley, Nick. 2010. "Arts-Based Learning at Work: Economic Downturns, Innovation Upturns, and the Eminent Practicality of Arts in Business." *Journal of Business Strategy*, 31(4), 8–20. https://doi-org.proxy.libraries.rutgers.edu/10.1108/0275666 (Retrieved June 21, 2020).

Nokia Bell Labs. 2020. *Programs/E.A.T. Now.* July 20. https://www.bell-labs.com/programs/experiments-art-and-technology/eat-now/ (Retrieved July 20, 2020).

Novartis Pharmaceuticals Corporation. 2014. *Interaction Leads to Innovation: Transforming a Campus.* San Francisco: ORO Editions.

Paine, Ashley, Susan Holden, and John Macarthur, eds. 2020. *Valuing Architecture Heritage and the Economics of Culture.* Amsterdam: Valiz.

Plautz, Dana. 2005. "New Ideas Emerge When Collaboration Occurs." *Leonardo,* 38(4), 302–309. https://muse-jhu-edu.proxy.libraries.rutgers.edu/article/185781/pdf (Retrieved July 19, 2020).

Prahalad, C. K. 2006. *The Fortune at the Bottom of the Pyramid, Eradicating Poverty Through Profits.* Upper Saddle River: Wharton School Publishing.

Sacco, Pierluigi, and Giorgio Tavano Blessi. 2009. "The Social Viability of Culture-Led Urban Transformation Processes: Evidence from the Bicocca District, Milan." *Urban Studies,* 46(5–6), 1115–1135. https://doi.org/10.1177/0042098009103857 (Retrieved January 24, 2021).

Sandell, Richard. 1998. "Museums as Agents of Social Inclusion." *Museum Management and Curatorship,* 17(4), 401–418. https://doi.org/10.1016/S0260-4779(99)00037-0 (Retrieved November 28, 2020).

Schnugg, Claudia, and BeiBei Song. 2020. "An Organizational Perspective on ArtScience Collaboration: Opportunities and Challenges of Platforms to Collaborate with Artists." *Journal of Open Innovation: Technology, Market, and Complexity.* Na. https://www.mdpi.com/2199-8531/6/1/6/htm (Retrieved July 19, 2020).

Segran, Elizabeth. 2015. "Welcome to the Brave New World of the Corporate-Sponsored Artist." *Fast Company.* March 10. https://www.fastcompany.com/3043276/welcome-to-the-brave-new-world-of-the-corporate-sponsored-artist.

Seifter, Harvey, and Ted Buswick, eds. 2005. "Arts-Based Learning for Business." *Journal of Business Strategy.* https://ebookcentral.proquest.com.

———. 2010. "Creatively Intelligent Companies and Leaders." *Journal of Business Strategy.*

Selvin, Claire. 2020. "Banking on Art: TD Bank Has Expanded Its Art Collecting—and Has the Stickers to Prove It." *ARTNews.* July 23. https://www.artnews.com/art-news/news/td-bank-art-collection-1202695037/ (Retrieved November 15, 2020).

Sheppard, Benedict, Hugo Sarrazin, Garen Kouyoumjian, and Fabricio Dore. 2018. "McKinsey Quarterly." *Mckinsey.com.* October 25. https://www.mckinsey.com/business-functions/mckinsey-design/our-insights/the-business-value-of-design (Retrieved July 14, 2020).

Sholette, Gregory. 2017. *Delirium and Resistance: Activist Art and the Crisis of Capitalism.* London: Pluto Press.

Silver, Hannah. 2020. "Bulgari and David Chipperfield Unite for Rome's Torlonia Marbles Exhibition." *Wallpaper.* https://www.wallpaper.com/watches-and-jewellery/bulgari-david-chipperfield-rome-torlonia-marbles-exhibition (Retrieved November 3, 2020).

Sisodia, Raj, and Michael J. Gelb. 2019. *The Healing Organization.* Nashville: HarperCollins Leadership.

Souls Grown Deep's Resale Royalty Award Program. 2021. *Souls Grown Deep's Resale Royalty Award Program.* March 13. https://www.soulsgrowndeep.org/foundation/resale-royalty-award-program.

Starr, Fiona. 2012. *Corporate Responsibility for Cultural Heritage : Conservation, Sustainable Development, and Corporate Reputation.* London: Taylor & Francis. https://ebookcentral.proquest.com.

Strauss, Anke. 2017. *Dialogues between Art and Business: Collaborations, Cooptations, and Autonomy in a Knowledge Society.* Newcastle upon Tyne: Cambridge Scholars Publishing.

Teather, Lynn. 1998. "A Museum Is a Museum Is a Museum Or Is It?: Exploring Museology and the Web." *Museums and the Web.* https://www.academia.edu/1448926/A_Museum_is_a_Museum_is_a_Museum_Or_is_it_Exploring_Museology_and_the_Web (Retrieved November 30, 2020).

The New MBA. 2020. *The New MBA.* June 21. https://sites.google.com/site/visualandactive/Home/about-us/thats-edu-tainment/readings/reactions/the-new-mba.

Tyagi, Ruchi. 2012. "Sustaining by Working at the Bottom of the Pyramid: A Case of Indian Rugs Manufacturing Company." *Socialiniu Mokslu Studijos,* 13(1), 427–442. https://search-proquest-com.proxy.libraries.rutgers.edu/docview/1426202372?-accountid=13626 (Retrieved July 26, 2020).

UNESCO. 2017. *Re I Shaping Cultural Policies: Advancing Creativity for Development.* Paris: UNESCO. https://unesdoc.unesco.org/ark:/48223/pf0000260592/PDF/260592eng.pdf.multi.

UNESCO. 2018. "Culture for the 2030 Agenda." *UNESDOC Digital Library.* https://unesdoc.unesco.org/ark:/48223/pf0000264687 (Retrieved August 16, 2020).

Upstart Co-Lab. 2020. "The Guide: What Cultural Institutions Need to Know About Investing for Values and Mission." *Upstart Co-lab.* November. https://www.upstartco-lab.org/wp-content/uploads/2020/12/Upstart-Co-Lab-The-Guide-Nov-2020-Final.pdf (Retrieved December 2, 2020).

Ventura, Claudia, Giuseppina Cassalia and Lucia Della Spina. 2016. "New Models of Public-Private Partnership in Cultural Heritage Sector: Sponsorships between Models and Traps." *Procedia—Social and Behavioral Sciences,* 223, 257–264.

Walker, Georgina S. 2019. *The Private Collector's Museum: Public Good Versus Private Gain.* Milton Park: Routledge.

Warwick Commission. 2015. *Enriching Britain: Culture, Creativity and Growth.* Warwick. https://warwick.ac.uk/research/warwickcommission/futureculture/finalreport/warwick_commission_final_report.pdf (Retrieved March 31, 2021).

Wilson, Stephen. 1984. "Industrial Research Artist: A Proposal." *Leonardo,* 17(2), 69–70. https://www-jstor-org.proxy.libraries.rutgers.edu/stable/pdf/1574990.pdf?refreqid=-excelsior%3A6b1c191833051a49c25d3ac2e6767a2f (Retrieved July 19, 2020).

World Economic Forum. 2020a. *Future of Jobs Report.* Geneva: World Economic Forum. http://www3.weforum.org/docs/WEF_Future_of_Jobs_2020.pdf (Retrieved October 22, 2020).

World Economic Fourm. 2020b. "Measuring Stakeholder Capitalism." *World Economic Fourm.* September 22. https://www.weforum.org/reports/measuring-stakeholder-capitalism-towards-common-metrics-and-consistent-reporting-of-sustainable-value-creation (Retrieved November 1, 2020).

Conclusion

Returning to a question posed at the beginning of this book, what if there were an index that measured how much cultural benefit a CEO brought to society during his or her tenure at a company? In lieu of an index, it is possible to look at legacy as a leading indicator. The Aspen Institute carried out Walter Paepcke's vision around our common humanity. The cultural legacy of Corning Glass is evident in both its museum and headquarters city. J. Irving Miller and Cummins Engine Company have made Columbus, Indiana, a thriving small city and a symbol of public-private partnership for the common good. Ivrea, Italy, still stands as a reminder of Olivetti's experimentation in design integration, if also a warning about a place's dependence on the success of a single company. Hopefully, the remarkable town's UNESCO status will revive it as an open-air museum to inspire future generations of business and cultural leaders. Rolf Fehlbaum's gift to his region is a model for a living museum coexisting with a thriving company, in this case Vitra. At the core of these examples is the aspiration to bridge the worlds of art and commerce for the benefit of many stakeholders.

The Olivetti tradition of working directly with artists to design products continues in other Italian companies. Alessi, founded in 1921, has maintained its image as a producer of well-crafted luxury goods with a self-conscious focus on progressive design. Based in Northern Italy, Olivetti and Alessi exemplify the family-owned businesses model—and both happened to engage designer Ettore Sottsass. Yet unlike Olivetti, Alessi works with artists, architects, and designers as consultants rather than employees. As Grace Lees-Maffei explained, "The company has enlisted an international group of high-profile designers and produces designs that are as international, aesthetically, as they are Italian. Alessi's marketing addresses a global audience by using a hybrid of national identity and internationalism" (Lees-Maffei, 2002).

In terms of traditional CSR, it is difficult to tease out Alessi's contributions to its many stakeholders. If anything, the company should be lauded for the ability to raise the design of everyday objects to a new standard. According to Tanja Kotro, "Alessi provides an important example of the way that design can be embedded in the organization not as an external activity but rather as a ubiquitous philosophy" (Kotro, 2001). The Italian company Illycaffè has also experimented with artist

DOI: 10.4324/9781003099222-8

collaborations since 1992, most visibly in a cup-design project, as a way to situate the brand in the world of cultural production and gain competitive advantage by attaching "symbolic, aesthetic, and cultural connotations to the company products or services" (Comunian, 2008).

Business can reenvision its role as patron and find new ways to encourage creativity and sustain artists and communities as part of a CSR practice. The commitments to design and architecture exemplified by Corning Glass, Cummins Engine, and Vitra serve as enduring models of business supporting art and culture on a community level with global ramifications. Over the past century, the practice of corporate patronage and the concept of the company town have evolved with the help of enlightened capitalism. Corporate leaders who firmly believe that business should be a force for good must move beyond rhetoric and take measurable actions. For example, Nokia Bell Labs claims to be committed to "enabling higher order modes of communication" and inventing "technology that will augment our senses." Will the company be reporting on the related outcomes in its annual report?

IBM and Alessi have contributed to design excellence, yet Olivetti, Cummins, Vitra, and Jaipur Rugs have reached more stakeholders and added value to society in more ways. These corporate leaders made great strides in bridging the gap between business and art, and in doing so enriched humanity. Employees, artists, designers, architects, and communities were given the opportunity to collaborate for the common good. Many of these efforts began as dialogues between the worlds of art and business with the intention of bridging these seemingly opposed realms. The intersection of art and commerce has proven to be a nexus of mutual potential, described by Julia Rowntree, who coined the phrase "Learning, not logos," as inspiring

> ways of knowing the world that are illuminating for all, including those people who work to create wealth. It is also a route to finding a way to sustain contemporary arts organizations in the new economy: global, wired, and largely privatized.
>
> (Rowntree, 2001)

While capitalism is being reinvented, there is no better time to elevate the arts as a corporate and societal responsibility. Taking all stakeholders seriously is at the heart of CCR, and the potential for collaboration between art and commerce has never been greater. As Charles Handy famously stated, "The purpose of a business, in other words, is not to make a profit, full stop. It is to make a profit in order to enable it to do something more or better." Given that the United Nations General Assembly declared 2021 the International Year of Creative Economy for Sustainable Development, it is a good time to reassert the arts into the dialogue around CSR and stakeholder engagement (United Nations, 2019). Artist and activist Lisa Russell has tirelessly advocated for the role of artists in the creative economy within global

development. As a filmmaker and founder of Create2030, she has demonstrated the critical part an artist can play in sustainable development, social justice, and public health (Russell, 2019). Business too has the opportunity, to support living artists, to elevate and preserve art and culture as key elements of global development as part of our shared humanity.

The creative industries are being recognized increasingly as critical to a healthy society and economy. In the context of the creative economy, art and culture have become more prominent and recognized elements of our society. The evolution of digital media presents a host of opportunities for success in both business and culture as well as for the intersection of art and commerce. The creative industries have enormous potential to capitalize on new modes of production, consumption, promotion, and stakeholder engagement. Museums and cultural heritage organizations have only just begun to realize the benefits and challenges of integrating digital innovation into their programming. Business leaders have a role to play in supporting cultural organizations in resolving the challenges around "authenticity, legitimacy, control, trust, and co-creation" (Massi, Vecco and Lin, 2021).

As Edward A. Shils argued many decades ago, the arts enhance our sense of legacy and ability to innovate. We have moved beyond traditional philanthropy and sponsorship since then "to present business investments in the arts as a meaningful socioeconomic choice within a company value-chain and must attempt to investigate its impact in terms of economic competitiveness" (Comunian, *Toward a New Conceptual Framework for Business Investments in the Arts: Some Examples from Italy*, 2009). Perhaps, a new movement like the Bauhaus could spark an exploration of new solutions to problems like workplace quality and climate change. Reflecting on the Bauhaus legacy, Nate Berg noted, "Its guiding principles of designing for functionality and responding to the needs of society are its more important legacies, and what can inspire designers taking on future challenges" (Berg, 2020). The principles of CCR can serve as a framework for future efforts to normalize corporate engagement with art, culture, design, and heritage.

Authentic CCR celebrates the humanity at the core of society. CCR can promote social inclusion and employee engagement while serving as a driver for a company's reputation. While certainly not a prescription for potential partnerships or corporate interventions in the arts, the CCR framework informs businesses, NGOs, and governments seeking to create new collaborations, coalitions, and partnerships. A well-designed CCR program perpetuates business as well as social value. At its core is the successful bridging of commerce and art for the benefit of society. As argued in an appeal by the Pirelli Foundation for support of a COVID-19 cultural relief fund:

> In short, economic development would not exist if our businesses were not characterized by such robust cultural foundations. The key to innovation lies not so much in a combination of 'business and culture' but in a synthesis of the two—'business is culture'.
>
> (Fondazione Pirelli, 2020)

Yet the narrative around art and commerce, starting in the 1950s, is far from complete. The contributions of many individuals, communities, and companies are underappreciated and, in some cases, excluded from the story. There is more work to be done to understand the contributions of critical art and design leaders such as Edith Halpert, Katharine Kuh, and Anne Swainson. The Jaipur Rugs business model should be incorporated into the MBA curriculum. The work of Upstart Co-Lab should be more central to the impact investment landscape, and the innovative practices of the Souls Grown Deep Foundation should be widely known and replicated.

As founding partner of Upstart Co-Lab Laura Callanan argues, "When creative people pursue businesses that have a social purpose, they can have a catalytic impact on job creation, the economy, and social well-being. And that benefits everybody" (Callanan, 2017). In her persistent call for more capital investment in arts and culture, Callanan advocates for bridging the worlds of art and commerce in culturally responsive ways. Paola Antonelli reminds us:

> Designers are about life and about the world and therefore they're very much in the present and also directed towards the future if they're doing their job. The present is, and we hear it every single day, about this crisis of understanding our position in the world and in the universe, a crisis that has to do with the environment and also with social bonds.
>
> (Pownhall, 2019)

Given the rich discourse over the past few decades focused on product design, corporate image, and design thinking, the concept and practice of design is poised to play an even greater role in CCR.

The role of architecture and design in corporate identity is more critical than ever. As architectural historian Grace Ong Yan has noted, "If 20th-century corporate brands communicated modern concepts like efficiency and progressiveness, 21st-century corporations are about transparency and societal responsibilities. … Society will inform corporations, not the other way around, of critical issues in building architectural brands for the future" (Ong Yan, 2020). Since the private sector is a major contributor to the built landscape, there is increasing pressure to be more responsible in designing, building, maintaining, and preserving corporate office buildings. Organizations such as Architects Declare promote a more deliberate approach. The following are among its key tenets: "Evaluate all new projects against the aspiration to contribute positively to mitigating climate breakdown, and encourage our clients to adopt this approach. Upgrade existing buildings for extended use as a more carbon efficient alternative to demolition and new build whenever there is a viable choice. Include life cycle costing, whole life carbon modelling, and post occupancy evaluation as part of our basic scope of work, to reduce both embodied and operational resource use" (Architects Declare, 2021). This call for transparency should include contingency planning for mergers, acquisitions, and sales of

properties to avoid corporate campuses becoming "white elephants" or preservation challenges (Willis, 1995).

As humanity confronts climate change, social injustice, economic inequity, and pandemics, conscious capitalism offers hope in the face of unprecedented levels of complexity. The power of large multinational corporations combined with their supply chains is almost unfathomable. In the spirit of Paepcke's vision for the Aspen Institute and Arthur Houghton's Corning Conference, the private sector could once again take the lead in convening a public dialogue around corporate cultural responsibility. Organizations such as the Twentieth Century Fund and the Ford Foundation were critical contributors to the discussion around art and culture in the mid-twentieth century and could contribute to its revival. Nearly 50 years ago, S. Prakash Sethi defined the social obligation, responsibility, and responsiveness required of business (Sethi, 1975). It is time for companies to revisit the expectations of multiple stakeholders around these principles to become legitimate, respected, and relevant actors in society. Art, design, and culture are at the core of our common humanity, and business has the moral imperative to demonstrate, support, and advocate for cultural responsibility.

Bibliography

Architects Declare. 2021. *UK Architects Declare Climate and Biodiversity Emergency.* April 11. https://www.architectsdeclare.com/.

Berg, Nate. 2020. "Toward a New Bauhaus: How a Century-Old Design Movement Could Help Save the Planet." *Fast Company.* October 6. https://www.fastcompany.com/90560186/toward-a-new-bauhaus-how-a-century-old-design-movement-could-help-save-the-planet (Retrieved October 13, 2020).

Callanan, Laura. 2017. "Capital for Creativity." *Stanford Social Innovation Review.* https://login.proxy.libraries.rutgers.edu/login?url=?url=https://www-proquest-com.proxy.libraries.rutgers.edu/magazines/capital-creativity/doc (Retrieved March 28, 2021).

Comunian, Roberta. 2008. "Culture Italian Style: Business and the Arts." *Journal of Business Strategy,* 29(3), 37–44. https://doi-org.proxy.libraries.rutgers.edu/10.1108/02756660810873209 (Retrieved July 18, 2020).

———. 2009. "Toward a New Conceptual Framework for Business Investments in the Arts: Some Examples from Italy." *The Journal of Arts Management, Law, and Society,* 39(3), 200–220. 10.1080/10632920903218521 (Retrieved September 26, 2020).

Fondazione Pirelli. 2020. *A Fund to Save Cultural Enterprises, Too: They Are the Cornerstones of Community and Economic Development.* April 6. https://www.fondazionepirelli.org/en/corporate-culture/blog/a-fund-to-save-cultural-enterprises-too-they-are-the-cornerstones-of-community-and-economic-development/ (Retrieved January 30, 2021).

Kotro, Tanja. 2001. "Culture, Design and Business: Alessi on a Fine Line." In *Industrial Design as a Culturally Reflexive Activity in Manufacturing,* by Juha Järvinen and Ilpo Koskinen eds., 150–165, Helsinki: University of Art and Design Helsinki UIAH.

Lees-Maffei, Grace. 2002. "Italianità and Internationalism: Production, Design and Mediation at Alessi, 1976–96." *Modern Italy,* 7(1), 37–57.

Massi, Marta, Marilena Vecco, and Yi Lin, eds. 2021. *Digital Transformation in the Cultural and Creative Industries*. London: Routledge.

Ong Yan, Grace. 2020. *Building Brands: Corporations and Modern Architecture*. London: Lund Humphries.

Pownhall, Augusta. 2019. *Dezeen*. February 22. https://www.dezeen.com/2019/02/22/paola-antonelli-extinction-milan-triennale-broken-nature-exhibition/ (Retrieved May 7, 2021).

Rowntree, Julia. 2001. "Learning, Not Logos—A New Dialogue between Arts and Business." *Reflections: The Sol Journal,* 2, 76–80 https://doi-org.proxy.libraries.rutgers.edu/10.1162/152417301750385486 (Retrieved July 30, 2020).

Russell, Lisa. 2019. "10 Steps on How UN/NGOs Can Work Responsibly with Artists." *medium.com.* July 24. https://medium.com/@lisarussellfilms/10-steps-on-how-un-ngos-can-work-with-responsibly-with-artists-54a65bac291 (Retrieved May 25, 2021).

Sethi, S. P. 1975. "Dimensions of Corporate Social Performance: An Analytical Framework." *California Management Review,* 17(3), 59–64. https://doi.org/10.2307/41162149 (Retrieved November 22, 2020).

United Nations. 2019. "United Nations General Assembly." *Seventy-Fourth Session, Second Committee Agenda Item 17, Macroeconomic Policy Questions*. November 8. https://undocs.org/A/C.2/74/L.16/Rev.1 (Retrieved September 17, 2020).

Willis, Carol. 1995. *Form Follows Finance: Skyscrapers and Skylines in New York and Chicago*. New York: Princeton Architectural Press.

Index